ILLUSION
CONFUSION

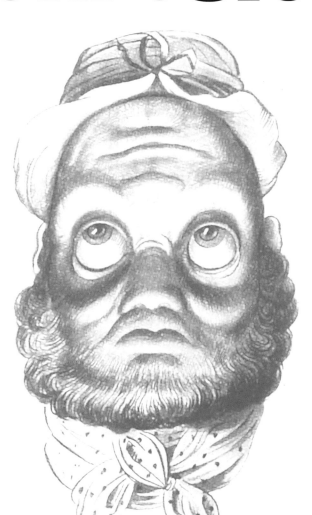

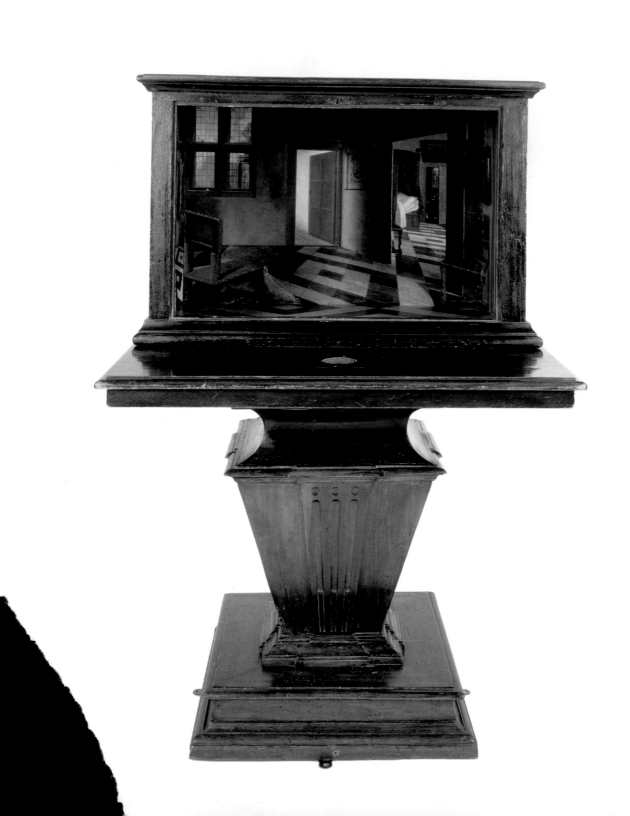

Paul M. Baars

ILLUSION CONFUSION

THE WONDERFUL WORLD OF OPTICAL DECEPTION

 Thames & Hudson

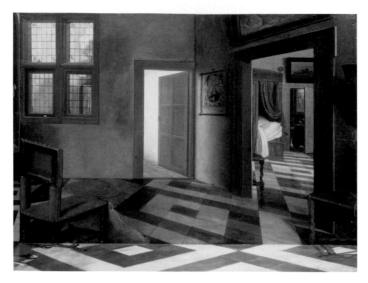

Frontispiece and above:
Samuel van Hoogstraeten (1627–1678).
Peepshow with Views of the Interior of a Dutch House. c. 1655–1660.
This page shows the interior as viewed from the front.

First published in the United Kingdom in 2014 by
Thames & Hudson Ltd, 181A High Holborn,
London WC1V 7QX

British Library Cataloguing-in-Publication Data
A catalogue record for this book is available from the
British Library

ISBN 978-0-500-29131-3

A Joost Elffers Book

Printed and bound in China

To find out about all our publications, please visit
www.thamesandhudson.com.
There you can subscribe to our e-newsletter, browse or
download our current catalogue, and buy any titles that are
in print.

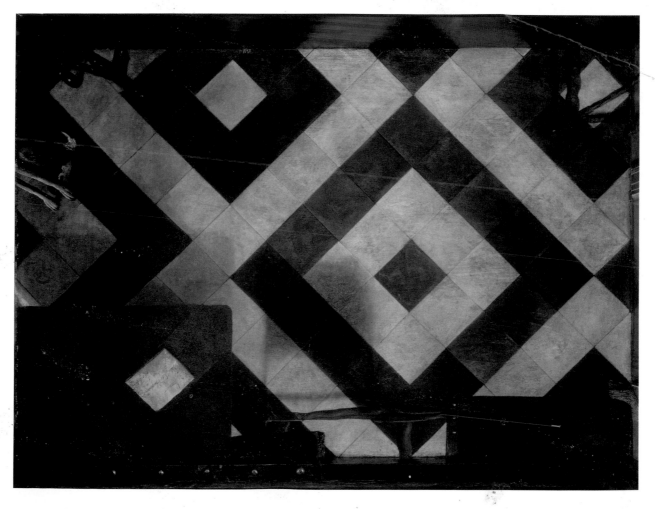

Samuel van Hoogstraeten (1627–1678). *Peepshow with Views of the Interior of a Dutch House*. c. 1655–1660. Detail of the interior as viewed from above, looking down at the floor.

Contents

Foreword

Although illusionistic images have been found in ancient cave paintings dating back to 13,000 BC, one of the first recognized optical illusions was created by Leonardo da Vinci in 1485. Linear perspective, where a picture convincingly reproduces a view as seen from a fixed central point, had been invented not even half a century earlier, and Leonardo, the master, was already questioning the strict rules of the method. He played with anamorphic perspective; the first anamorphic drawing we know is his sketch of an eye, which had to be turned to the side in order to be seen correctly.

Leonardo had invented a type of picture that could not be "seen" from a static, central position. Fifty years later, Holbein painted *The Ambassadors* (see page 28), and placed an anamorphic perspective (a skull) within a larger work that he constructed using linear perspective. The viewer had to step away from the center and look at the painting from the side for the skull to "appear." Holbein used anamorphic perspective in a symbolic, secret, and almost hidden way, perhaps alluding to life's ever-present invisible parallel world—death in life.

When I found my first eighteenth-century anamorphic gravure in an antique shop in Amsterdam in the 1970s, I saw the expressive world of placing differing perspectives one on top of another as a way of evoking multiple realities in a single image. Anamorphic art, and optical illusions in general, became more than just a mere interest of mine. Those who know me can follow this thread through many of the books and projects I have worked on, whether through a formal exploration of hidden images and anamorphic art, playing games and solving tangram puzzles to create new images out of pre-existing shapes, or even just seeing faces in fruits and vegetables. They are all nonlinear and interactive, calling for "reader participation."

Today we have entered a new era of optical illusions. Gone is the symbolism of other centuries. In our time, many of the interesting inventions and discoveries in optical illusions are being made by psychologists and neuroscientists investigating the functioning of eye-brain coordination. When the "Magic Eye" books were published in the 1990s, I was shocked to see totally new illusions, invented by scientists using computers. Today, the optical illusion is a viewing tool, a means to stimulate a physical experience. To produce surprise and amazement in the viewer is its sole purpose.

Fortunately for "book people," optical illusions are best viewed printed on paper and bound as a book. Many simply would not work on a screen. The images in this book are tools to play with your perception. Although you might think you know them all, there is always that moment when a picture strikes back and stays hidden. If you are patient, it will reveal its secret.

I hope you enjoy the collection of pictures in this book. My own passion for the world of illusions remains undiminished.

Joost Elffers

Introduction

Thanks to our five senses, we are generally capable of traveling the road from cradle to grave unscathed. Via the extremely refined mechanism of our eyes, one of the most important senses, we are able to capture visual information about our environment. Our brain then does the rest—receiving impulses from the optic nerve and interpreting this data to identify opportunities or threats in our immediate surroundings. Our "common sense" effortlessly fills in the gaps in our physical seeing to create a vision of how the world is. Ironically, we have blind trust in our visual experience—for us, seeing is believing. Optical illusions, however, should give us a healthy skepticism about this.

Perspective Illusions, Anamorphic Images, Murals, and Camouflage

Since prehistoric times, people have used pictures to communicate their visual experiences. Styles of picture-making differ radically from era to era, as do the materials and methods used to make them. Some cultures limit themselves to purely geometric patterns while others aspire to lifelike representations of reality.

In this way, each culture constructs its own particular tradition of seeing. In the West, for example, the clear preference for true-to-nature depictions ultimately goes back to Classical Greece.

In the Western tradition of seeing, we strive to make images on flat surfaces that are true to our perception of three-dimensional space in nature. In reality, each image consists of nothing more than lines and areas of color applied skillfully by an artist. Although our eyes perceive only these lines and the areas of color, our brain reads a story into them that creates depth.

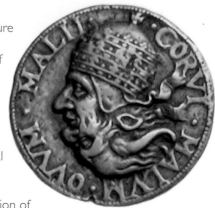

MALI CORVI MALVM OVVM ("A bad crow from a bad egg"). c. 1543.
The Pope turns into the Devil when the medal is flipped upside-down.

Painting of a human figure surrounded by bison in the Grotte des Trois Frères, Montesquieu-Avantès, France, c. 13,000 BC.

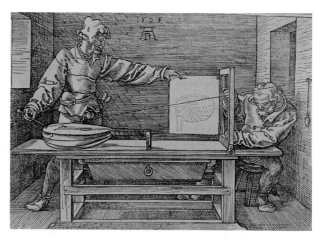

Albrecht Dürer (1471–1528). *Man Drawing a Lute*. 1525.

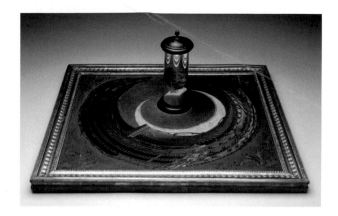

Anamorphic painting of a ship. c. 1744–1774. *(See p. 38.)*

separate perspectival points of view in one and the same work, or when viewpoints disappear entirely in pictures that only give up their secret when reflected in a cylindrical mirror! By transgressing the rule of linear perspective, an artist seems to be saying: "Just take a few steps sideways," or "How about turning your head?"

Breaking the rules of linear perspective provides artists with a perfect opportunity to add secondary meanings to their work or to camouflage contradictory messages. One could compare it to a form of camouflage, in which

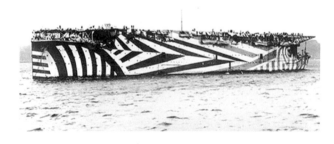

HMS *Argus* in dazzle camouflage. 1917. *(See also p. 56.)*

an object is covered with patterns that cause it to disappear into its surroundings, or that at least confuse the viewer regarding its true form. In military affairs, this

form of optical illusion can be a matter of life or death. Similarly, for many species in the animal world, it is sometimes desirable to imitate the environment or to blur physical outlines in order to mislead prey or predators.

Impossible Illusions in Perspective

Many artists have been inspired to tease our brains by subverting linear perspective. M. C. Escher is one of the undisputed masters in creating this type of optical illusion. With astonishing technical skill, he constructs seemingly normal buildings, colonnades, and staircases. It is only upon closer scrutiny that the impossibility of their internal structures become evident. Only then do we see that he has condemned his human subjects to

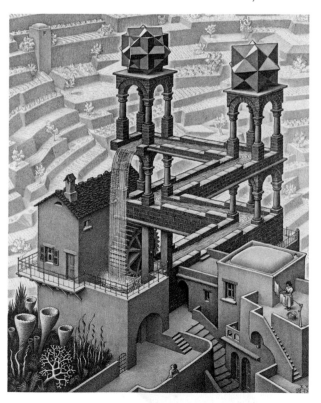

M. C. Escher (1898–1972). *Waterfall.* 1961.

In this battle, the brain always wins—it is almost impossible to see only the lines and areas of color, and when that does occur, the illusion of a coherent picture in physical space immediately disappears. Our brain cannot process two observations simultaneously.

standard approach to composition in the centuries that followed. As a convincing mode of picture-making, it builds on our innate understanding that the smaller an object appears to be, the farther away it is. It's difficult for us to imagine making pictures that represent reality without using linear perspective. In this way, our Western

![Andrea Mantegna illusionistic ceiling fresco]

Andrea Mantegna (1431–1506). *Illusionistic ceiling*. Fresco, 1465–1474. Palazzo Ducale, Mantua, Italy. *(See p. 20.)*

With the invention of linear perspective in the Renaissance, artists perfected a technique for making pictures that gave an illusion of depth. In doing this, they also furthered the attitude, which was then starting to be fashionable, that humans are at the center of the universe.

This way of constructing a picture—filling the space between a single, central viewpoint and the horizon with objects that diminish regularly in size—became a

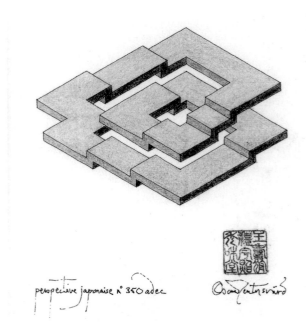

persopective japonaise n° 350 a dec

Oscar Reutersvärd (1915–2002).
Drawing 350 from *Perspective Japonaise*. Undated. *(See p. 76)*

tradition of image making is quite different from the Japanese tradition, for instance.

Creative minds, however, feel challenged to explore the limits and possibilities of linear perspective. To do this turns out not to be very difficult. Yet how startling it is to us when an artist incorporates two (or even more)

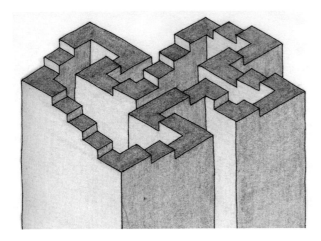

Oscar Reutersvärd (1915–2002). *Untitled drawing of impossible stairs.* Undated.

ascend and descend in an infinite loop, never allowing them to reach their final destination, or that his waterfall will never run dry.

Equally impossible are Oscar Reutersvärd's geometric figures. This Swedish artist, a contemporary of Escher, sketched well over twenty-five hundred isometric illusions. Both artists have a widespread following among scientists, particularly mathematicians and crystallographers.

Upside-Down Illusions

The venerable upside-down illusion (the Victorians called them "topsy-turvies"), in which one of the representations embedded in a picture is in an unfamiliar orientation, is always a delight. For centuries, moreover, such images have been a way for artists—or their patrons—to sneak subversive commentary into portraits of the powerful. Historically, this often could not be done openly, though we find it perfectly acceptable these days; for example, in political cartoons. By turning an image upside-down, a sharp observer might find a subtle (or not-so-subtle) critical annotation in the apparently accidental jumble of lines rendering a collar, chest, or beard, for example. If the subversive message was discovered by the authorities, the artist who put it there could simply apologize and insist on the sheer randomness of the lines, as if it were merely akin to seeing haphazard faces in the clouds.

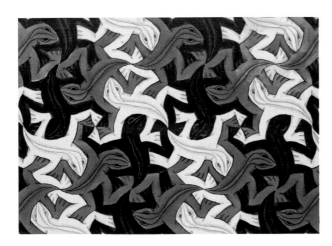

M. C. Escher (1898–1972). *Symmetry Drawing E 56.* 1942. (See p. 280.)

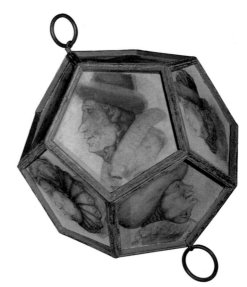

Dodecahedron with topsy-turvy heads. c. 1600. (See p. 128.)

Ambiguous Figures and Figure-Ground Illusions

In "normal" pictures, we distinguish between figure and background. We use the outline of a figure to identify it. The space around the figure, the background, usually lacks a clear form of its own; it is "empty" and we disregard it. When an artist activates this "empty" space by turning it into another object, he produces an illusion. Since the human brain cannot "see" both objects simultaneously, as you turn your attention to one, the other "hides."

Faces seen in cloud formations, or in the moon, can easily toy with our common sense, as can rock formations. As soon as we begin to see a picture emerge out of nature's chaos, our brains cannot let go of it. And what about a rainbow, or a mirage? This is where the laws of optics are at work in full force on our visual apparatus. These phenomena are not illusions at all, but the result of air temperature and humidity bending light.

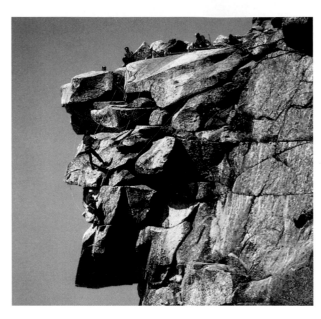

The Old Man of the Mountain, Cannon Mountain, New Hampshire. (Collapsed 2003.) *(See p. 149.)*

Neon- and After-Effects, Color Brightness, Static Movements, and Vibrations

So far we have looked at illusions that have a narrative element. In them, the viewer discovers hidden alternative realities. This can take effort. Sometimes the viewer has to become actively involved in the search by taking a step sideways, for instance, or turning the image around.

Illusions that act directly on the human optic system have a wholly different nature. Here, the artist finds ways to produce visual phenomena—movement, vibration, distortion—that our brains cannot resist. Once narrative art had relinquished its absolute monopoly, during the second quarter of the twentieth century, artists were

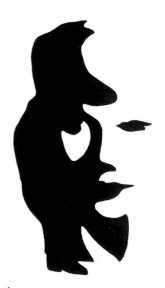

Roger N. Shepard (born 1929). *Sara Nader.* c. 1990. *(See p. 188.)*

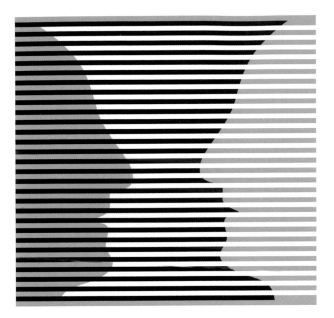

Studio PBD. *Tête à Fleur in Lines*. 2012. *(See p. 223.)*

free to explore non-representational compositions: geometric combinations, transparencies, and overlapping elements. They discovered subtle tricks that could be used to generate optical and kinetic effects.

These techniques have aroused increasing interest among scientists. Physicists study natural phenomena like light and color; psychologists and neurologists research how things work in the eye and brain. Yet some of the most simple illusions still resist explanation.

So, what have we learned? For one thing, that our eyes always perceive the luminosity of a color in relationship to its immediate surroundings. An artist can therefore make an area of color appear brighter by placing it

between darker colors. Conversely, when lighter colors surround that same color, our brain interprets it as being darker. This aspect of our vision actually helps us to perceive continuous surfaces even when the light on them is variable—an ability that is extremely useful for survival in a sunlit world, but that also gives rise to some startling illusions.

Our visual mechanics can even cause us to see colors where there are none, as, for instance, when pale hues spread into empty space. We speak of this phenomenon as a "neon effect," recalling the radiance of neon gases.

Consider, too, the static compositions in which our brains read movement. One could be forgiven for assuming that there is quite a significant disconnect between our refined optical mechanics and our brains. How easily we are misled! Our eyes jump back and forth between isolated shapes and colors, searching for similar or equal components in the image. What happens then?

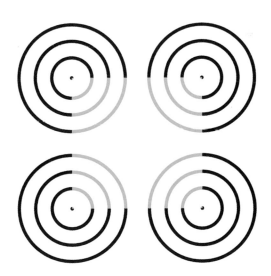

Studio PBD. *Illusory Pink Square*. 2007. *(See p. 212.)*

Because our eyes jump back and forth between forms or colors, the composition appears to move! As soon as artists became aware of this phenomenon, they made use of it in constructing illusions of motion.

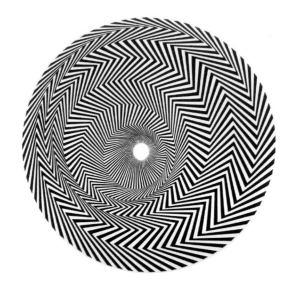

Bridget Riley (born 1931). *Blaze.* 1964. *(See p. 234.)*

our heads toward or away from such an image, illusory color or light spots appear at intersections and turns, and everything begins to vibrate!

Troxler's Effect. *(See p. 229.)*

Our vision is sharp over only a small portion of our visual field. The rest of that visual field sees with less acuity, and the place in the retina where the nerve ends come together is actually completely blind. Many artists, playing at being neurologists, capitalize on this blindness and invite us to focus on a particular point in the work. The further away elements in an optically stimulating image are from the area in sharpest focus, the less accurately we perceive them. This indeterminate perception, too, is transformed into movement in our brains. When an artist additionally invites us to move

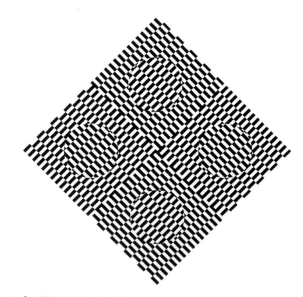

Studio PBD. *4 Ouchi*. 2013. *(See p. 244.)*

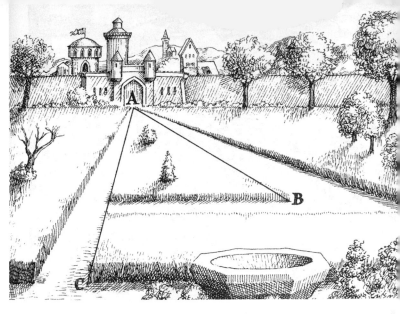

Estimated Sizes, Image Distortions, and Geometric Illusions

Our visual experience of 3-D space causes us to make assumptions about the relative sizes and positions of objects in pictures that are not easily overturned by objective measurement.

We expect that an object will appear to shrink as it moves away from us and approaches the visual horizon. But what if the artist places two identical figures in a picture, yet doesn't make the one closer to the horizon proportionately smaller than the one in the foreground? Then the "farthest figure" (the one closer to the horizon) appears to be much larger than the one in front, even though both are the same size. We are equally flummoxed when lines of identical length emanating from the same vanishing point are superimposed at different angles on a scene of linear perspective—the one that extends closer to the foreground will always appear to be longer.

Perspective illusion: Which is longer, A to B or A to C?

Speaking of lines, it is easy to make them misbehave. The perceived shape of a line or edge of a form is highly sensitive to the shapes of the lines and edges nearby. Curves appear to be straight, straight lines seem to curve, circles become spirals, and the sides of a square look concave or convex. It's all a matter of visual context.

Without being aware of it, a nineteenth-century mason created an optical illusion by slightly staggering the white-and-black tiles on the shopfront of a café in Bristol, England. The pattern gained world renown as

Roger N. Shepard (born 1929). *Terror Subterra*. c. 1990. *(See p. 255.)*

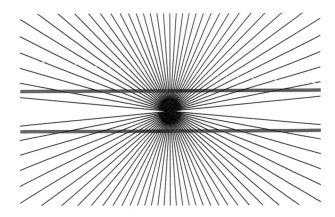

Studio PBD. *Bent Lines Illusion*. 2013. *After Ewald Hering. (See p. 275.)*

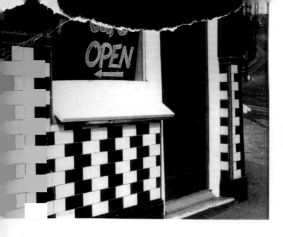

Café wall, Bristol, England.
(See page 272.)

the "café effect." So how did it work? The offset areas of black and white affect the way we perceive the angles of the horizontal lines made by the uniformly gray mortar, so even though all the tiles really have the same rectangular form, they form rows that appear to get wider and then narrower!

The search for images that the brain misreads is endlessly fascinating. Geometric forms are often useful in such experiments as they have no secondary layer of meaning. In addition to artistic creativity, the quest requires scientific creativity. Scientists do actively participate in this kind of research, hence the many optical illusions that are named after the psychologists and neurologists who discovered them.

Tessellations and Illusions of Depth and Distance

A tessellation is simply a pattern of tiles that fills a surface without gaps. It does not create an illusion in and of itself. But what happens when the tiles turn into complex interlocking figures? At last, the distinction between figure and ground is erased completely. Again we enter the realm of M. C. Escher, for it was he who pioneered this demanding type of picture making. He worked on his famous light-blue squared paper, reworking the borders between shapes until he managed to transform these shapes gradually to resemble living creatures. In the final play between form and counter-form, we see 3-D space disappear into the squirming piles of lizards and flocks of birds that we instantly recognize as the work of his hand.

Many artists have been inspired by Escher's tessellations. Some have added an illusion of depth. When Victor Vasarely's geometric lozenges are cemented into a tiled wall, do they form a niche, a bulge, or both? Vasarely comes at the end of a long tradition of image-making that is intended to generate confusion about depth and distance. Cubes project into space: Does our brain think we are seeing them from above or from below? And what about concentric circles whose lines differ in thickness? Do they really pull the true center of the image to the side where the lines are thinnest? Illusions leave us lost in space.

In the end, our eyes and brains are beautifully adapted to help us master our daily environment, and it is not surprising that we cannot "see" the aspects of that environment that are not normally needed for our survival. We owe the discovery of the many limitations in our normal vision, and the astounding ways that these can be exploited, to the boundless creativity and inspiration of the makers of optical illusions.

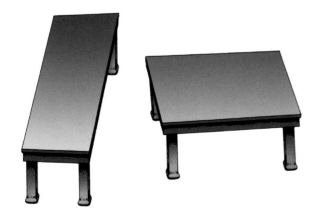

Shepard's Tabletops. After Roger N. Shepard's *Turning the Tables*, c. 1990. *(See p. 250.)*

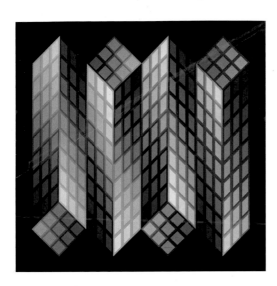

Victor Vasarely (1908–1997). *Toroni-Nagy*. 1969. *(See p. 304.)*

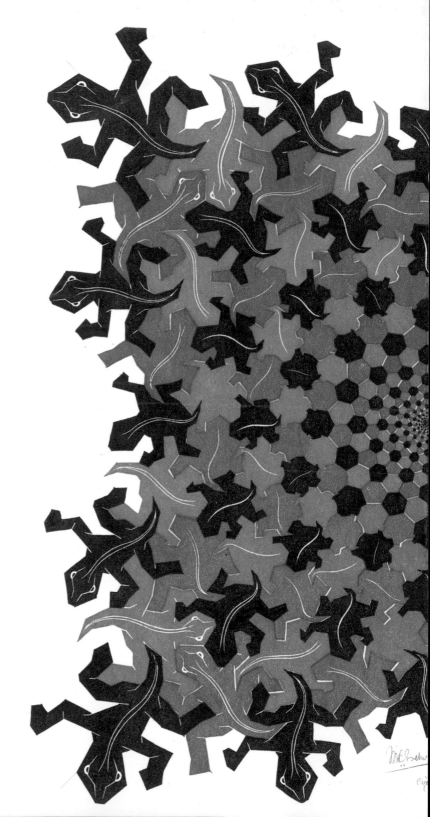

M.C. Escher (1898–1972).
Development II (detail).1939.

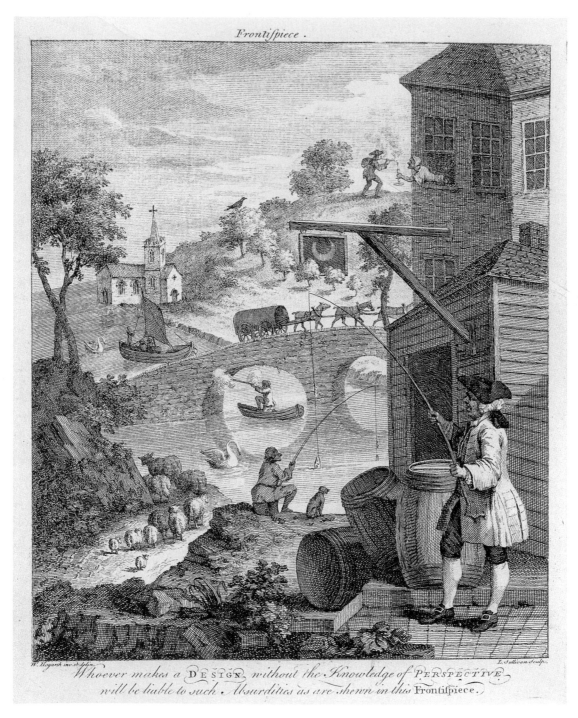

Frontispiece.

Whoever makes a DESIGN, without the Knowledge of PERSPECTIVE will be liable to such Absurdities as are shewn in this Frontispiece.

Luke Sullivan (1705–1771). *Satire on False Perspective* (after William Hogarth). 1754.

• *Search for the ingenious and incorrect perspectives in this beautiful engraving.*

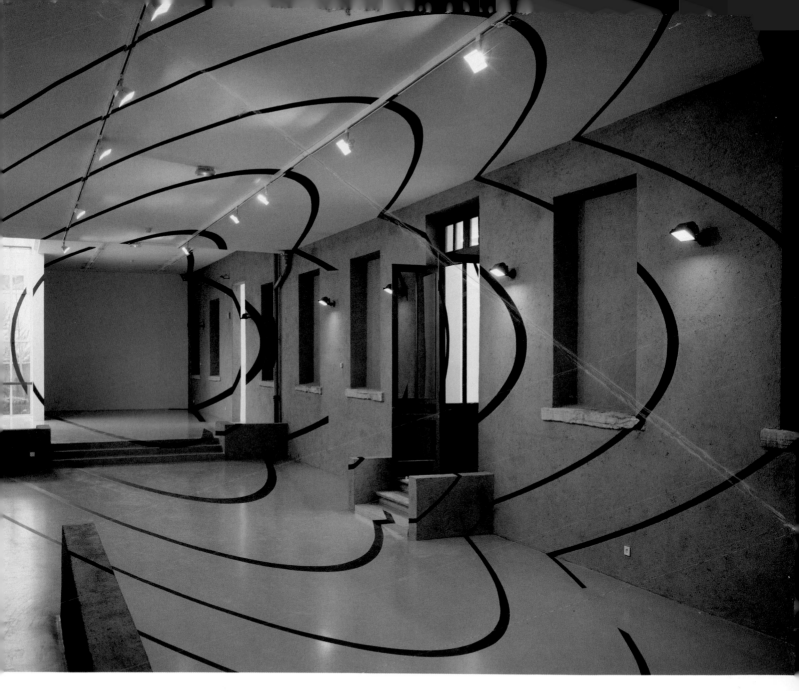

Felice Varini.
Five Concentric Black Circles. 1997.
View from outside the room.

Fra Giovanni da Verona (1457–1525/6). ▶
Panel with a seventy-two-sided sphere, geometry instruments,
and, below, a *mazzocchio.* c. 1502.
This flat panel of inlaid wood is a tour de force of trompe-l'oeil
perspective rendering. A *mazzocchio* is a form of headgear.

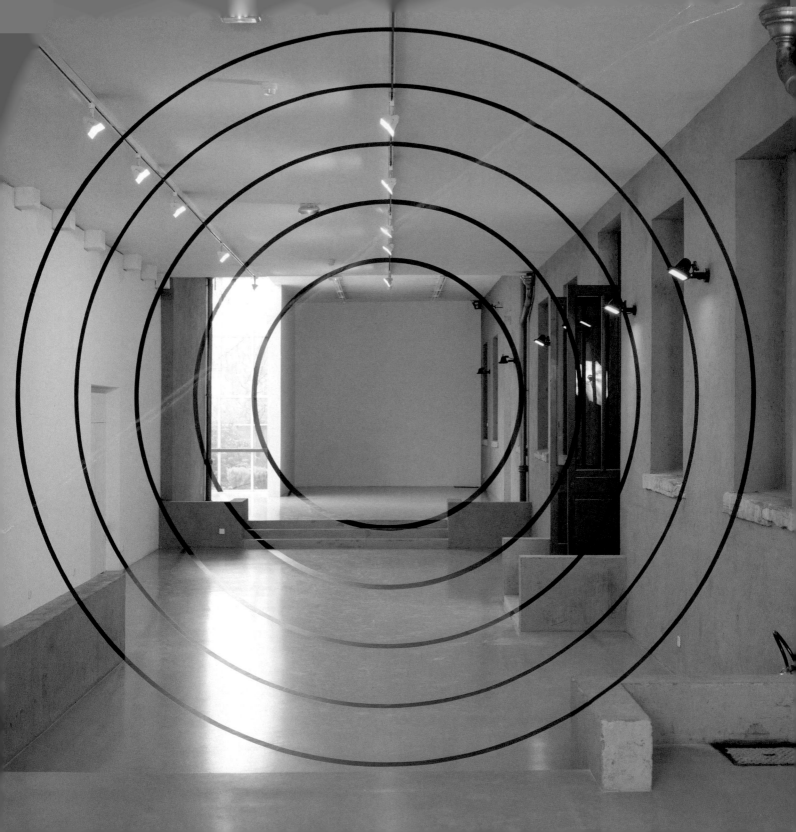

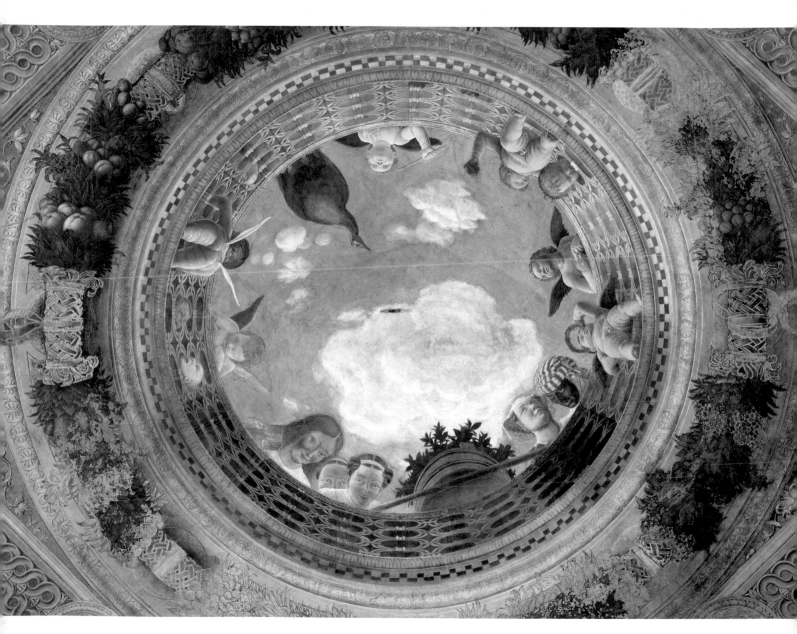

Andrea Mantegna (1431–1506).
Illusionistic ceiling. Fresco, 1465–1474. Palazzo Ducale,
Mantua, Italy.

Felice Varini (born 1952). ▶
Five Concentric Black Circles. 1997.
View from the front of the room. *(See overleaf.)*

Perspective Illusions, Anamorphic Images, Murals, and Camouflage

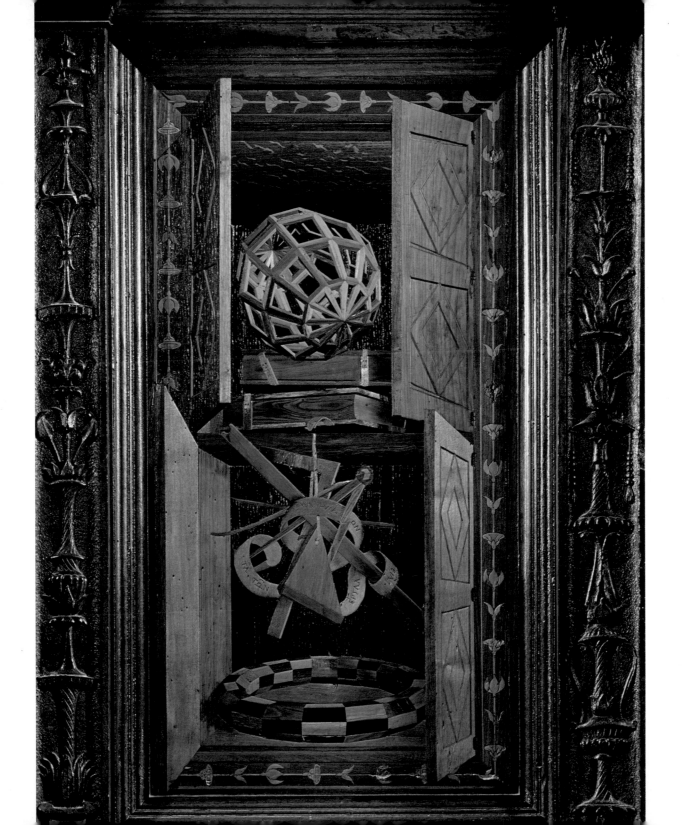

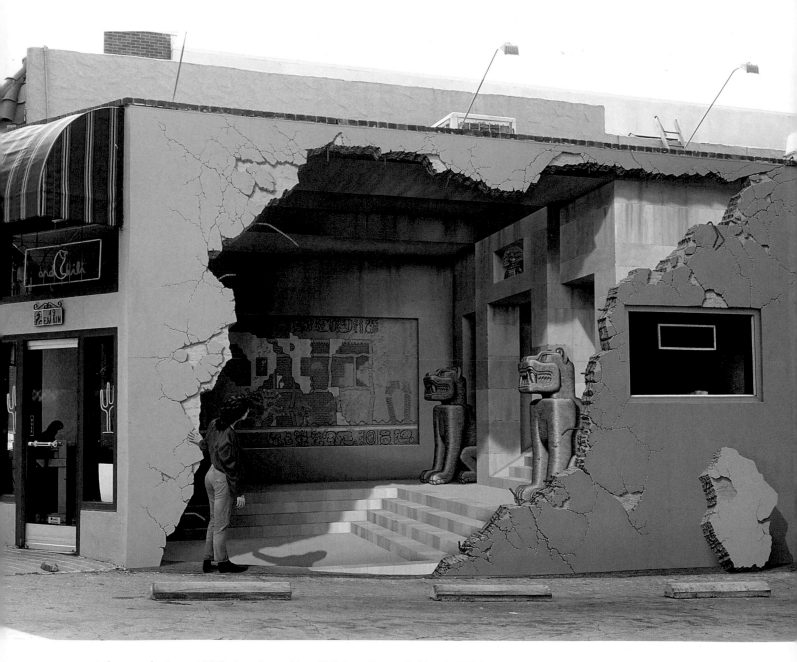

John Pugh (born 1957). *Siete Punto Uno (7.1)*. Los Gatos, California, 1990.
Los Gatos suffered a severe earthquake in 1990. The two jaguars are a reference both to the city's name
(which means "the cats" in Spanish) and to Tepeyollotl, the Aztec god of earthquakes, echoes, and jaguars.

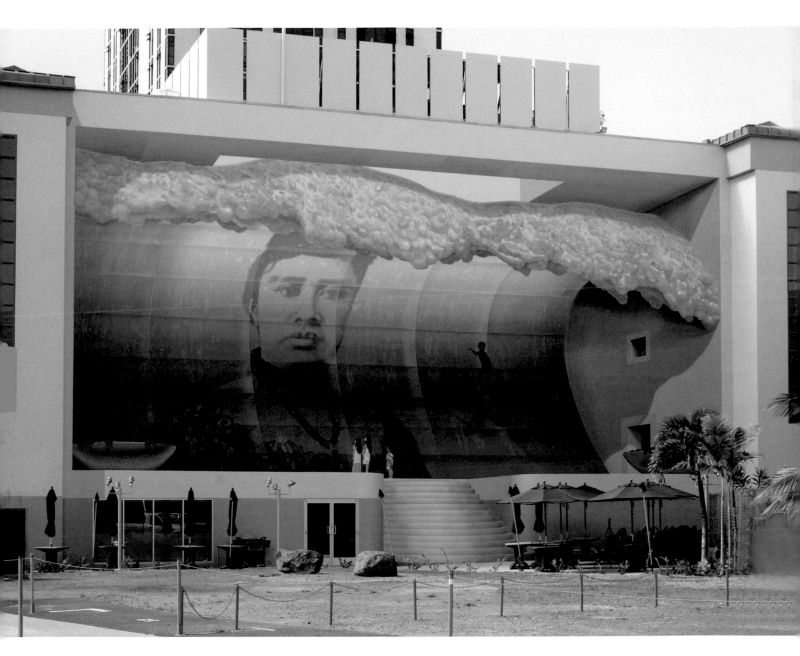

John Pugh. *Mana Nalu* ("Spirit of the Wave"). Honolulu, Hawaii, 2008.

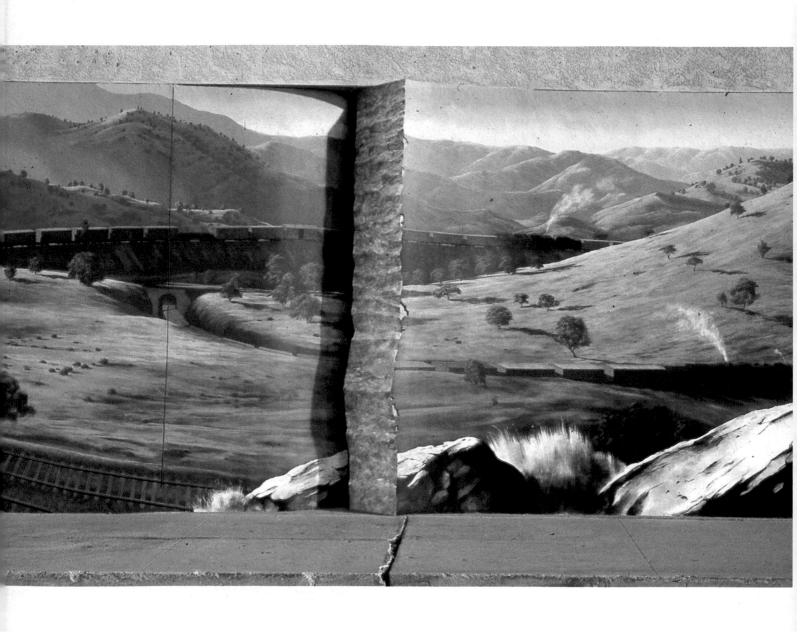

John Pugh and **Marc Spijkerbosch** (born 1967). *Reverse, Lateral and Loop*. Tehachapi, California, 2002.

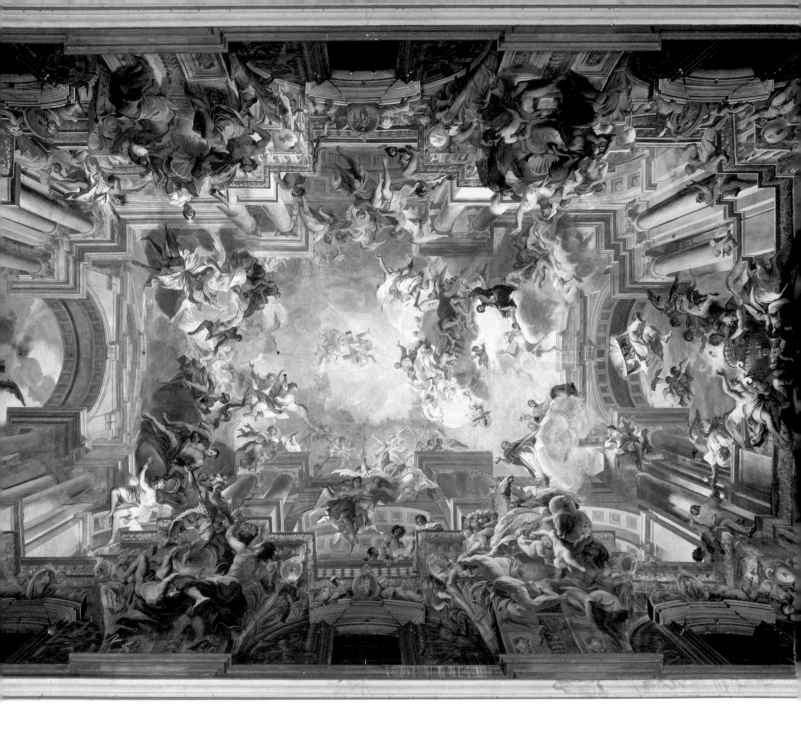

Andrea Pozzo (1642–1709). *The Glorification of St Ignatius*. Illusionistic ceiling fresco, Sant'Ignazio, Rome, 1691–1699.

Hans Holbein, the Younger (1497–1543). *The Ambassadors*. 1533.
Jean de Dinteville, a French nobleman posted to London as an ambassador (left), poses with his bishop friend Georges de Selve, exemplifying, respectively, the active and contemplative lives. Holbein famously included an anamorphic picture of a human skull in the foreground of this painting.

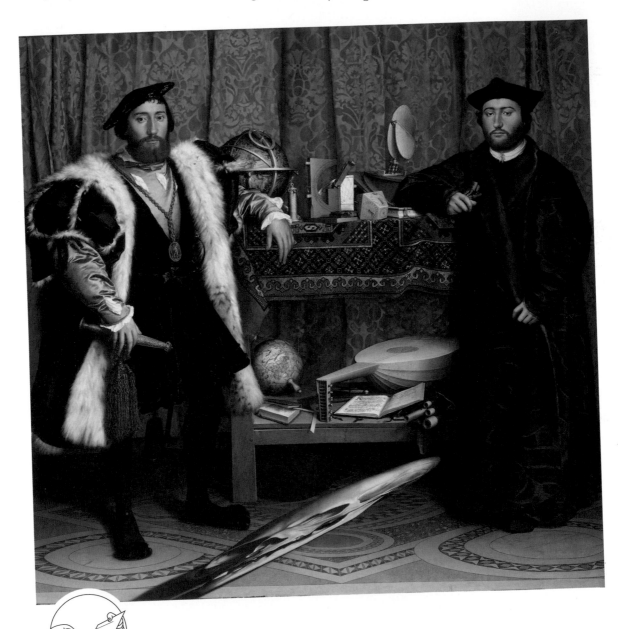

These lines stand upright when you correctly position the page diagonally from bottom left for viewing.
(See "visual angle" indicator, page 28.)

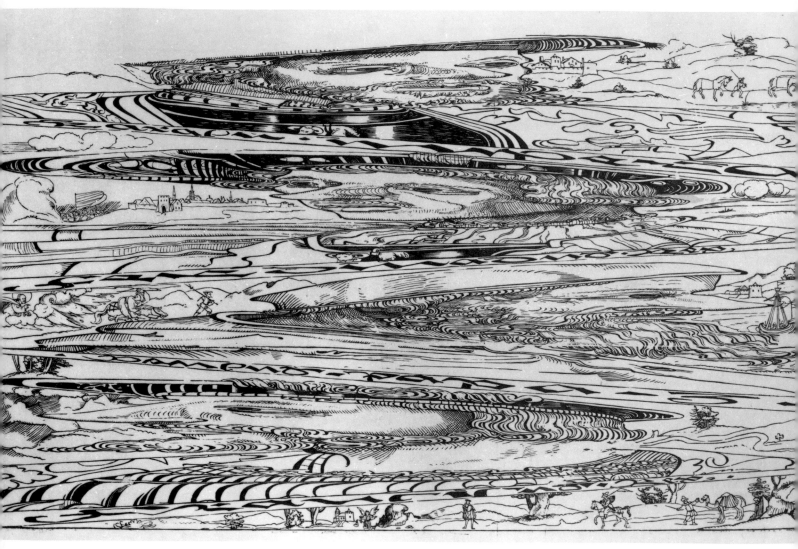

Erhard Schoen (c. 1491–1542). *Vexierbild*, a picture puzzle with a hidden image or trick. c. 1530.
• *Find the anamorphic portraits of Charles V, Ferdinand I, Pope Paul II, and Francis I.*

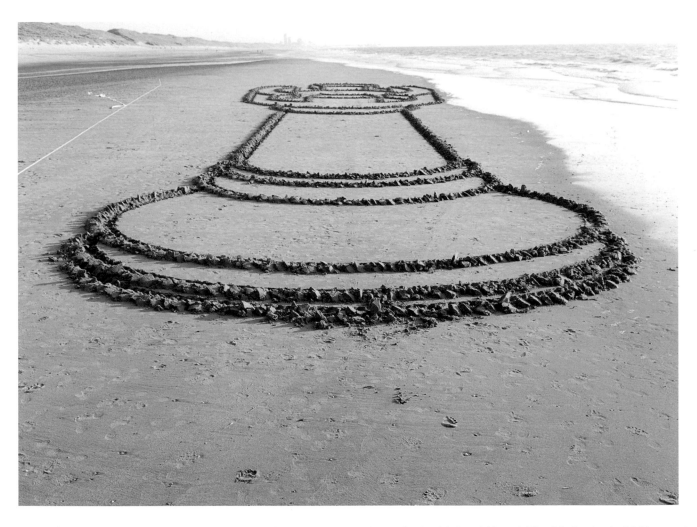

Nico Laan (born 1956). *Tower at the Sea*, from the Anamorphoses Series. Meijendel beach, The Netherlands, 2009. This sand picture is designed to be viewed from above. The lines are slightly raised, and the low sun gives a strong shadow effect. When the tide rises everything disappears—the ultimate illusion!

(See page 34.)

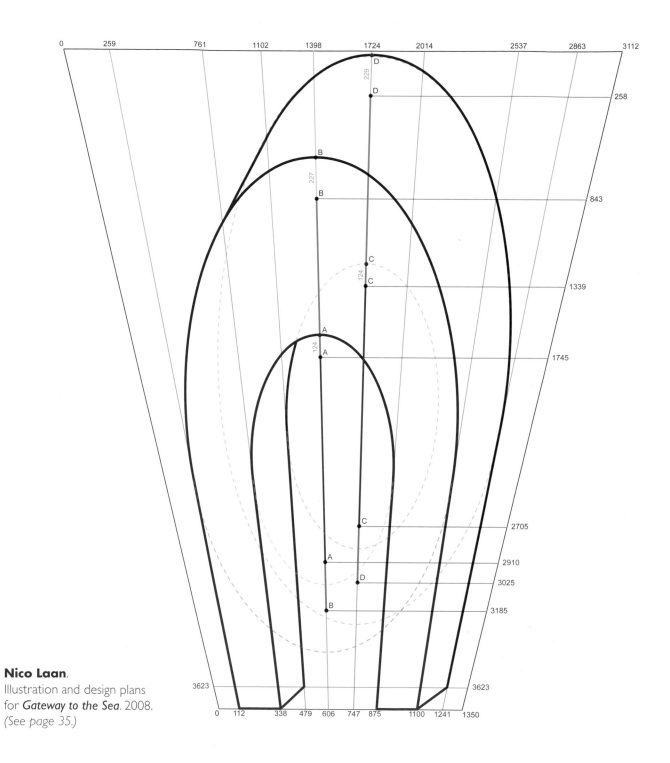

Nico Laan.
Illustration and design plans
for *Gateway to the Sea*. 2008.
(See page 35.)

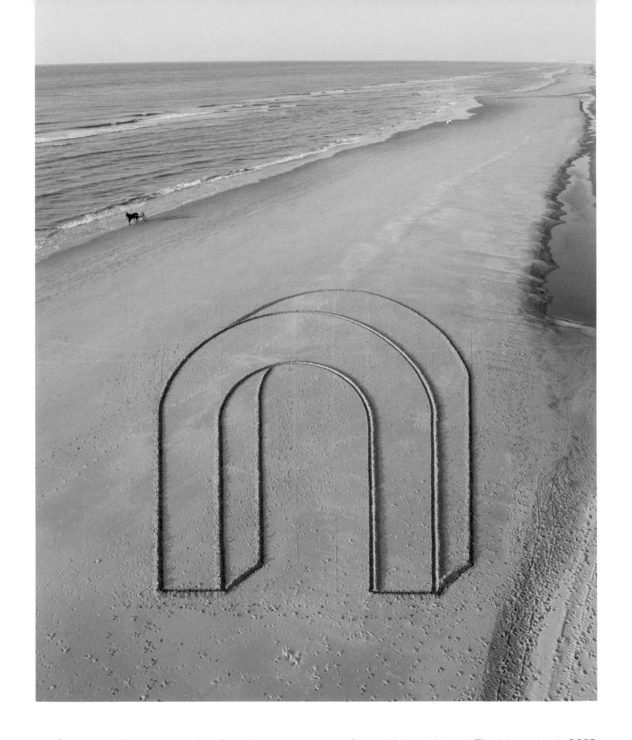

Nico Laan. *Gateway to the Sea*, from the Anamorphoses Series. Meijendel beach, The Netherlands, 2008. The photo was taken using a kite.

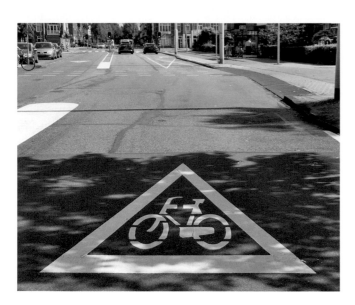

Anamorphic bicycle lane sign viewed from the rider's perspective and from above.

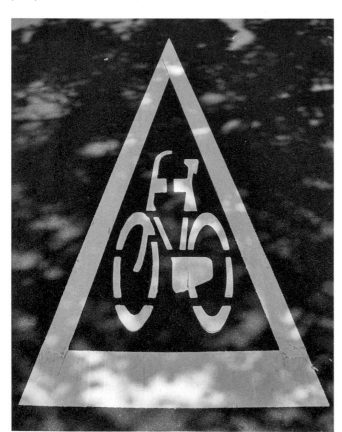

◄ • *Try reading the text (at left) from the driver's perspective. (See visual-angle indicator.)*

Jan W. Marcus (born 1941). *Impossible Arch*. 2010. Anamorphic drawing viewed in a cylindrical mirror.

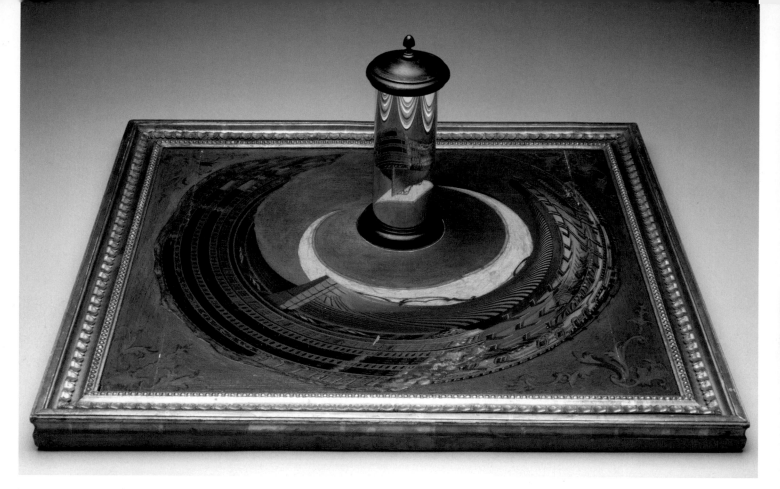

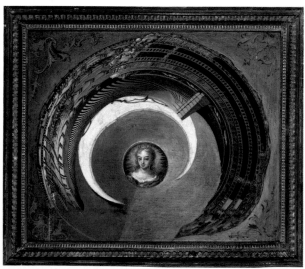

Anamorphic painting of a ship, c. 1744–1774.

István Orosz (born 1951). *Greek Column*. 1994. ▶
Anamorphic etching with reflecting column.

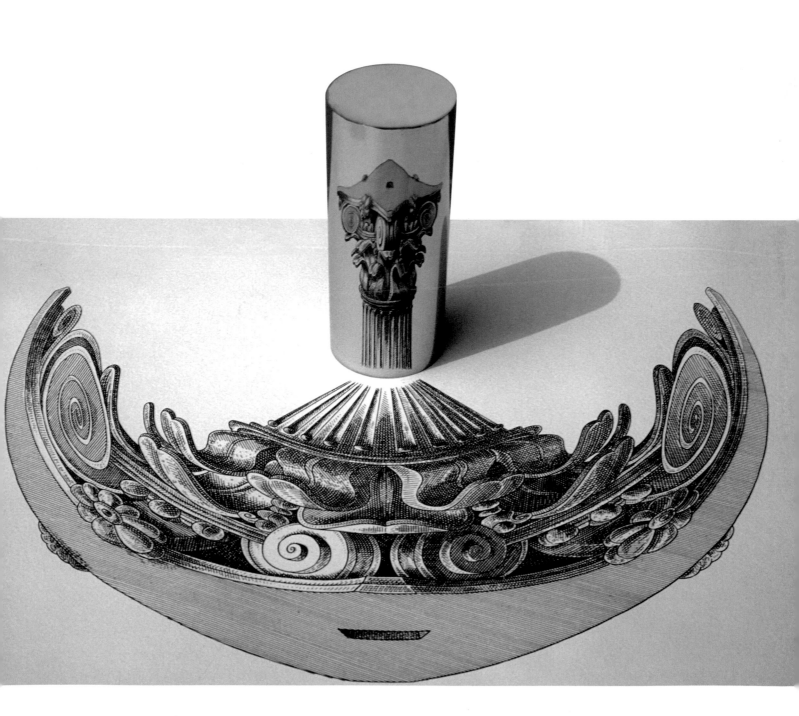

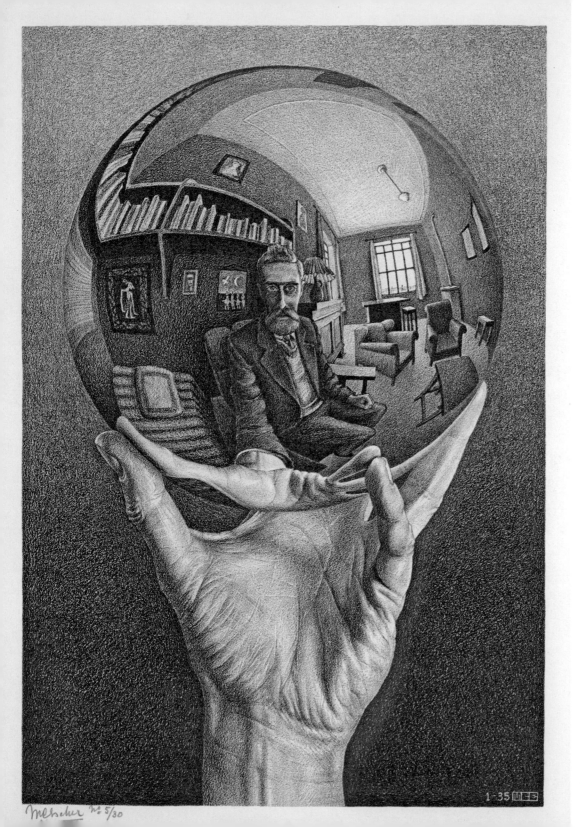

Mescher Nº 5/30

1-35 MCE

M. C. Escher (1898–1972).
Hand With Reflecting Sphere.
1935.

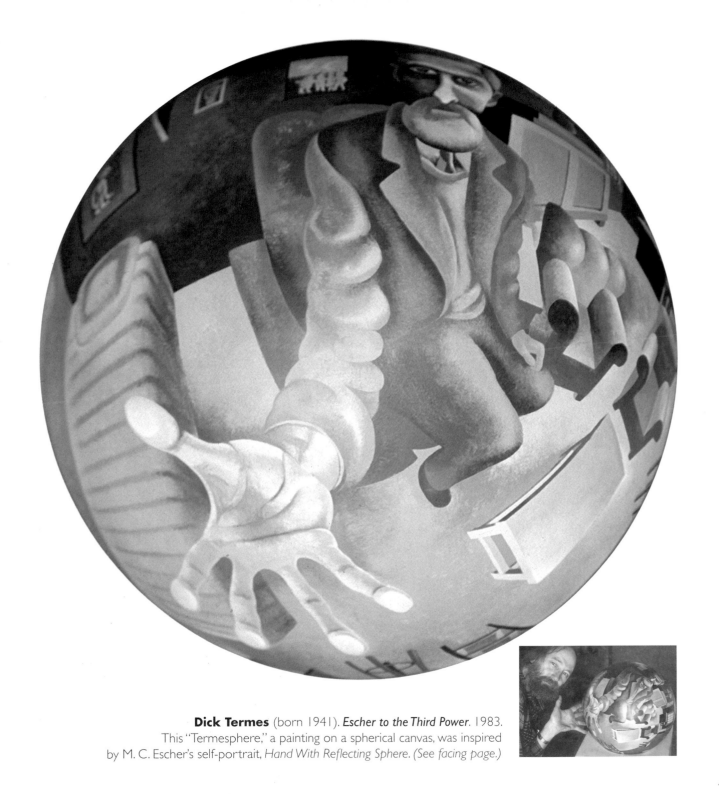

Dick Termes (born 1941). *Escher to the Third Power*. 1983.
This "Termesphere," a painting on a spherical canvas, was inspired
by M. C. Escher's self-portrait, *Hand With Reflecting Sphere*. *(See facing page.)*

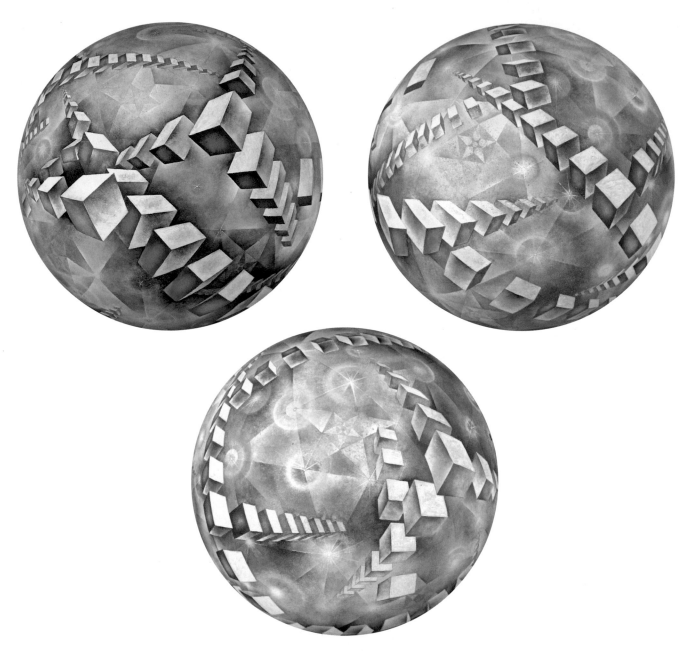

Dick Termes. *Brain Strain*. 2004.
Three Termespheres.

François Abélanet (born 1960). *Who to Believe?* 2011. ▶
Anamorphic art project in front of the
Hôtel de Ville, Paris. *(See also page 44.)*

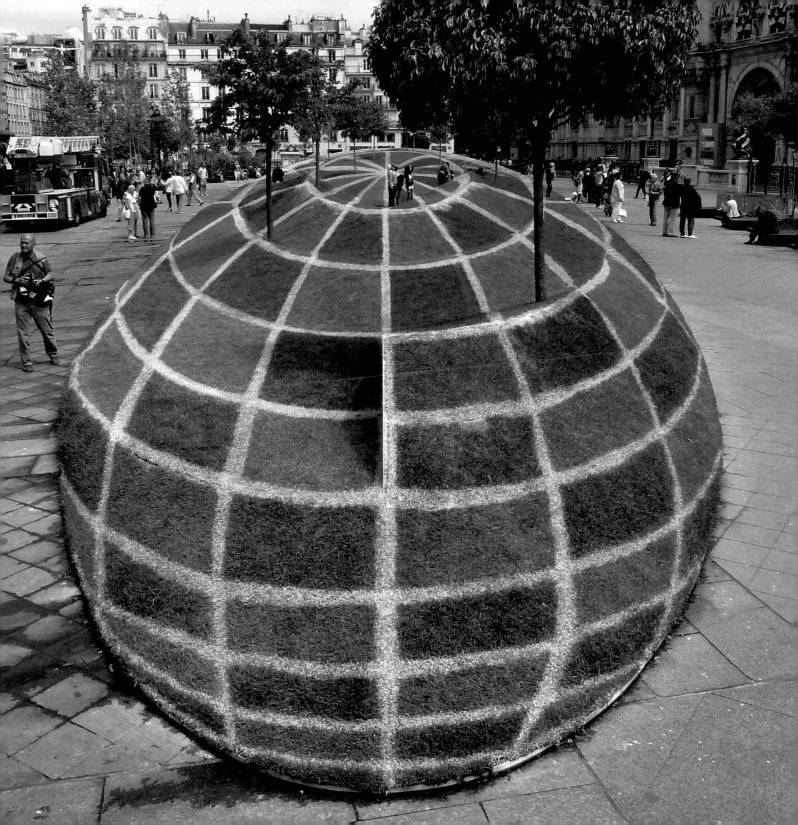

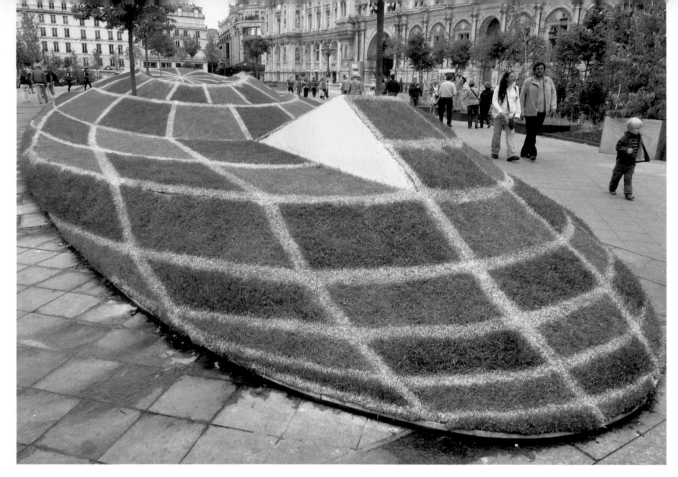

François Abélanet's **Who to Believe?** was a 3-D anamorphic art project in the center of Paris. This masterpiece of landscape art covering 1,500 square meters was built from straw and sand and covered with turf and trees. It is shown above as viewed from the side.
(*See also page 43.*)

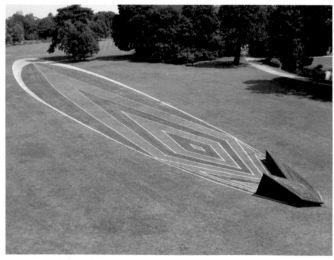

François Abélanet. *Where Are We?* 2010.
Parc de Bagatelle, Paris.
Anamorphic art project viewed from the side.

Where Are We? viewed from the front. ▶

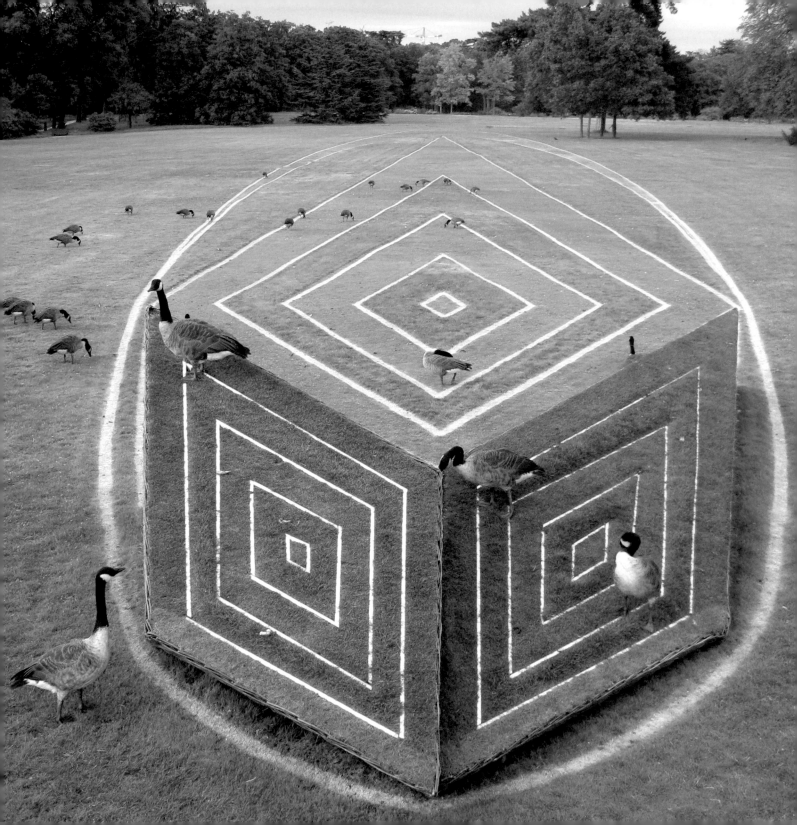

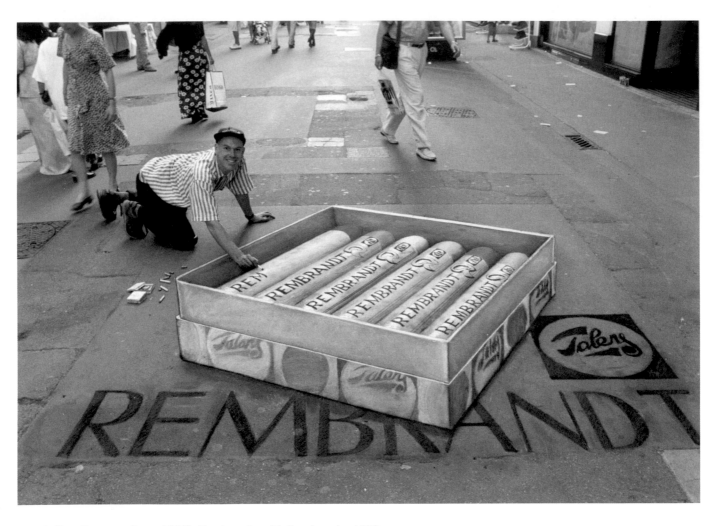

Julian Beever (born 1959). *Rembrandts with Rembrandts*. 1992.
Trompe-l'oeil pavement drawing created with anamorphic technique.

Edgar Müller (born 1969). *The Crevasse*. 2008. ▶
Pavement painting at East Pier in Dún Laoghaire, Ireland, created for the town's
Festival of World Cultures. *(See also page 48.)*

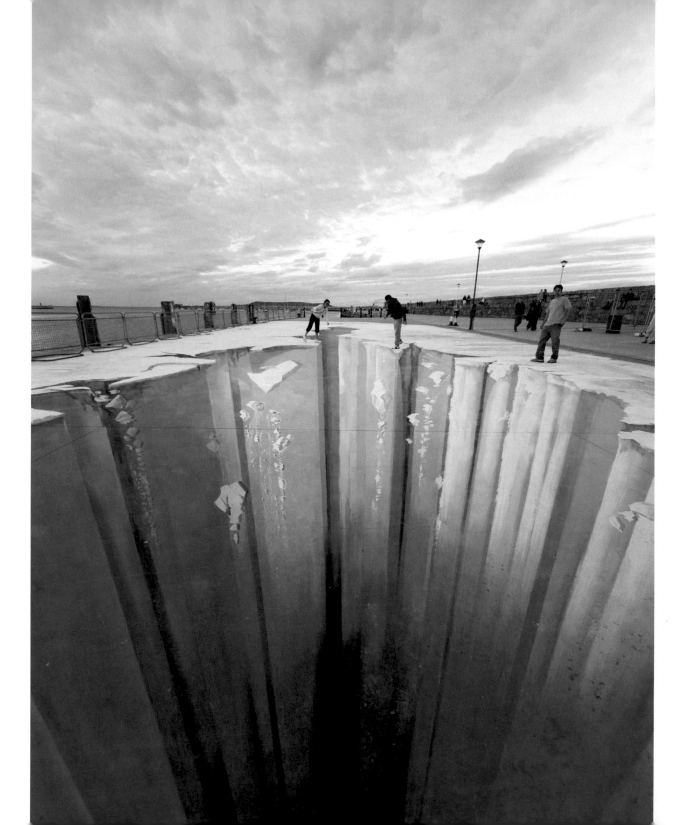

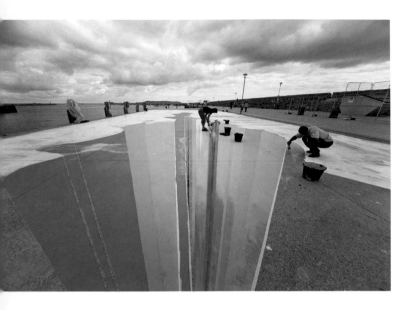

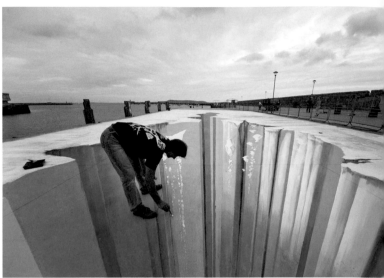

The beginnings of *The Crevasse*, and…

the finishing touches.

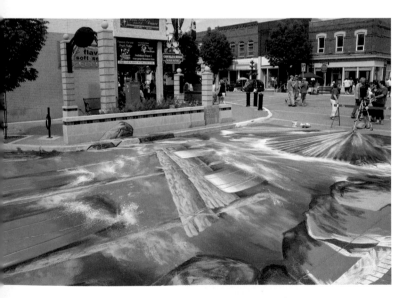

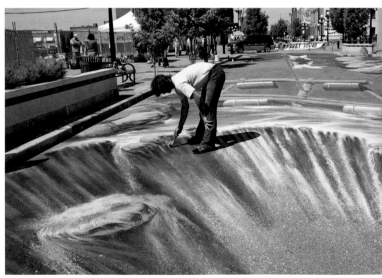

Edgar Müller. *The Waterfall (Turning River Street Into a River)*. 2007. Anamorphic street painting in Moose Jaw, Saskatchewan, Canada.

This three-dimensional painting turned the street into a river that ended in an enormous waterfall.

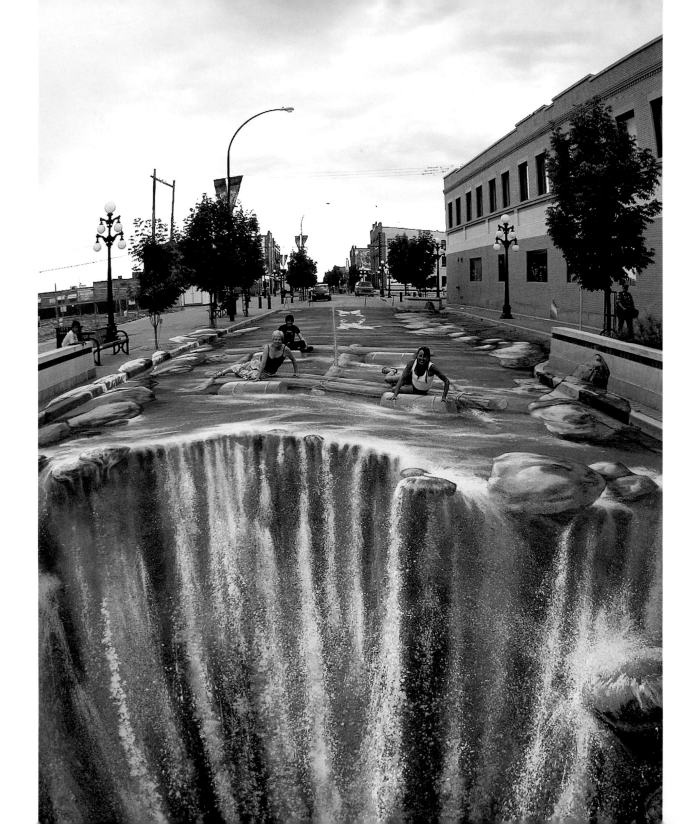

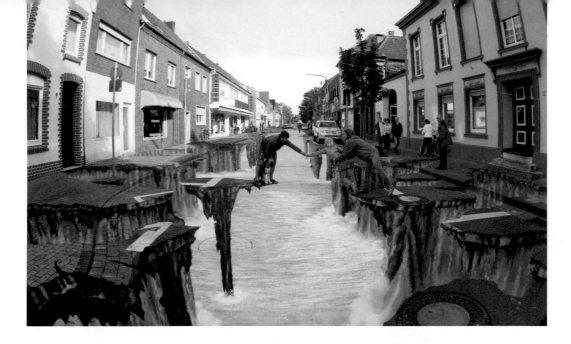

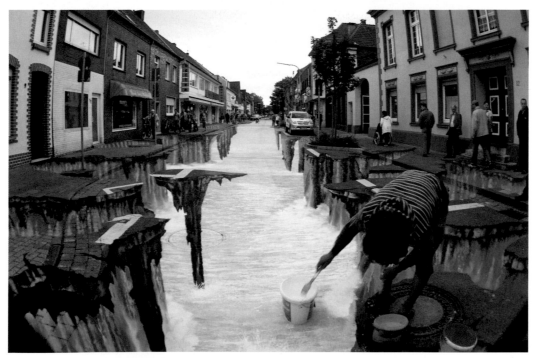

Edgar Müller. *Lava Stream*. 2008.
This anamorphic painting transforms a street in Geldern, Germany, into an apocalyptic scene.

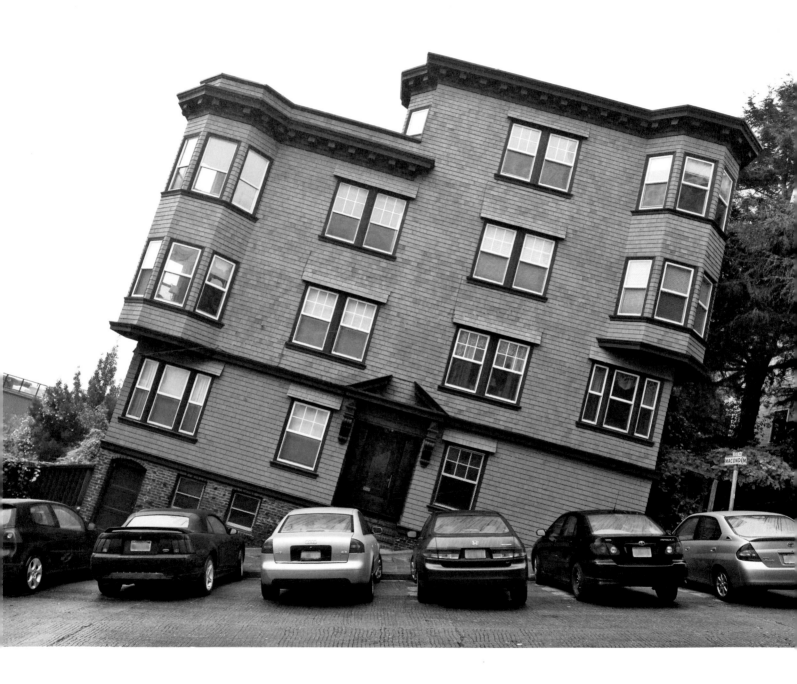

Håkan Dahlström (born 1947). *Crazy Hill in San Francisco.* 2009.
Dahlström photographed this house on a steep hill in San Francisco.

51

Ames Room

Invented in 1934 by the American opthalmologist Adelbert Ames, Jr. (1880-1955), an Ames Room is a staged space that appears to be a normal room when viewed through a peephole in the front, but is actually a trapezoid in its floorplan. When the room is viewed through the peephole, people standing in the space appear to have radically different heights.

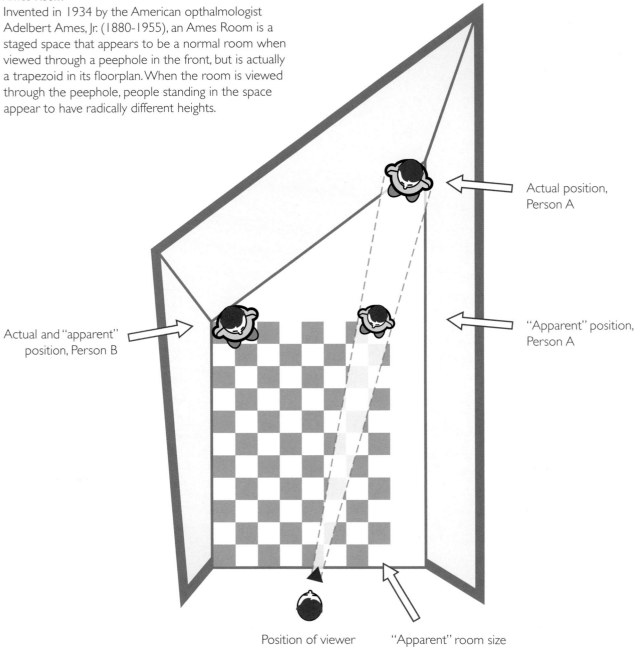

Actual position, Person A

"Apparent" position, Person A

Actual and "apparent" position, Person B

Position of viewer "Apparent" room size

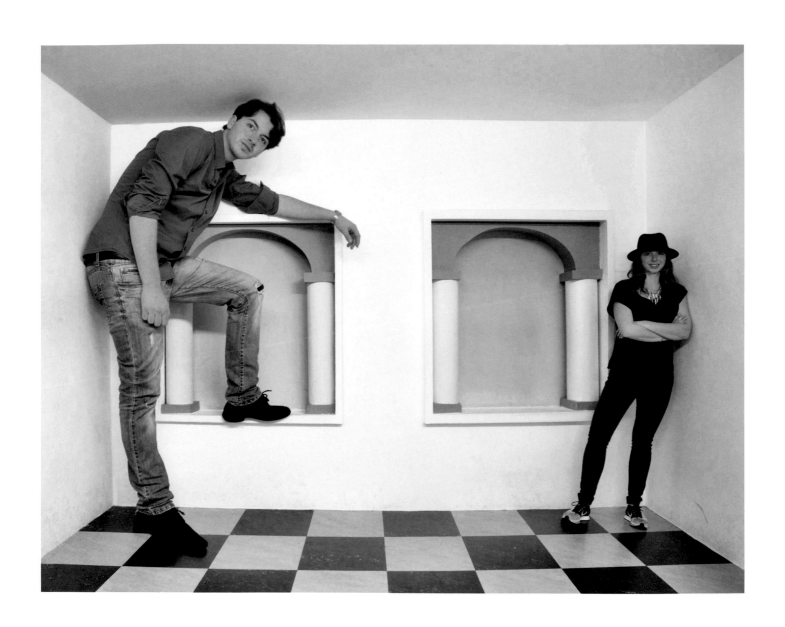

Ames Room. Escher Museum, The Hague.
View of two people through the peephole.

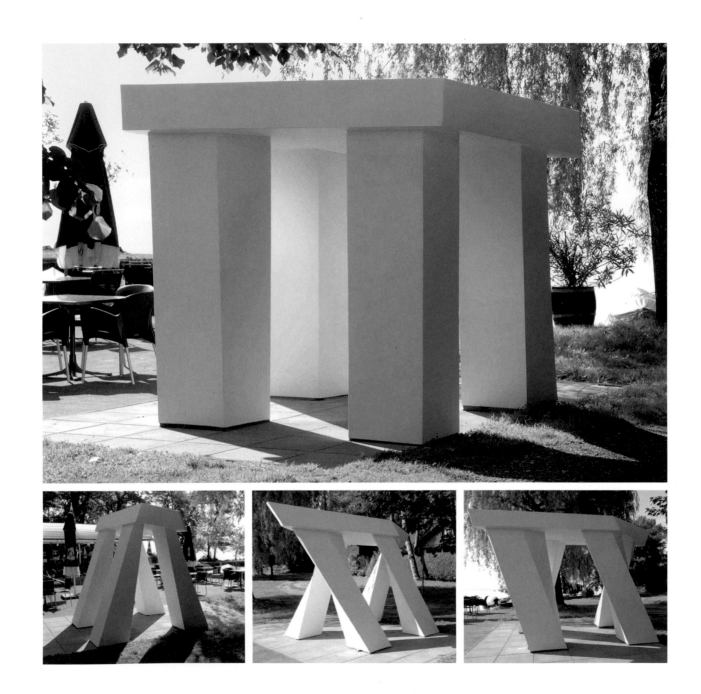

Tjeerd Alkema (born 1942). *Pour Max*. Colombier, Switzerland, 2007.
This anamorphic sculpture is viewed from four different perspectives.

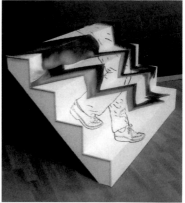

From another angle, the viewer sees a dressed man walking down the stairs.

Viewed from the front, both images are distorted.

István Orosz. *Stairs*. 1992.
From one angle, the viewer sees a naked man walking up the stairs.

55

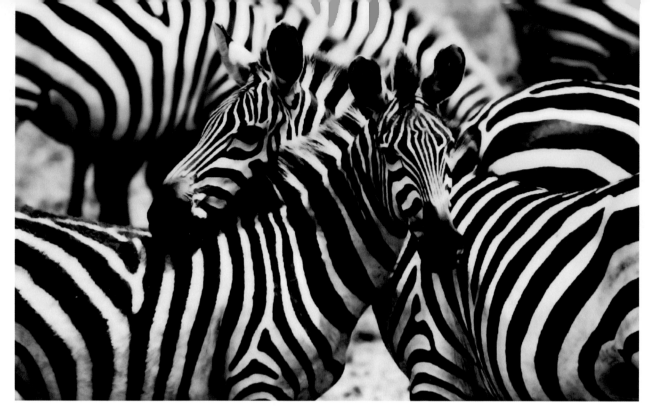

Zebras—dazzle pattern.
Some biologists believe the
zebra's stripe pattern is confusing
to predators. Others think that
it is a defense mechanism against
the tsetse fly.

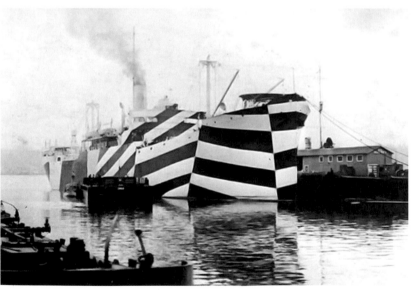

USS *West Mahomet* in dazzle camouflage. c. 1918.
The idea of using the dazzle camouflage on ships during World War I is credited to the artist Norman Wilkinson.
The graphic pattern was designed to confuse the enemy regarding the position and distance of British ships.

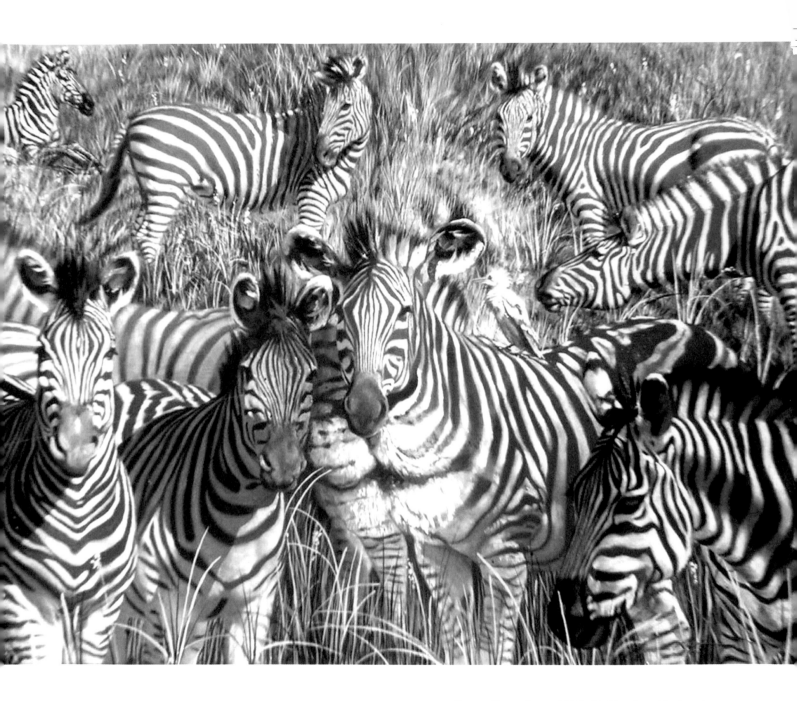

Rusty Rust (born 1932). *Hidden Lion*. Undated.
The head of a lion is hidden amidst the zebras.

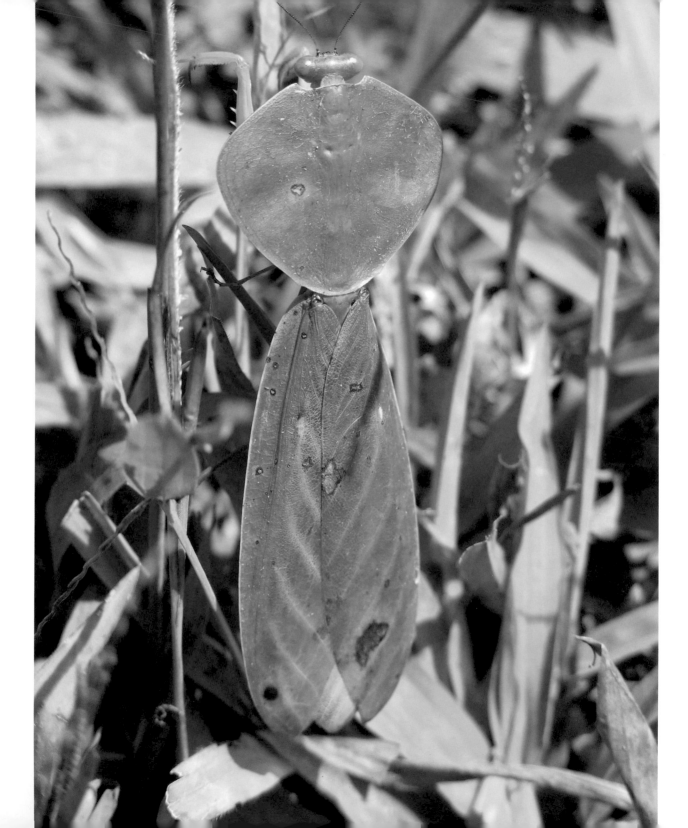

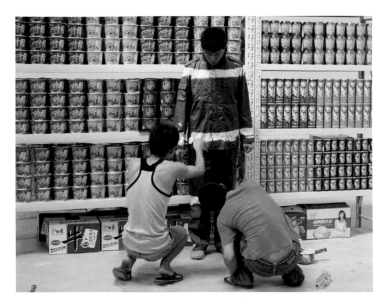
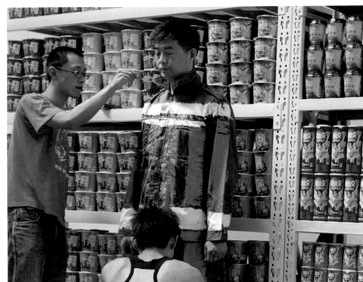
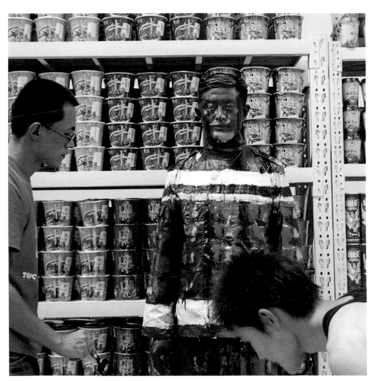
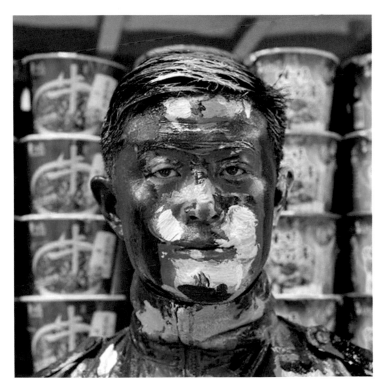

◄ *Hooded leaf mantis*, Costa Rica.
This is an example of natural camouflage.

Liu Bolin (born 1973). Making *Hiding in the City No. 83—Supermarket*. 2009. *(See page 61.)*

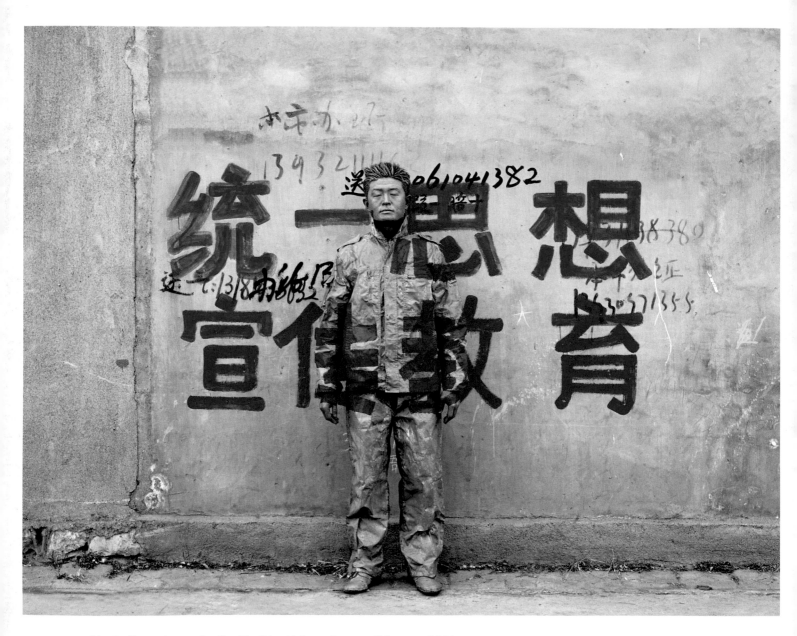

Liu Bolin. *Hiding in the City No. 36—Unity to Promote Education*. 2006.

Liu Bolin. *Hiding in the City No. 83—Supermarket*. 2009. ▶

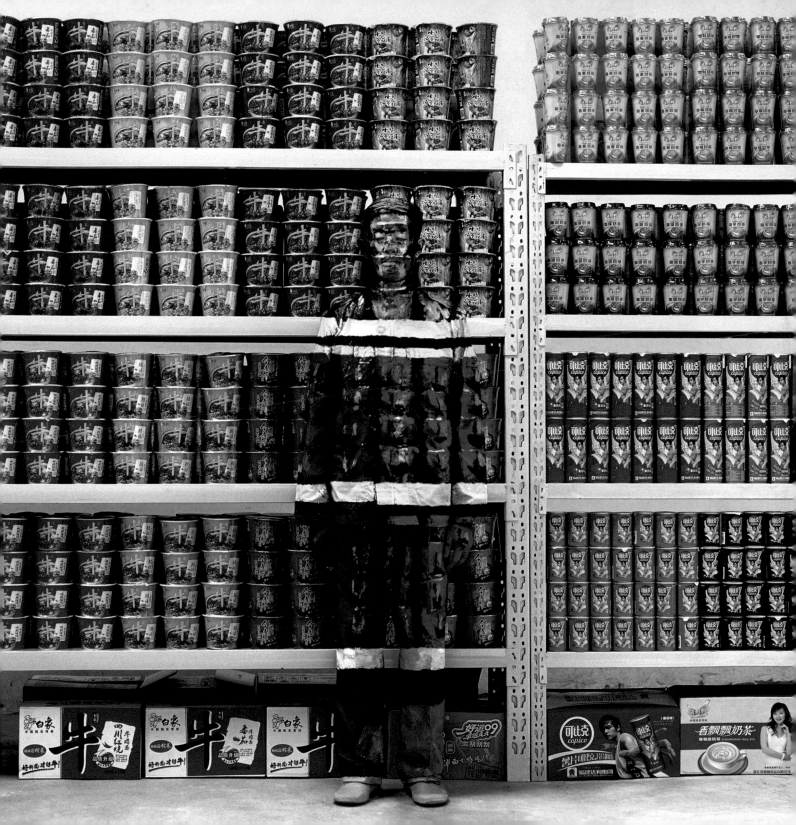

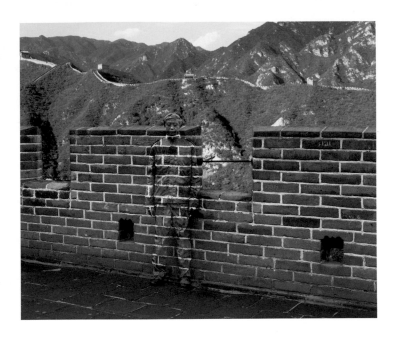

Liu Bolin. *Hiding in the City No. 91—The Great Wall.* 2010.

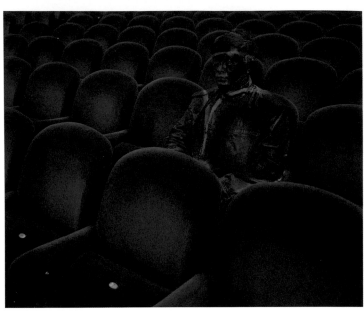

Liu Bolin. *Teatro alla Scala.* 2010.

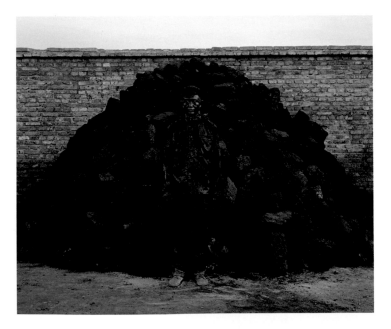

Liu Bolin. *Hiding in the City No. 95—Coal Pile.* 2010.

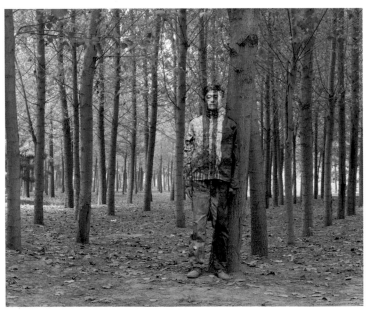

Liu Bolin. *Hiding in the City No. 94—In the Woods.* 2010.

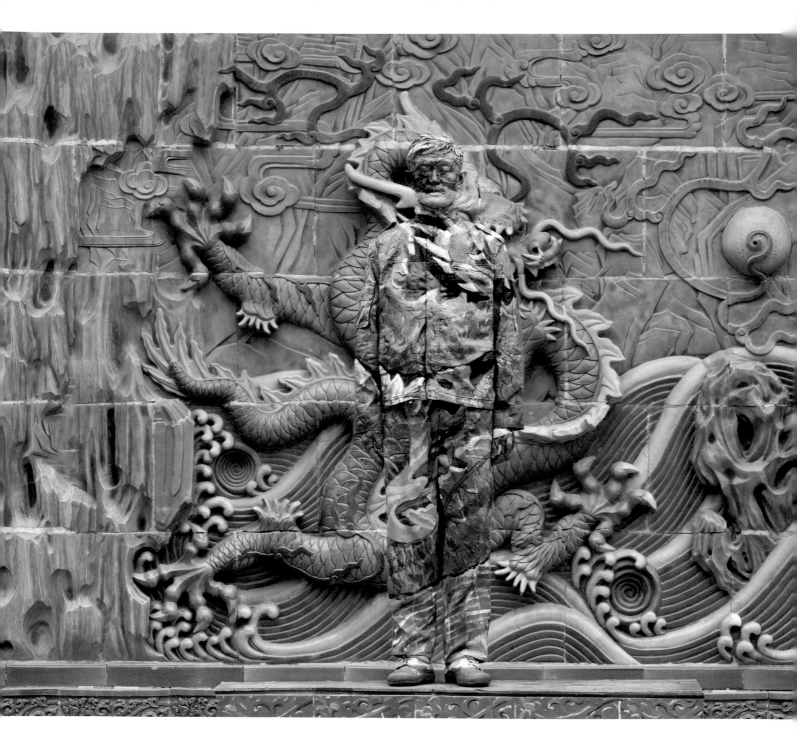

Liu Bolin. *Dragon Series*, Panel 1 of 9. 2010.

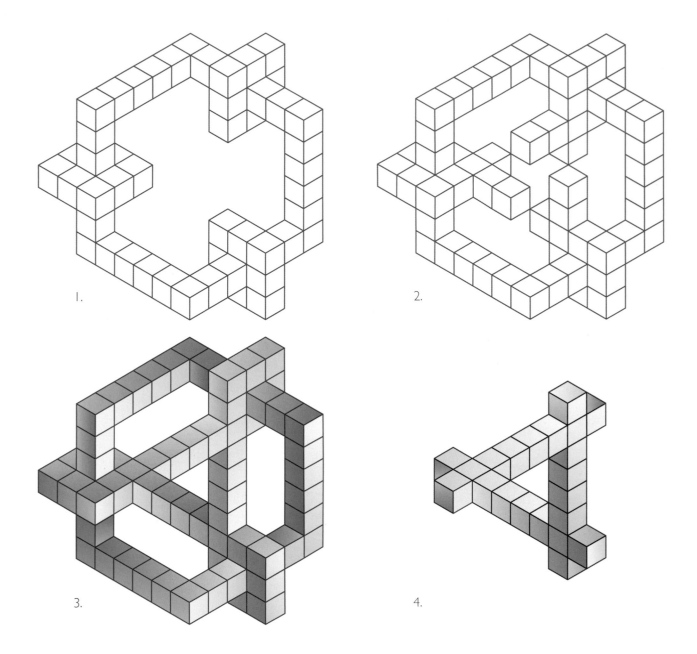

1.

2.

3.

4.

Vladimir Krasnoukhov (born 1944). *From Possible to Impossible?* 2008.
This sequence shows the transformation of isometric figures 1 and 2 into impossible figures 3 and 4 in spatial perspective.
The final figure is a Penrose triangle, which was first drawn by *Oscar Reutersvärd* in 1934, and was reinvented by the
mathematician *Roger Penrose* twenty years later. Penrose called it, "impossibility in its purest form."

Impossible Illusions
in Perspective

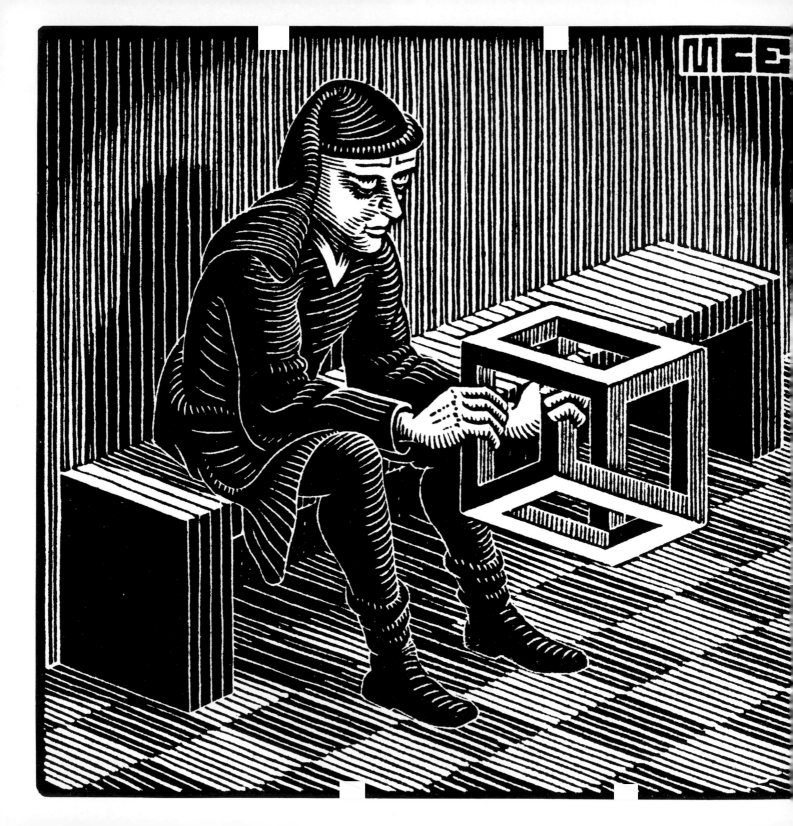

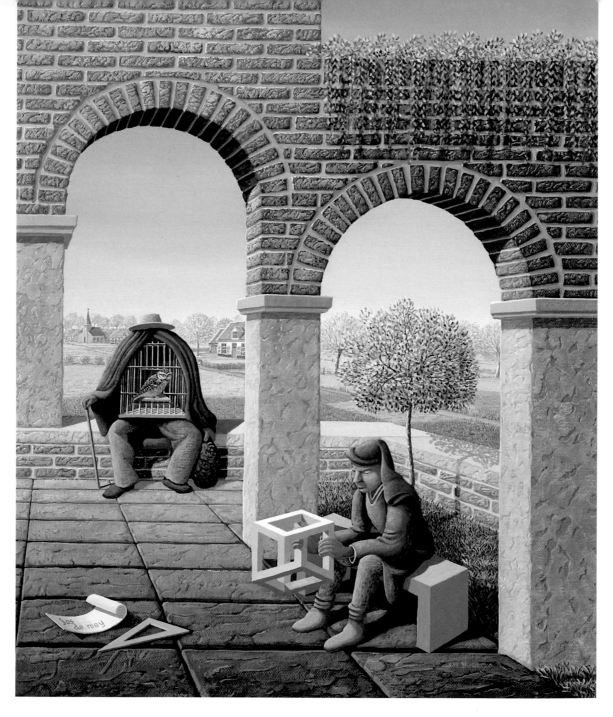

Jos de Mey (1928–2007). *Escher's Thinker Observed by Magritte's Therapist.* 1997.

◀ **M. C. Escher** (1898–1972). *Man With Cuboid.* 1958.

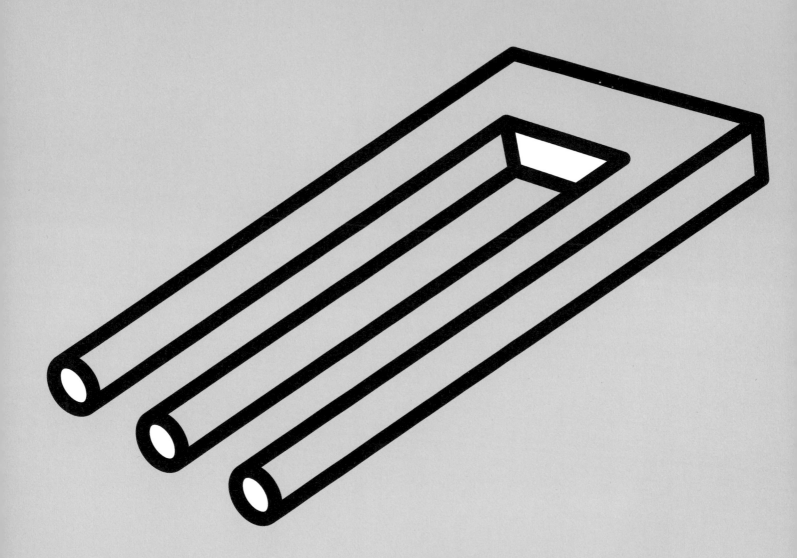

Studio PBD. *Impossible Fork*. 2012.
The first illustrations of the impossible fork, also called the "devil's fork," appeared in the mid-1960s.

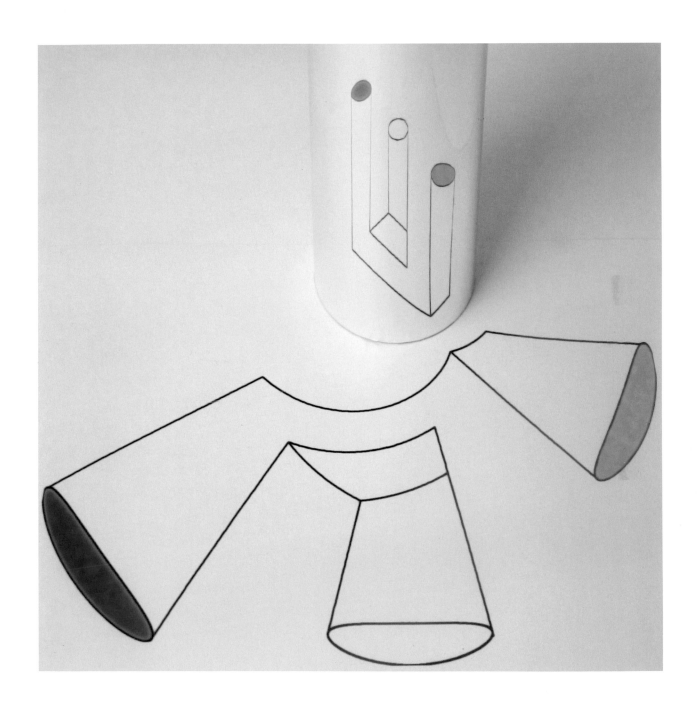

Jan W. Marcus (born 1941). *Devil's Fork*. Undated.
Anamorphic drawing viewed in a cylindrical mirror.

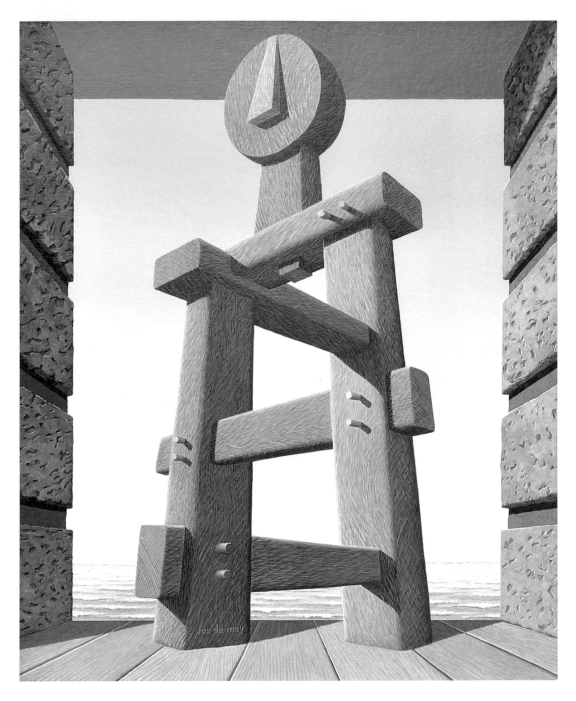

Jos de Mey. *Confusing Triangulated Idol.* 1990.

Sandro Del-Prete (born 1937). *Crusader of the Lattice Fence.* 1978. ▶

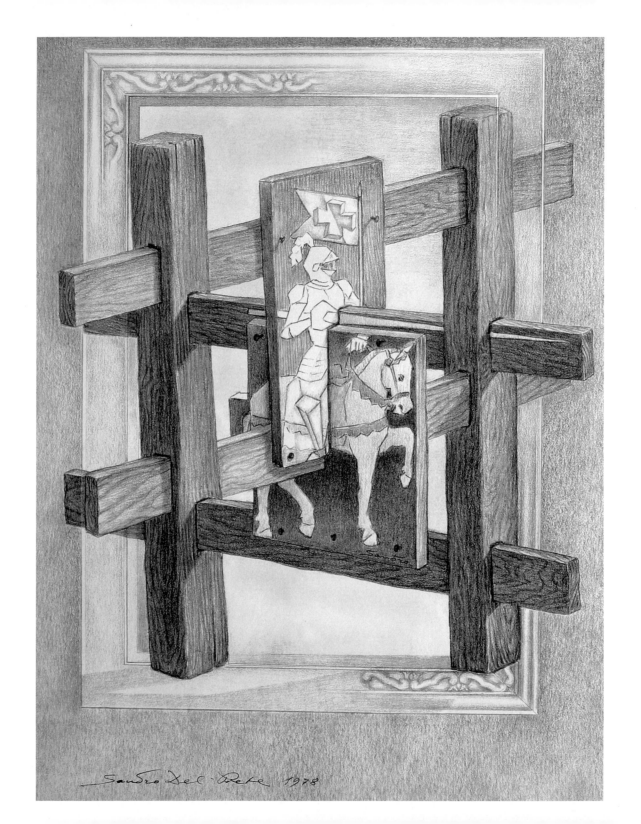

Sandro Del Prete 1978

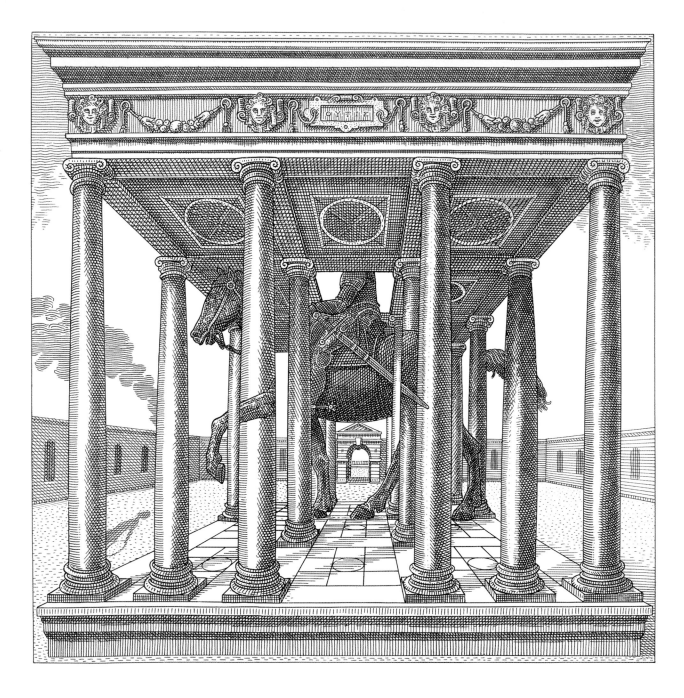

István Orosz (born 1951). *Horse*. 1996.

René Magritte (1898–1967). *Le Blanc-Seing* ▶
("Free Hand"). 1965.

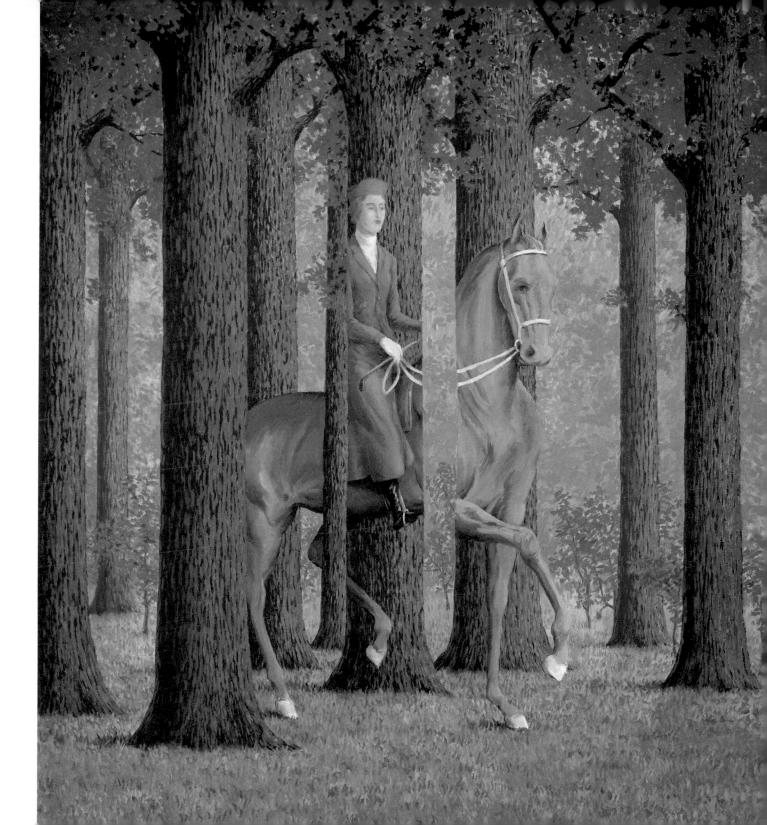

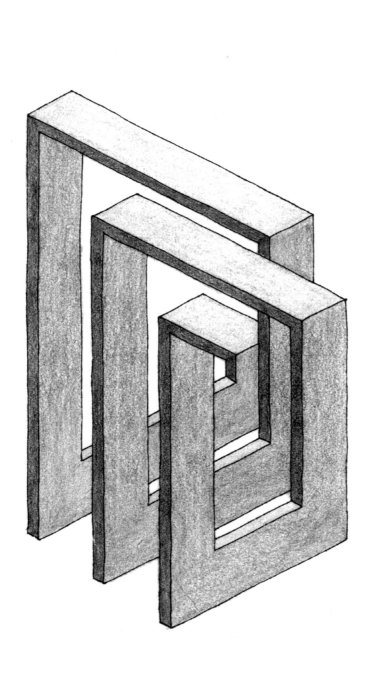

Oscar Reutersvärd (1915–2002). Drawing from *Perspective Japonaise*. Undated.

István Orosz. *The Wall*. 2005.

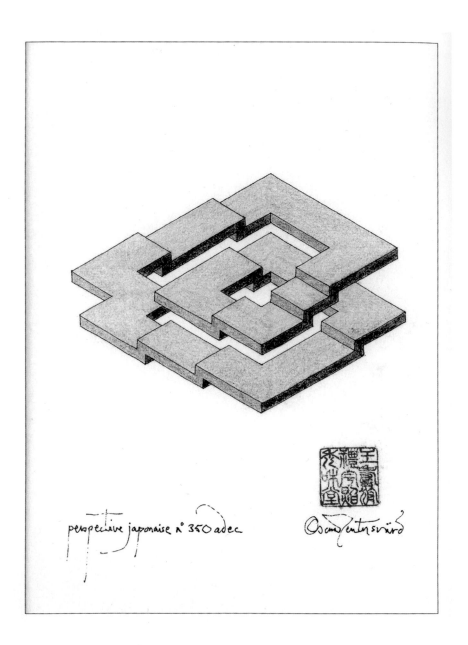

perspective japonaise n° 350 adec

Oscar Reutersvärd. Drawing 350 from *Perspective Japonaise*. Undated.

M. C. Escher. *Ascending and Descending* (detail). 1960. ▶

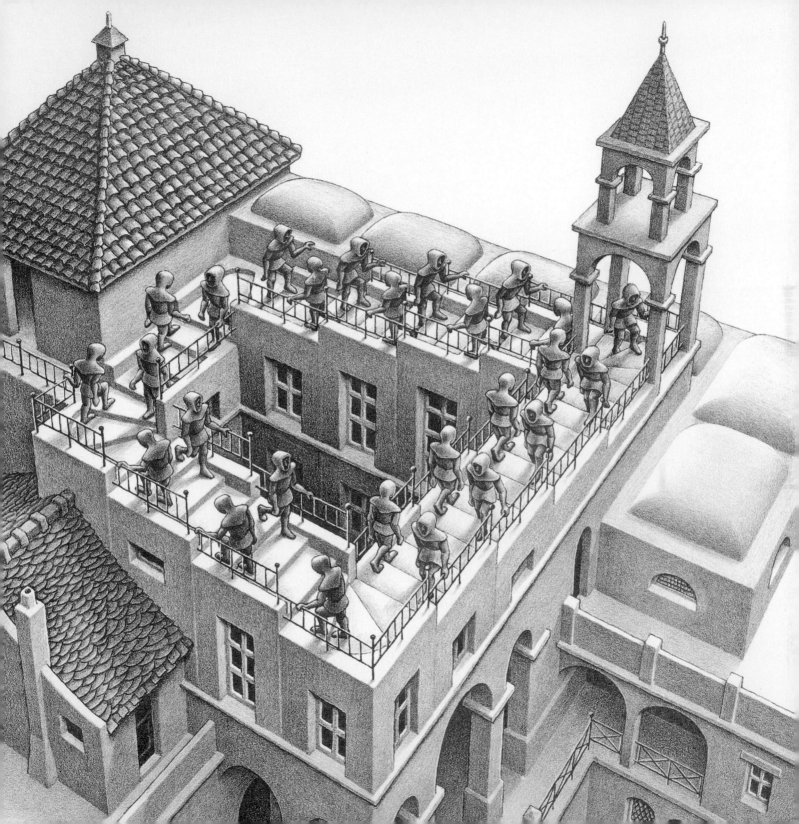

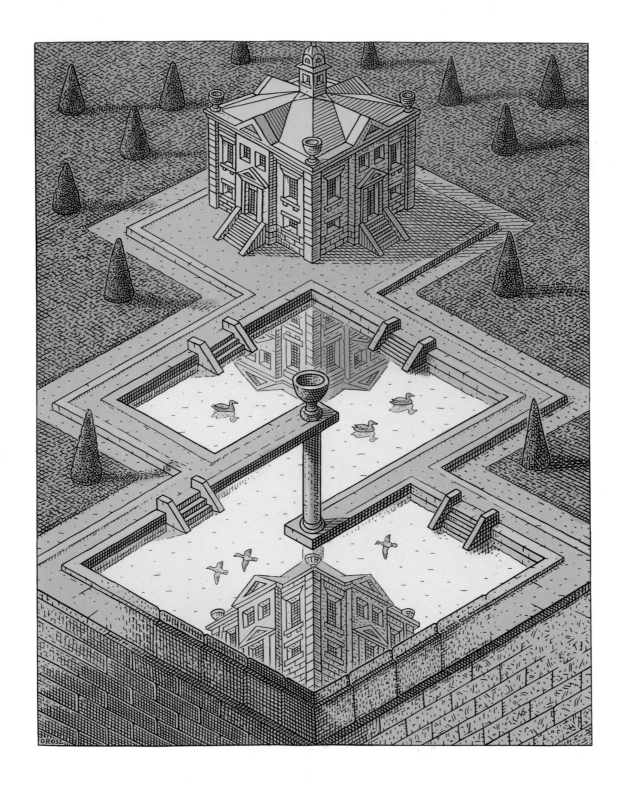

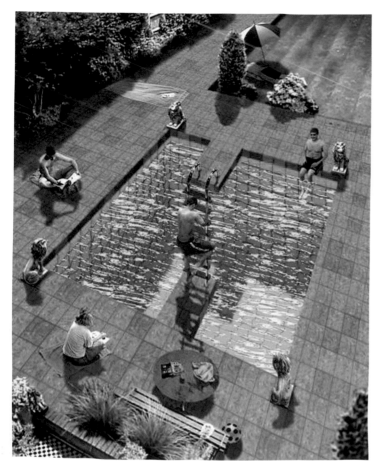

David Macdonald (born 1943). *Pool*. Undated.

David Macdonald. *Peregrination*. Undated.

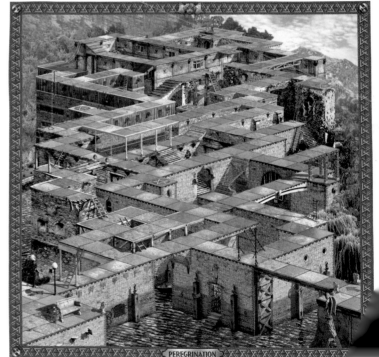

...teau, Chateau. 2005.

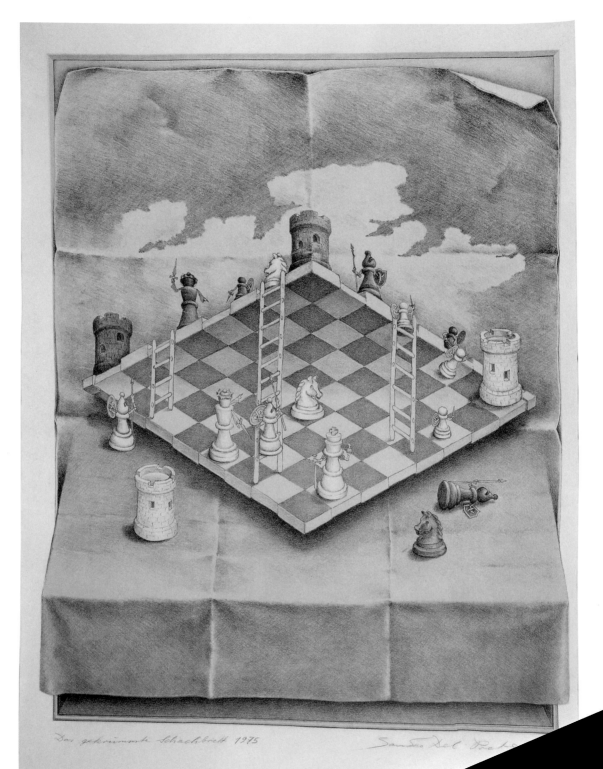

Der gekrümmte Schachbrett 1975

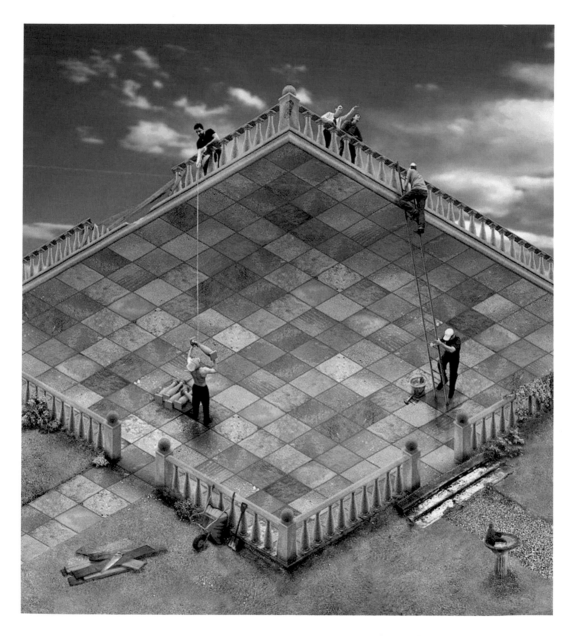

David Macdonald. *The Terrace*. 1998.

◀ **Sandro Del-Prete**. *The Warped Chessboard*. 1975.

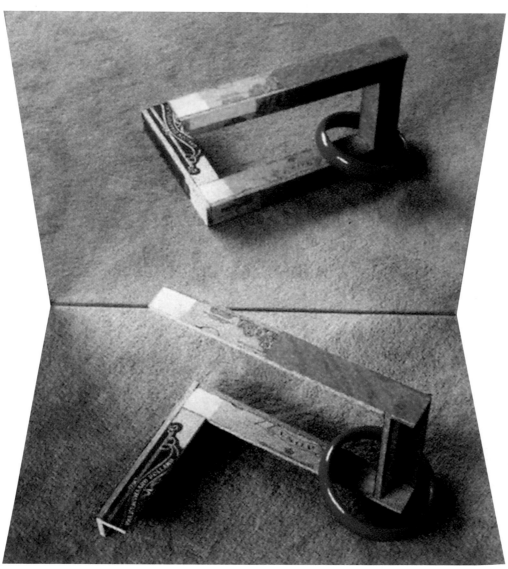

Bruno Ernst (born 1926). *Untitled*. Undated.
This object is transformed into an "impossible four bar" when viewed in a mirror from the correct perspective.
(Inspired by Oscar Reutersvärd.)

Impossible Four Bar inspired by Oscar Reutersvärd. ▶

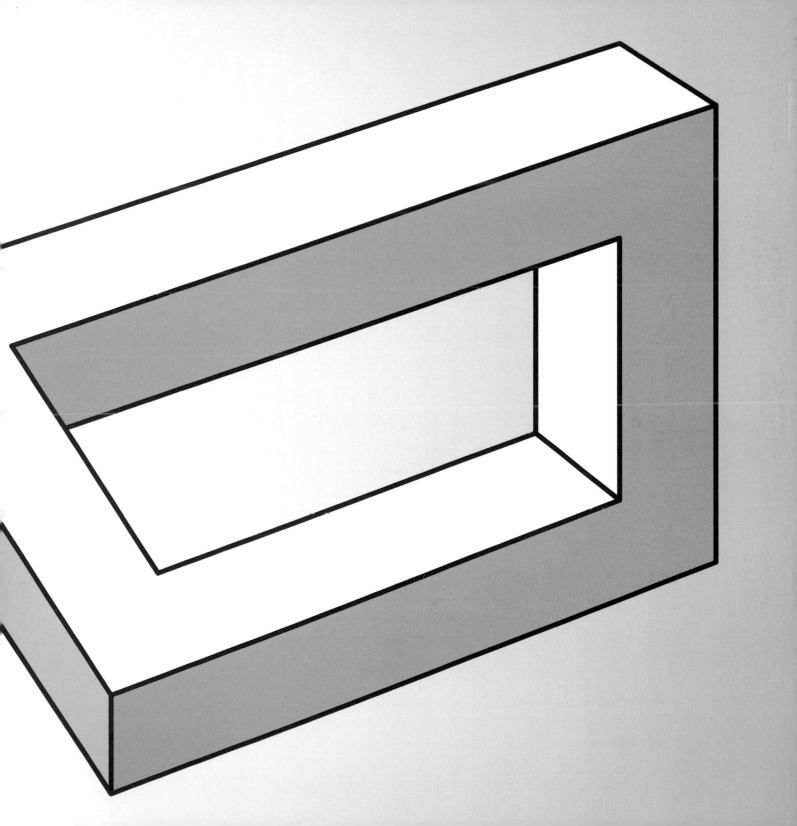

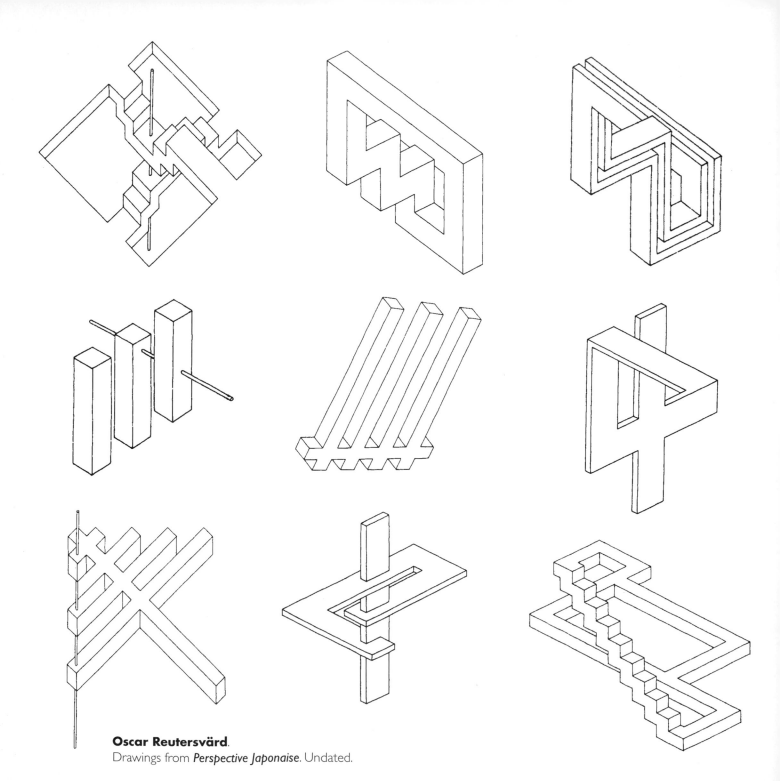

Oscar Reutersvärd.
Drawings from *Perspective Japonaise*. Undated.

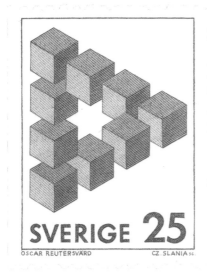 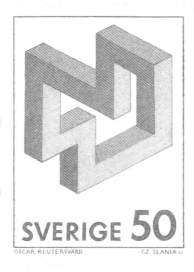 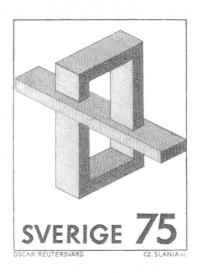

Series of three postage stamps featuring the drawings of **Oscar Reutersvärd** issued by the Swedish Postal Service in 1982.

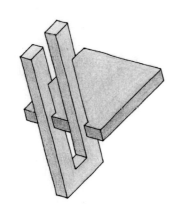

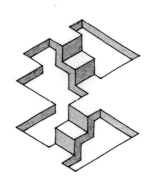

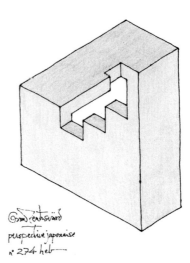

Oscar Reutersvärd. Drawings 466, 360, and 274 from *Perspective Japonaise*. Undated.

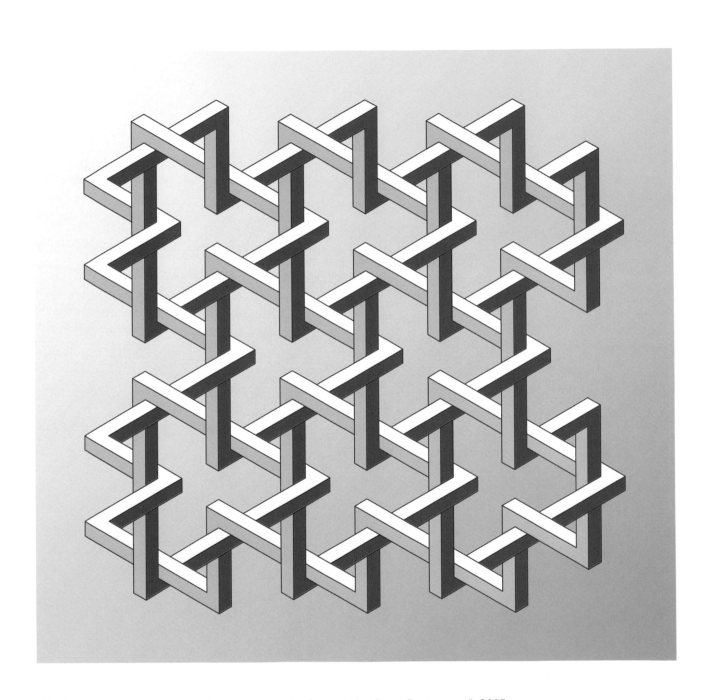

Vlad Alexeev (born 1976). *8 Impossible Triangles* (inspired by Oscar Reutersvärd). 2005.
Each of the eight triangles is a Penrose triangle.

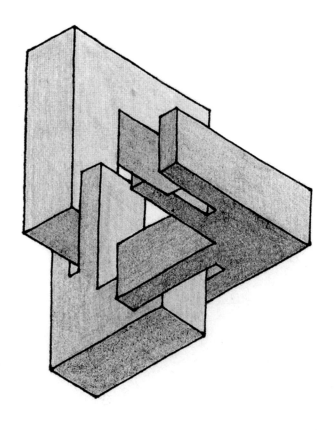

 perspective japonaise n° 262 gbm Oscar Reutersvärd

Oscar Reutersvärd. Drawing 262 from *Perspective Japonaise*. Undated.
This is another variant of the Penrose triangle.

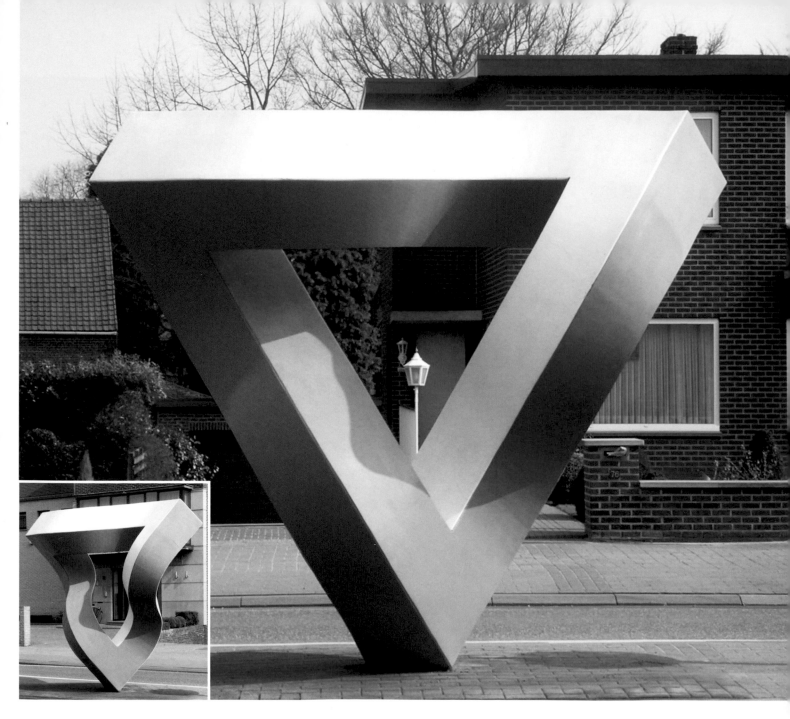

Mathieu Hamaekers (born 1954). *Unity*. 1995.
An "impossible sculpture" of the Penrose triangle. In the inset, the sculpture is viewed from another angle that reveals how this illusion works.

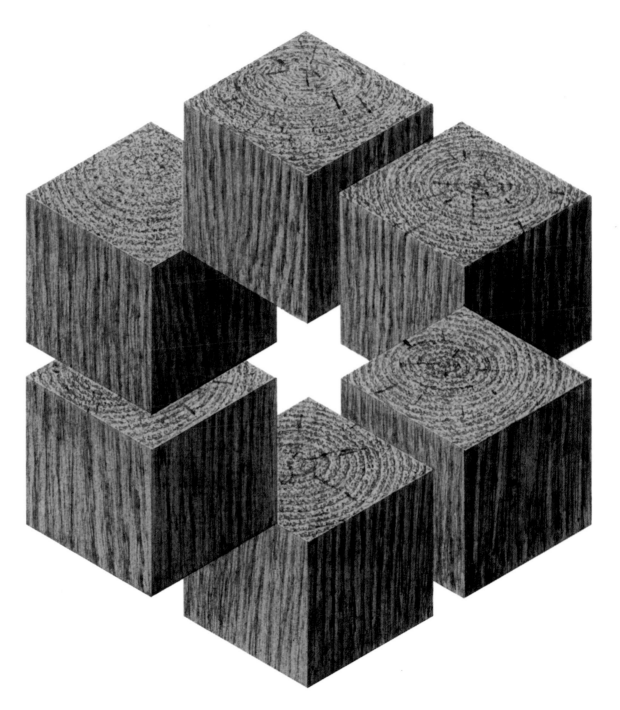

Mitsumasa Anno (born 1926). *Anno Blocks*. Undated.

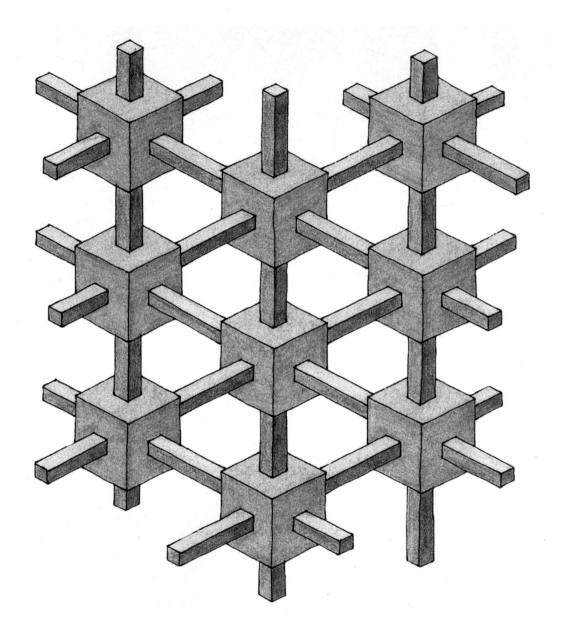

Oscar Reutersvärd. Drawing from *Perspective Japonaise*. Undated.
Reutersvärd applied an impossible perspective to the famous cubic space division
of M. C. Escher, opposite.

M. C. Escher. *Cubic Space Division* (detail). 1952. ▶

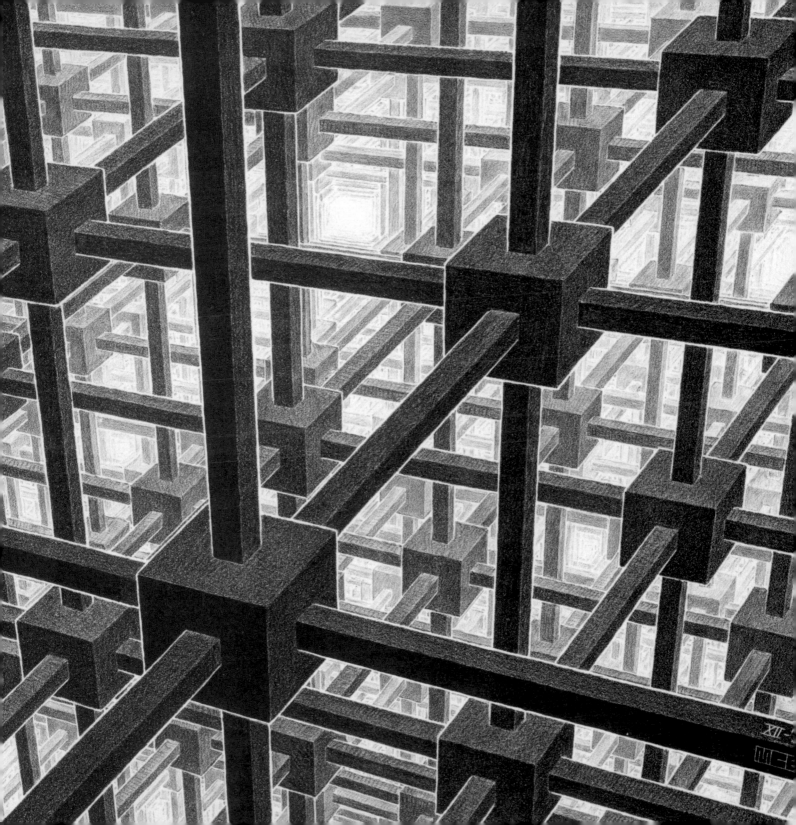

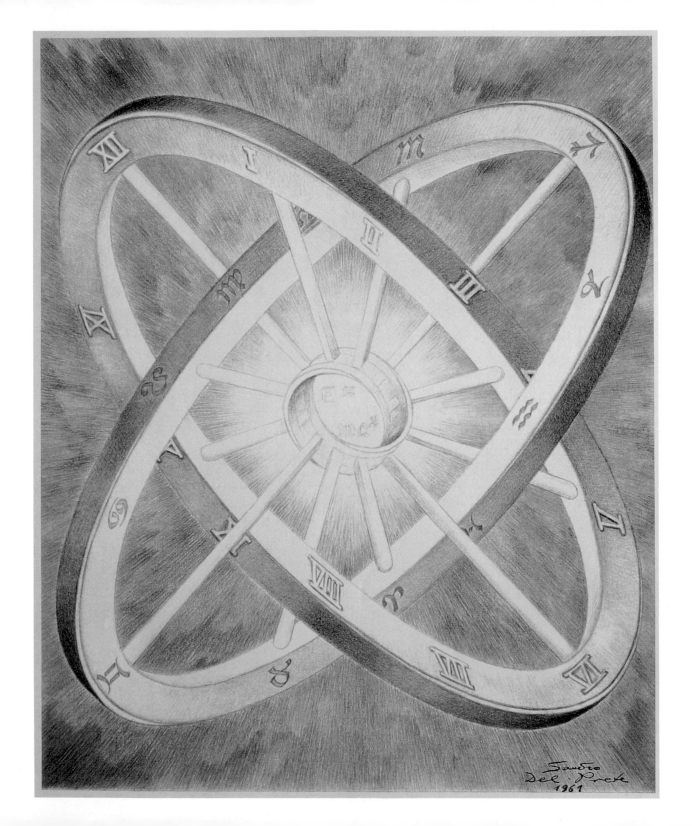

Sandro
Del Prete
1961

96

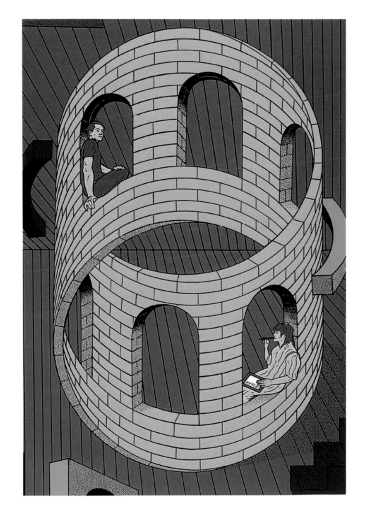

Roger N. Shepard (born 1929). *Wrought Up*. 1984.

◀ **Sandro Del-Prete**. *Cosmic Wheels*. 1961.

István Orosz. *Round Tower*. 1997.

M. C. Escher. *Moebius Strip II*. 1963. ▶

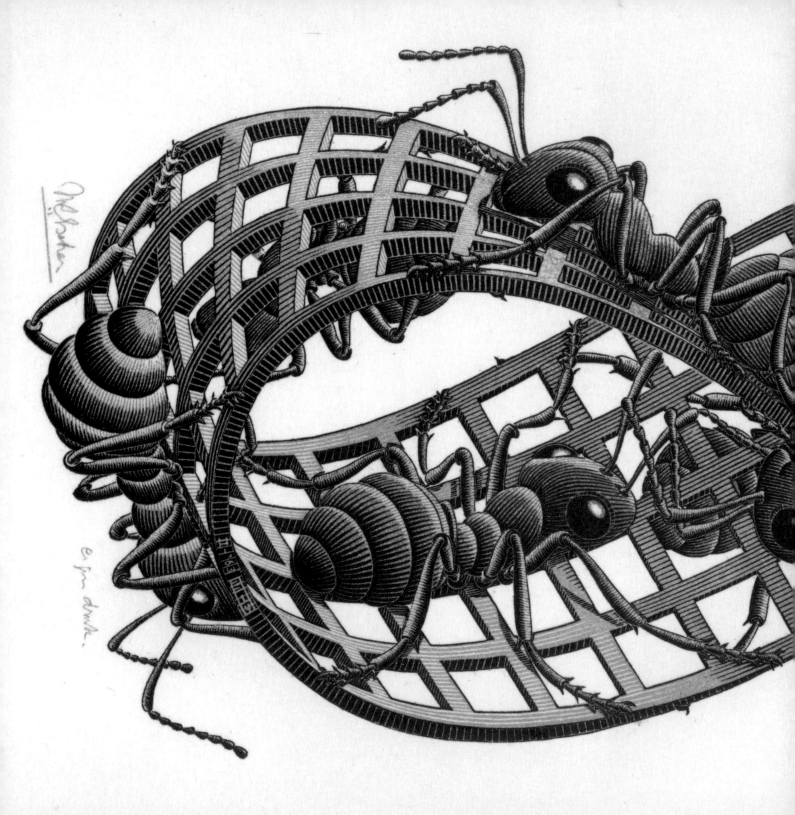

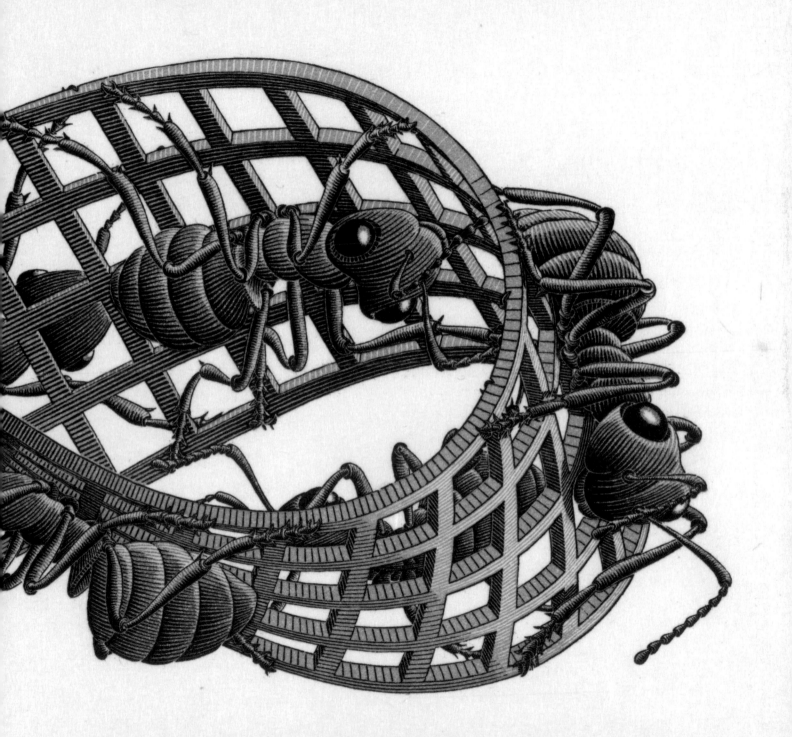

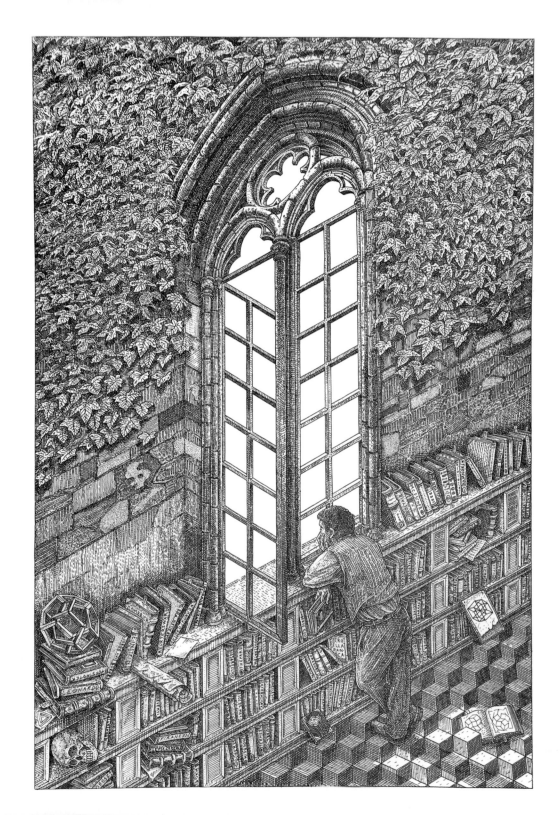

István Orosz.
Library 1. 2005.

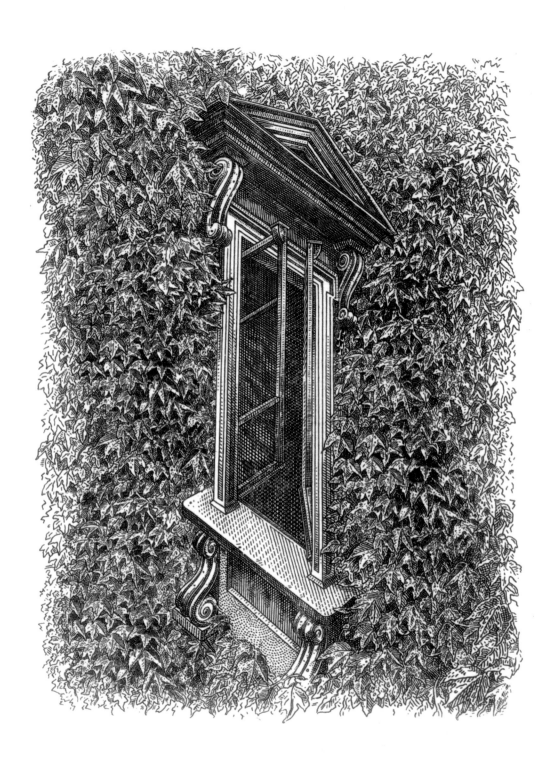

István Orosz.
Window. 1993.

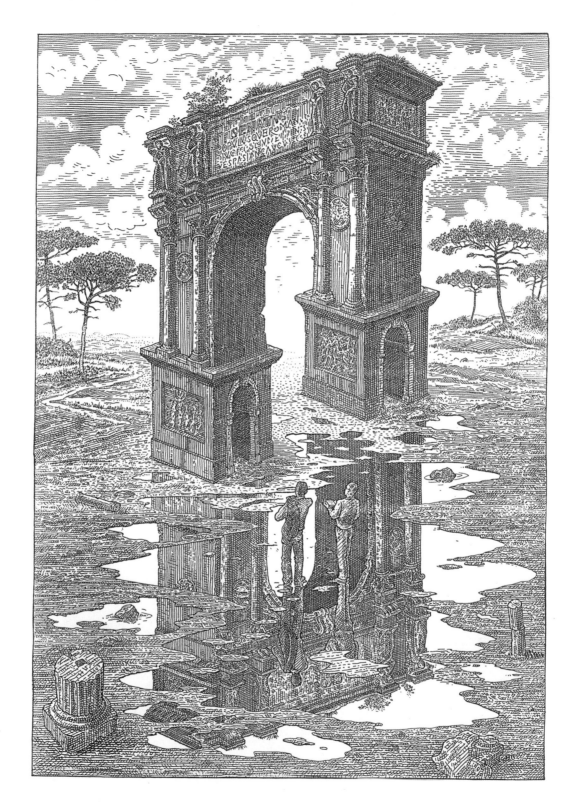

István Orosz.
Arc de Triomphe.
1996.

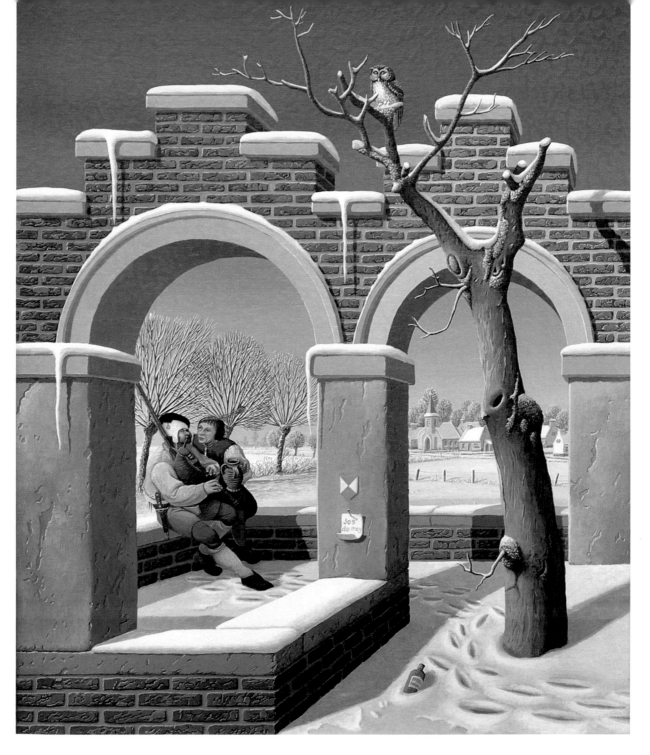

Jos de Mey. *An Afternoon Serenade in the Country Under an Escher-like Arch*. 1990.

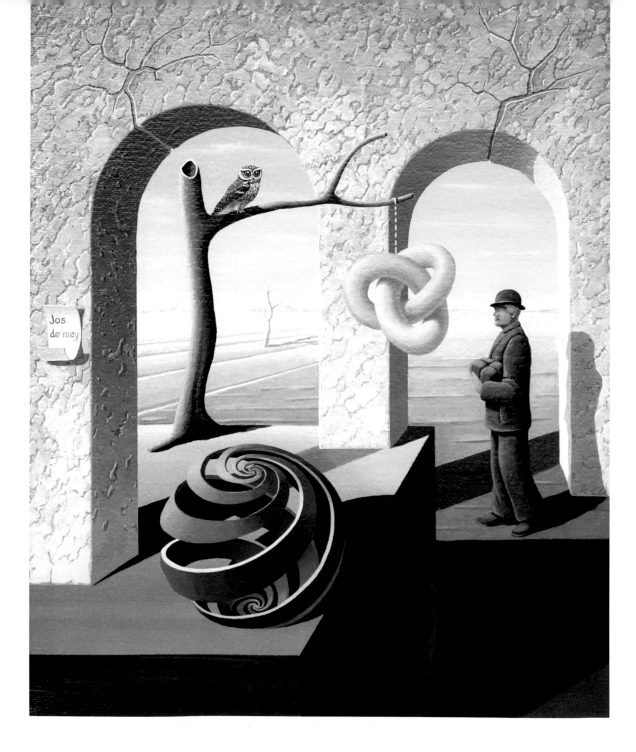

Jos de Mey. *Escher-Sphere and Knot With Magritte Man in a Constructed Landscape in Dalí Colors*. 1996.

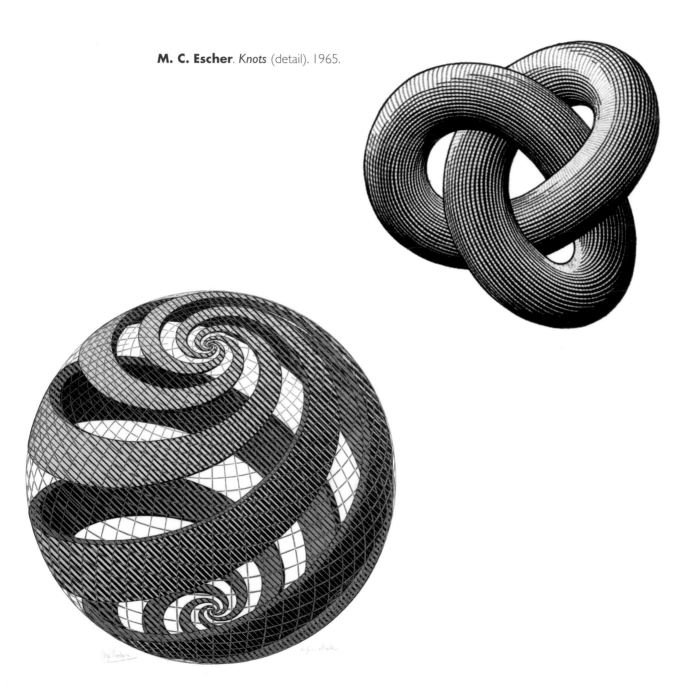

M. C. Escher. *Knots* (detail). 1965.

M. C. Escher. *Sphere Spirals*. 1958.

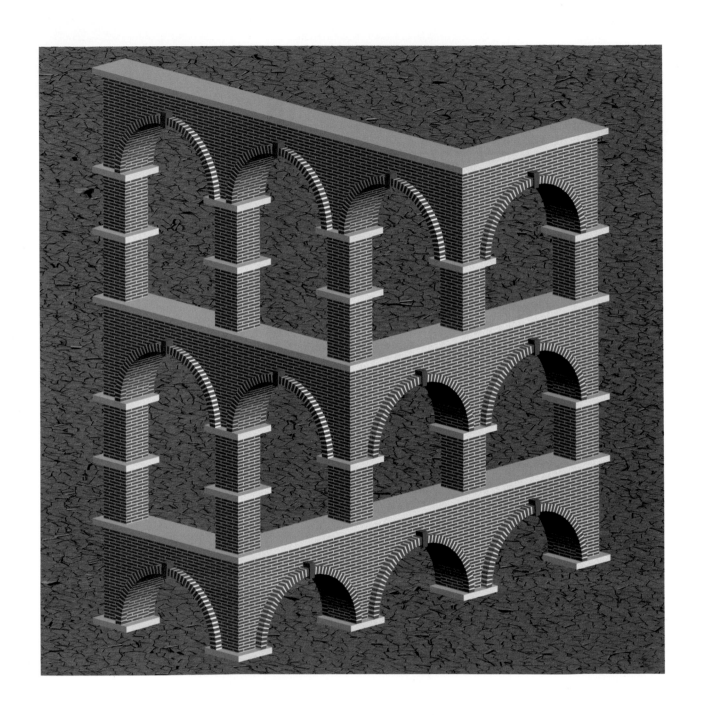

Catherine Palmer (born 1957). *Aqueduct, No. 4*. 2004.

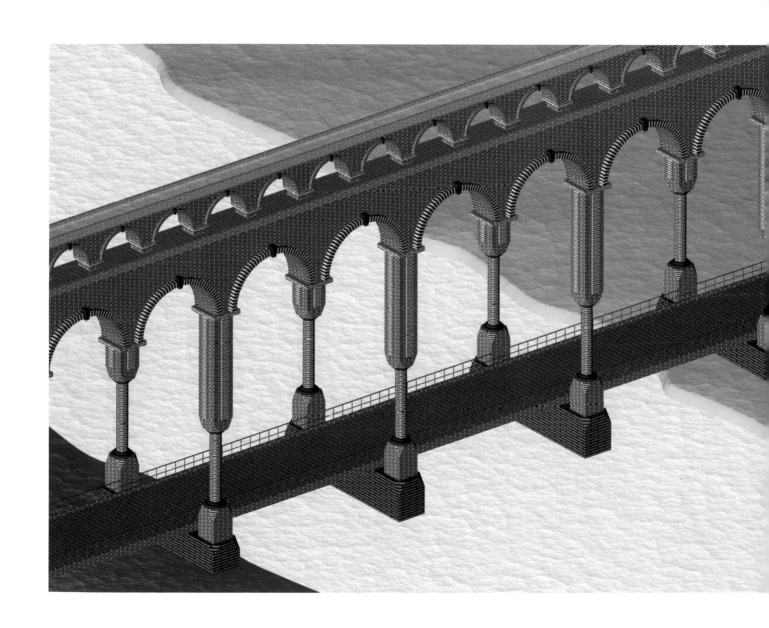

Catherine Palmer. *Aqueduct, No. 2*. 2004.

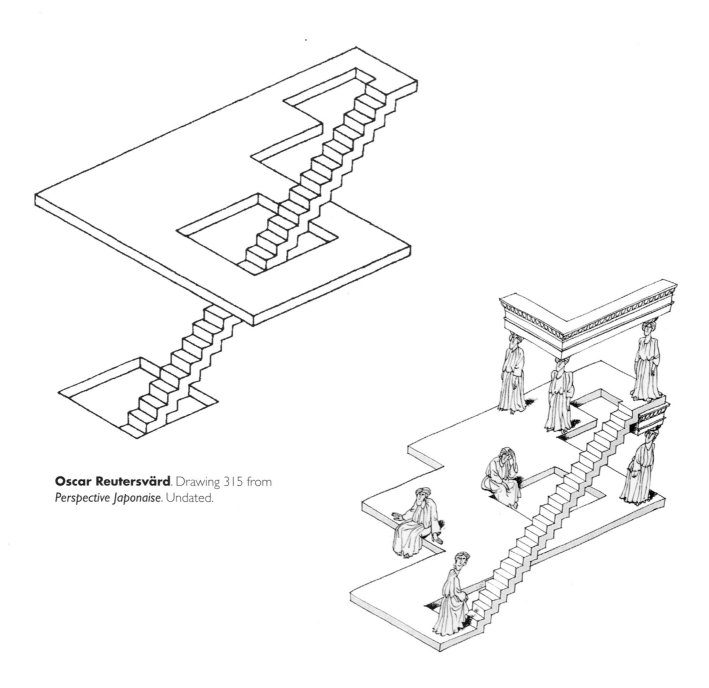

Oscar Reutersvärd. Drawing 315 from
Perspective Japonaise. Undated.

Oscar Reutersvärd and **Bruno Ernst**.
Caryatids. Undated.

Andreas Aronsson (born 1982). *Balconies*. 2009.

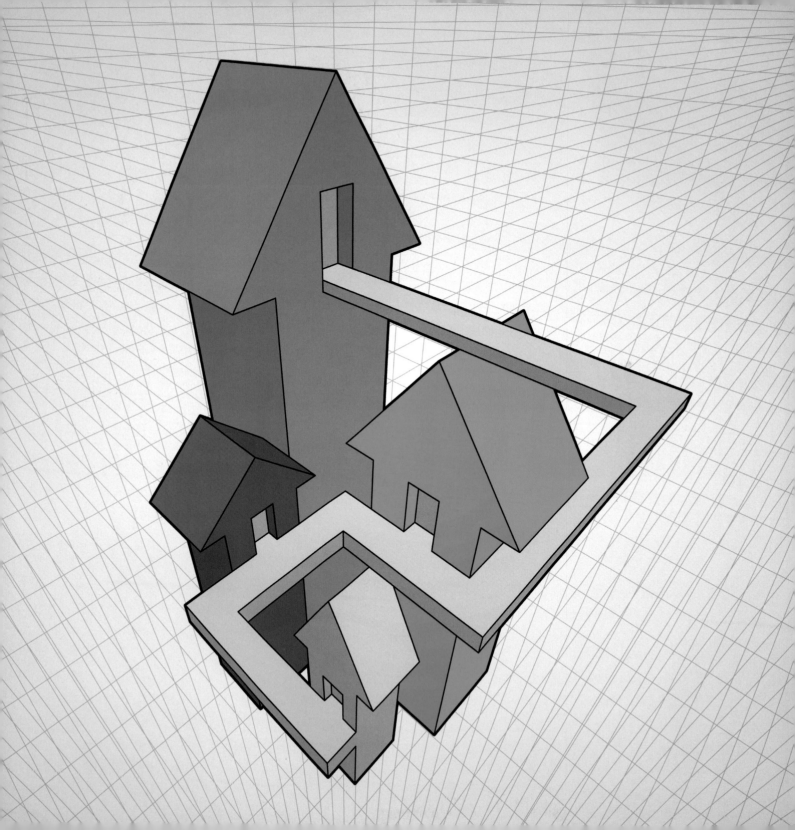

◄ **Andreas Aronsson**. *House*. 2007.

Andreas Aronsson. *Enigmatic Observation*. 2006.

Jos de Mey. *UFO Above the Flemish Landscape*. 2005.

◄ **Studio PBD**. Two drawings after *Josef Albers's* **White Embossings on Gray**. 1971.

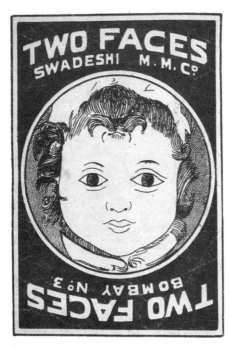

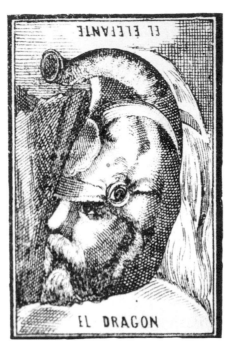

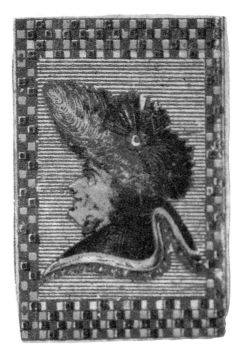

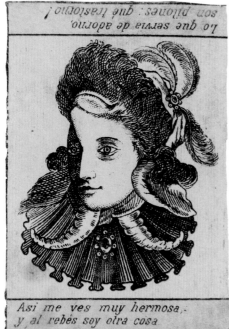

Topsy-turvy matchbox labels. c. 1860–1930.

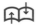

Upside-Down Illusions

Giuseppe (Italian artist). ▶
Animal and Human Head.
Italy, c. 1700.

Double-Head of Pope and Devil.
c. 1600.

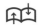

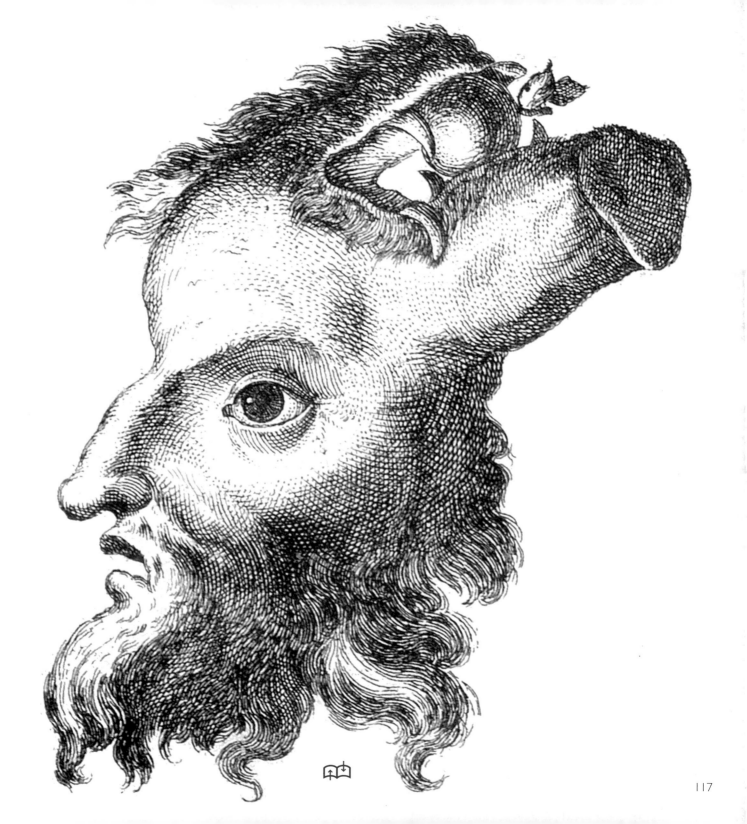

117

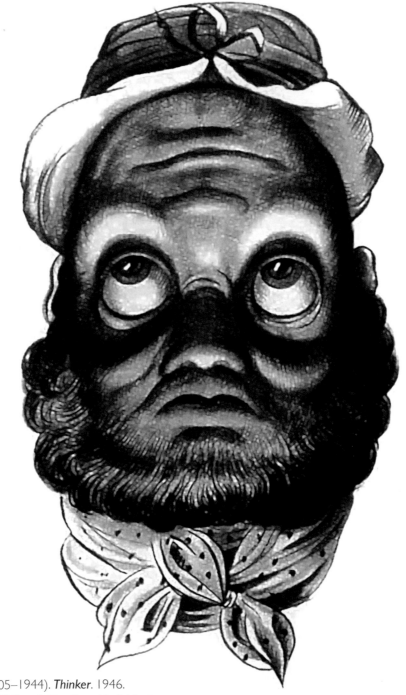

Rex Whistler (1905–1944). *Thinker*. 1946.
From his book *¡OHO! Certain Two-Faced Individuals*.

Sailor

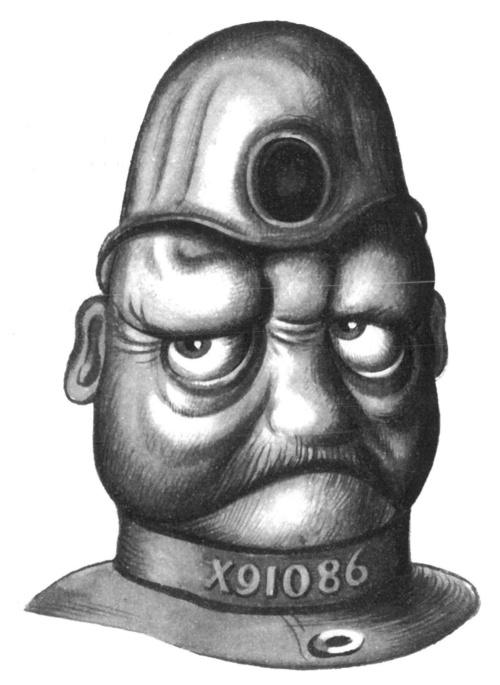

Rex Whistler. *Policeman*. 1946.
From his book *¡OHO! Certain Two-Faced Individuals*.

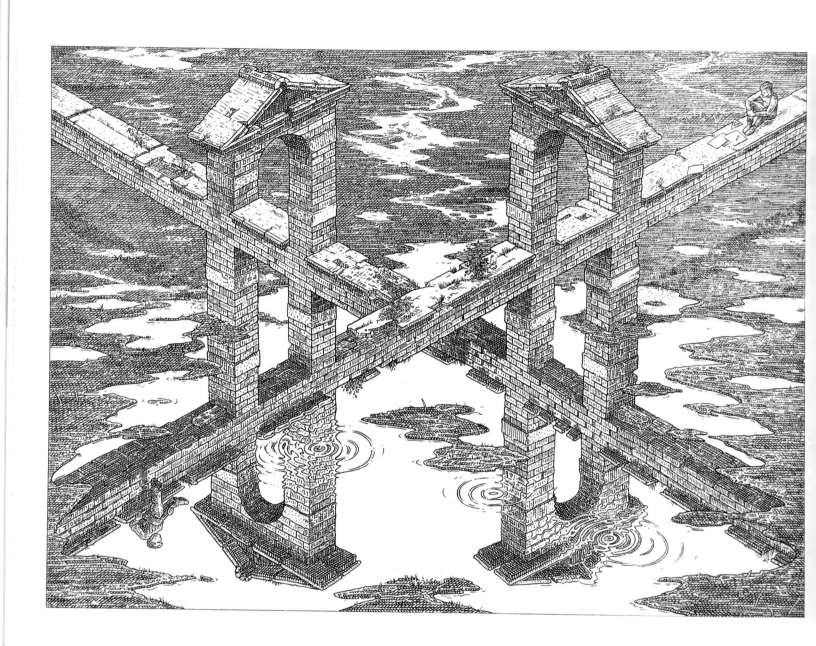

István Orosz (born 1951). *Crossroads*. 1998.

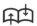

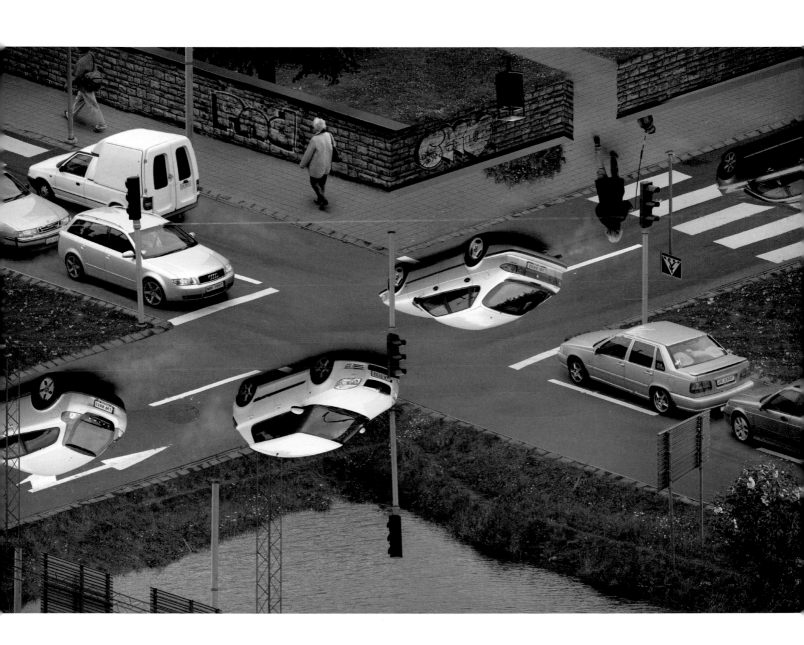

Erik Johansson (born 1985).
Common Sense Crossing. 2010.

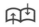

Maartje Jacquet (born 1963). *Owl.* 2010.

Ambiguous Figures and Figure-Ground Illusions

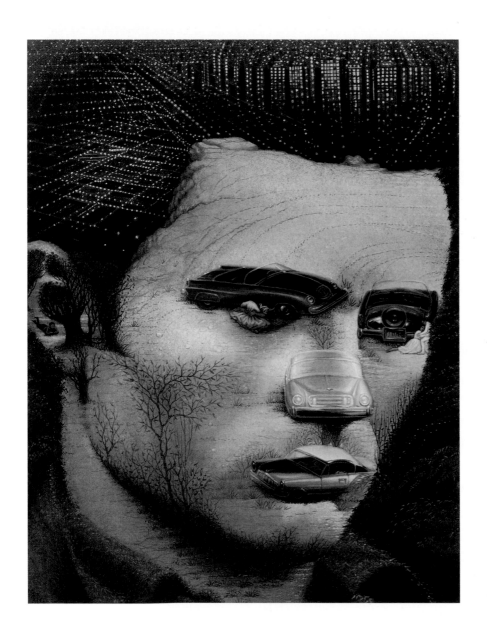

Octavio Ocampo (born 1943). *Hollywood Lights*. 1982.
James Dean with hidden images.

Hollywood Lights (detail): ▶
True Love? Couples and their cars.

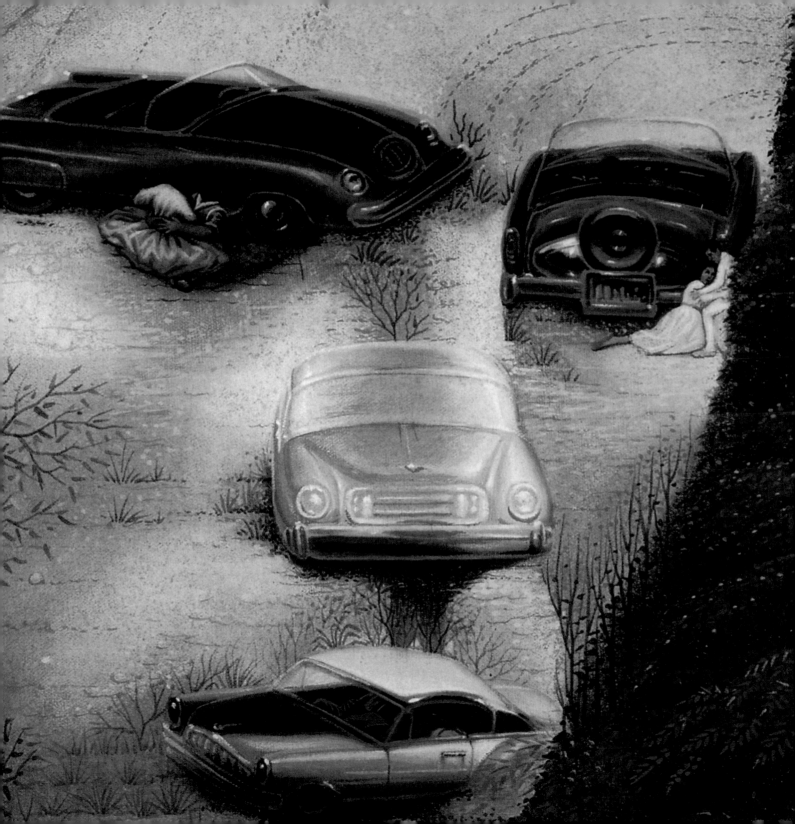

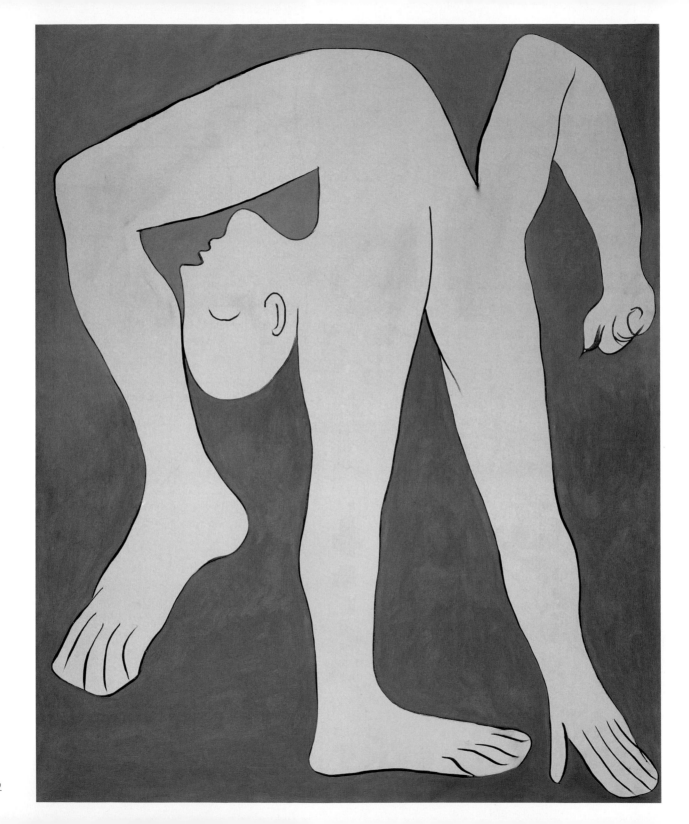

Rineke Dijkstra (born 1959). *Untitled.*1987.

Allen Jones (born 1937). *Odalisque (Concubine).* 1983.

◄ **Pablo Picasso** (1881–1973). *The Acrobat.* 1930.

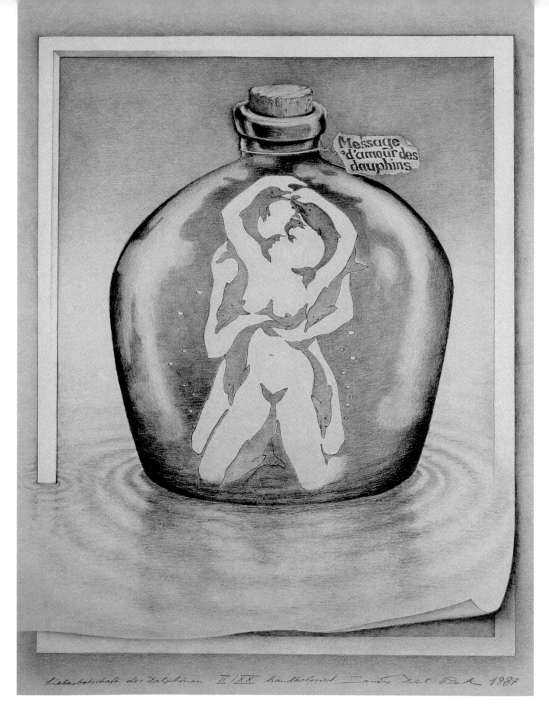

Liebesbotschaft der Delphinen II/XX handkoloriert Sandro Del-Prete 1987

Sandro Del-Prete (born 1937).
Message of Love from the Dolphins. 1987.

Message of Love from the Dolphins (detail). ▶
Is this the arms and bodies of a couple, or a pod
of playful dolphins? You can see both, but not simultaneously.

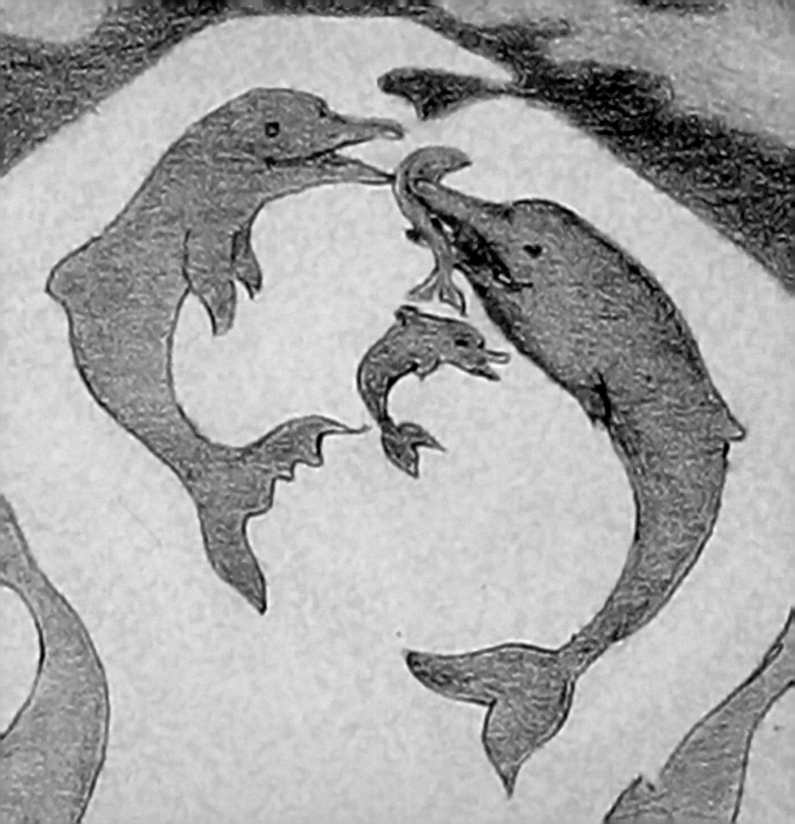

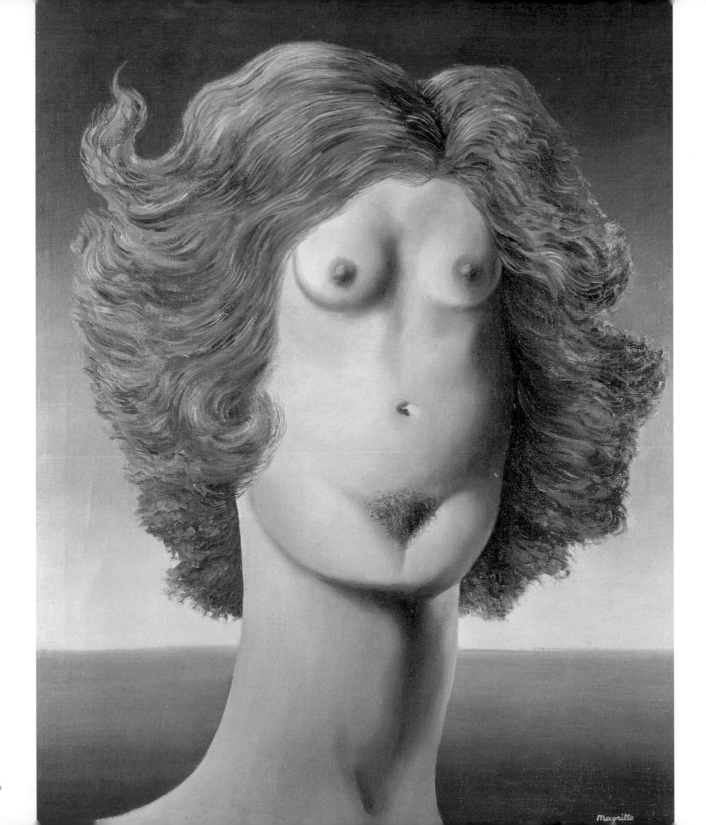

156

Sigmund Freud: What's on a Man's Mind. Undated.

◀ **René Magritte** (1898–1967). *Le Viol* ("The Rape"). 1934.

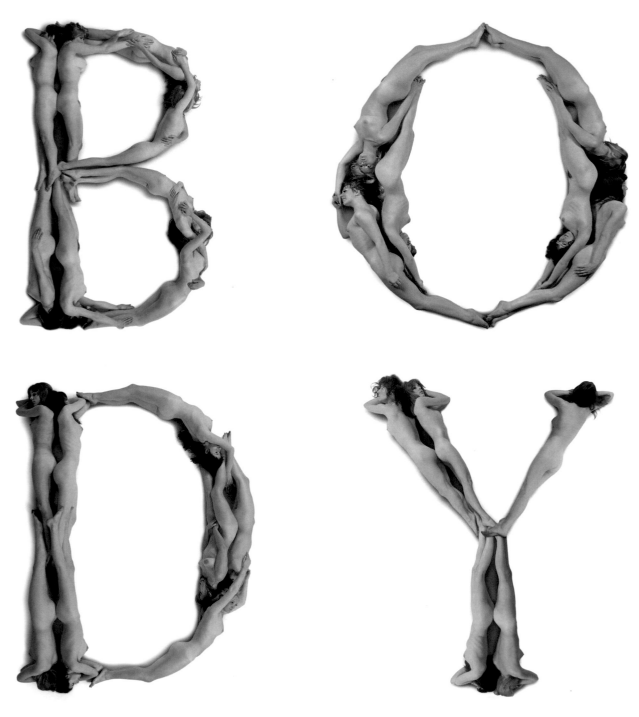

Anthon Beeke (born 1940). *Body Type*. 1969.

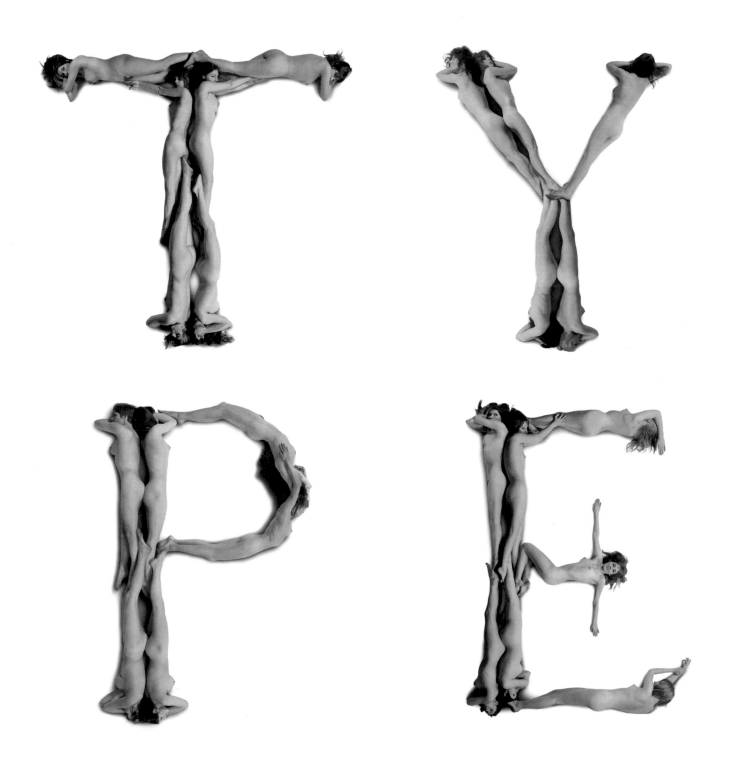

159

Variation: Male and Female Legs, after the original poster by
Shigeo Fukuda (1932–2009), *Female and Male Legs*, 1975.

Lemel Yossi (born 1957). *Israel Red Hands* ▶
(detail of a poster for Amnesty International). 1995.

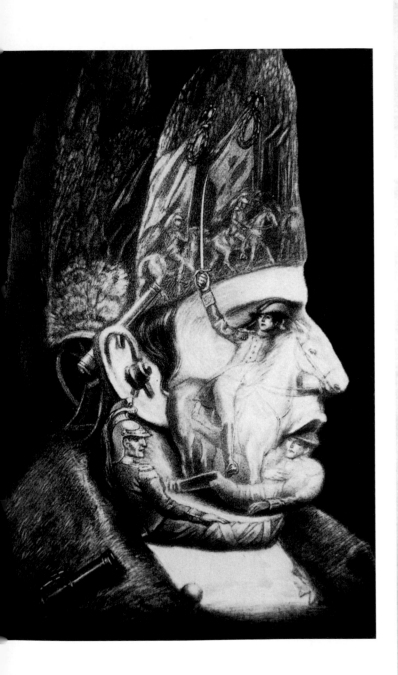

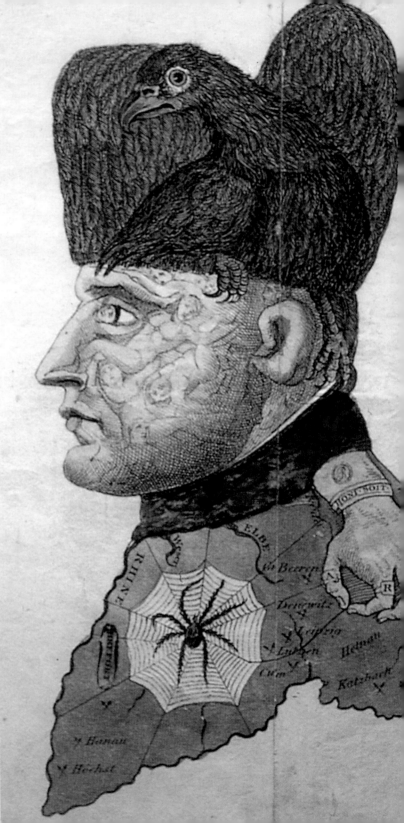

Cartoons of Emperor Napoleon Bonaparte with hidden pictures (1769–1821).

Napoleon's ghost haunts his grave on St. Helena.
• *Can you find the image of Napoleon?*

Salvador Dalí (1904–1989). *Invisible Afghan with Apparition on the Beach of the Face of Garcia Lorca in the Form of a Fruit Dish with Three Figs*. 1938.

Attributed to **R. C. James**. *Hidden Dalmatian*. 1965. ▶

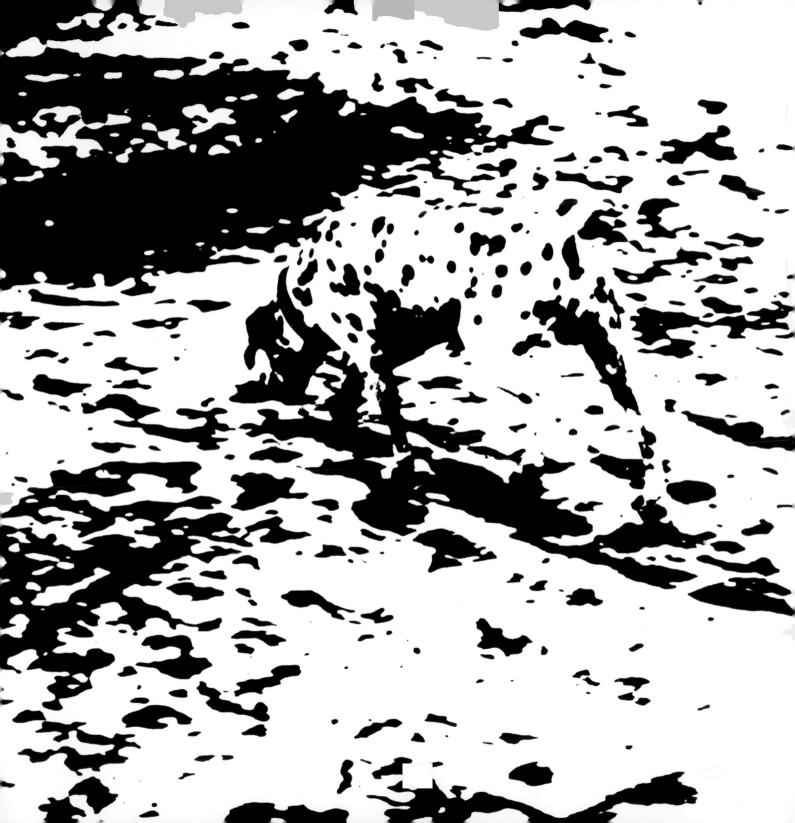

• Look for the cow.

Dallenbach Figure. Psychologist *Karl Dallenbach* (1887–1971) created this illusion in 1952. Without knowing what to look for, many people can never find the picture hiding in it; however, once the viewer finds the hidden image, it's impossible not to see it. If you can't find it, there's a hint at the upper right.

Photograph with ambiguous image. ▶
Late nineteenth century.
• *Look between the standing woman on the left and the seated man on the right: Do you see a child or a man with beard?*

166

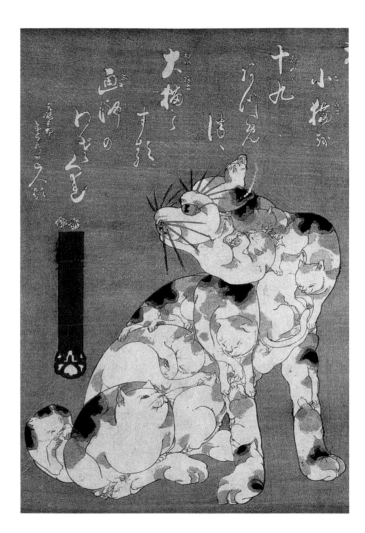

Yoshifuji Utagawa (1828–1887). *Kittens Gather Together to Become a Mother Cat.* c. 1850.
Yoshifuji Utagawa was a student of Utagawa Kuniyoshi.

Utagawa Kuniyoshi (1798–1861).
At first glance he looks fierce, but he is really a nice person. 1847–1848.
A caricature made from a collection of images.

◀ *Artist's model book.* Armenia, c. 1600.

Pablo Picasso. *Baboon and Young*. 1951.

Baboon and Young (detail). ▶

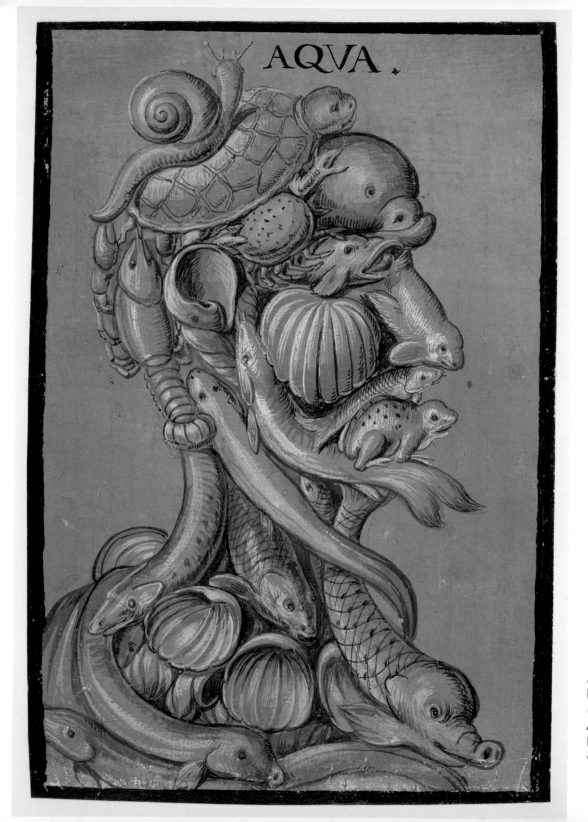

AQVA.

Attributed to
Heinrich Göding
(1585–1615).
Aqua (Water). c. 1600.
Head composed of
water animals.

177

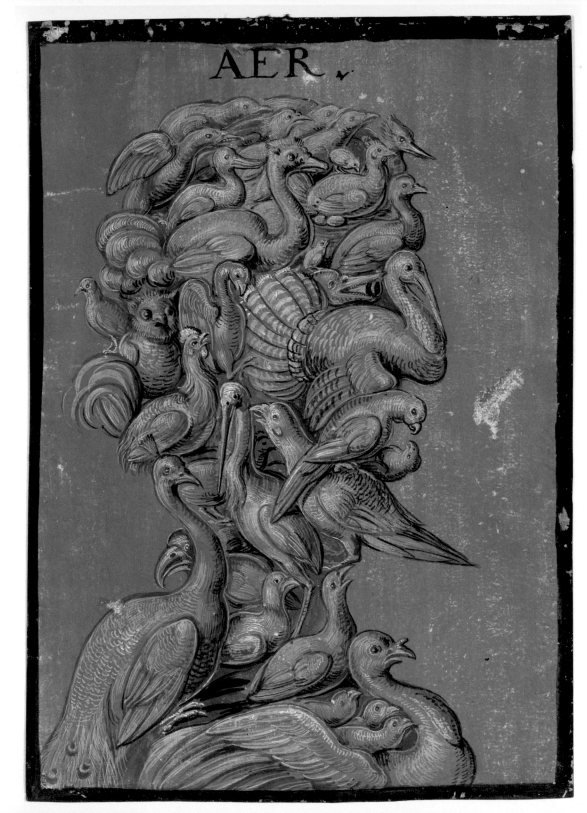

Attributed to
Heinrich Göding.
Aer (Air). c. 1600.
Head composed
of birds.

178

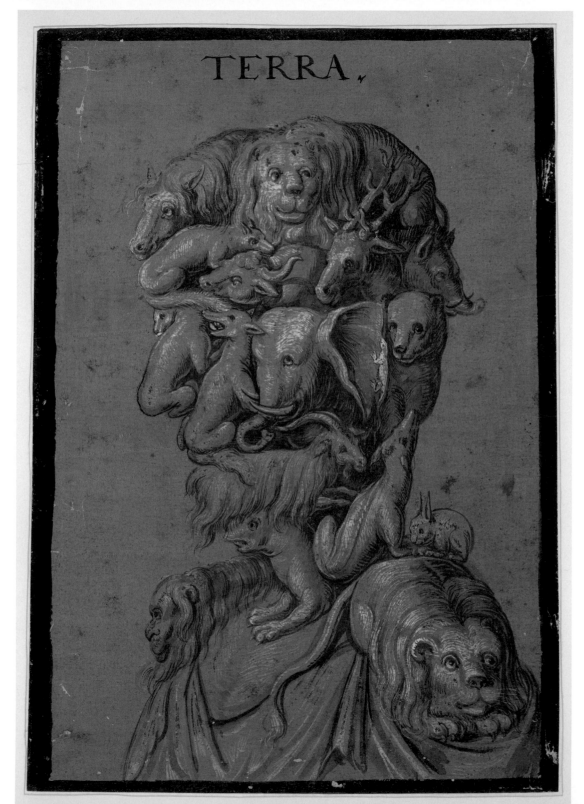

TERRA

Attributed to
Heinrich Göding.
Terra (Earth),
c. 1600.
Head composed
of land animals.

Bottom—Horse's or Lady's? Postcard, c. 1900.

Bosom or Bald Heads? Postcard, 1905.

W. E. Hill (1887–1962). *My Wife and Mother-in-Law.* 1915. ▶
A famous illusion as published in *Puck* magazine.
• *Do you see a young woman or an old woman?*

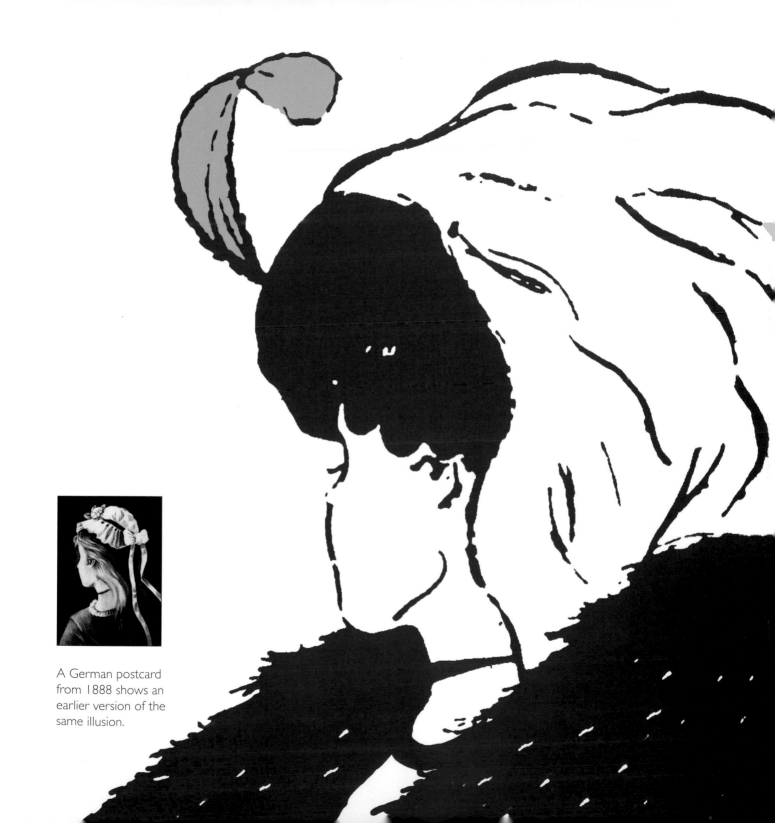

A German postcard from 1888 shows an earlier version of the same illusion.

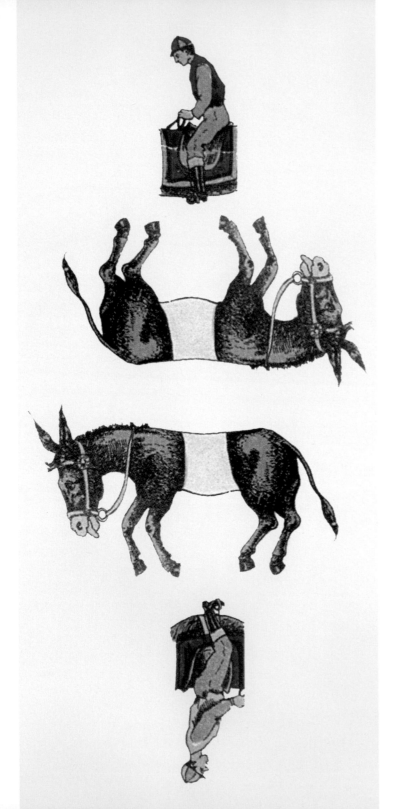

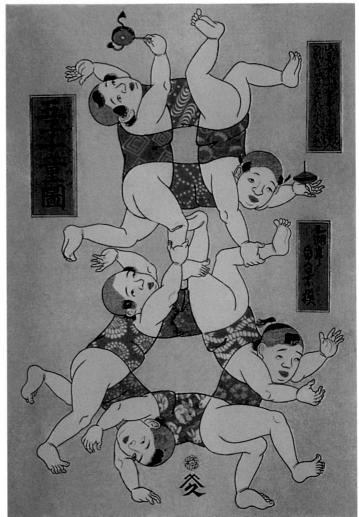

Five Sumo wrestlers and ten bodies. Japan, undated.

◀ **Sam Loyd** (1844–1911). *Trick Donkeys*. 1871.
 • *Can you figure out in which position the riders have
to sit so the donkeys start galloping? (Solution on page 319.)*

Bowl. Persia, early seventeenth century. ▶
 • *Horse Sense: How many horses and
how many horse heads?*

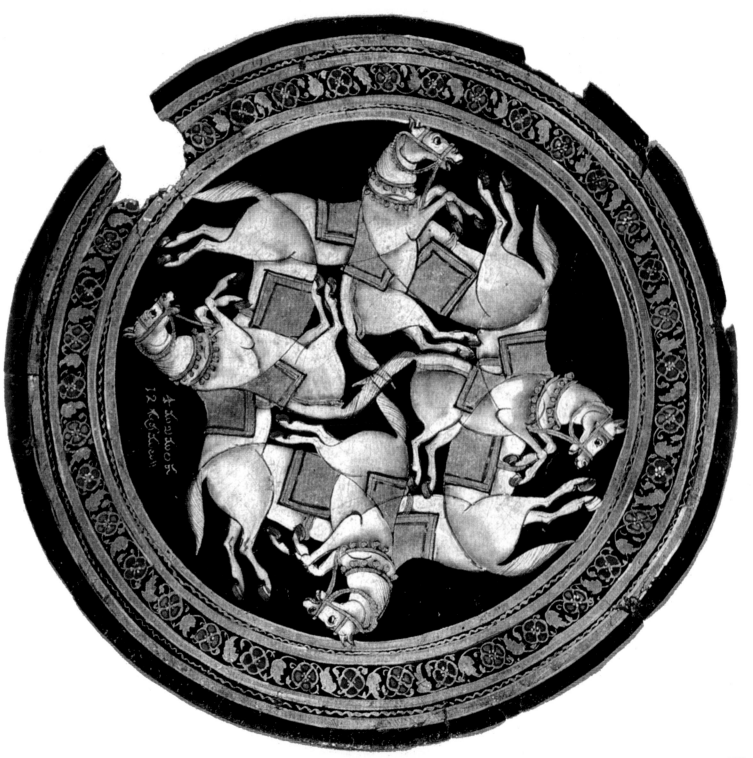

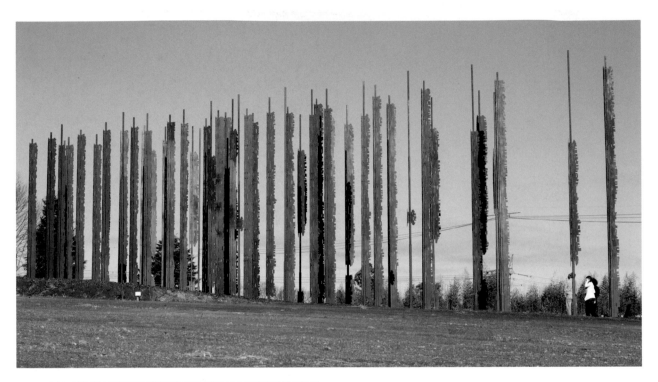

Marco Cianfanelli (born 1970). *National Monument—Nelson Mandela*. 2012.

This monument marks the spot in the KwaZulu-Natal midlands where Nelson Mandela was captured on August 5, 1962. The steel sculpture, composed of fifty columns, reveals the head of Nelson Mandela when viewed from a particular perspective. The columns are telescoped square tubes with face plates, gussets, and fins attached to them.

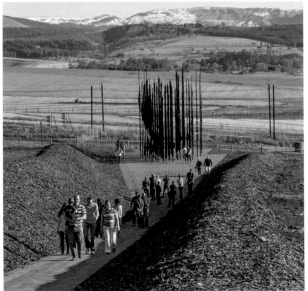

National Monument—Nelson Mandela, ▶
viewed from the front.

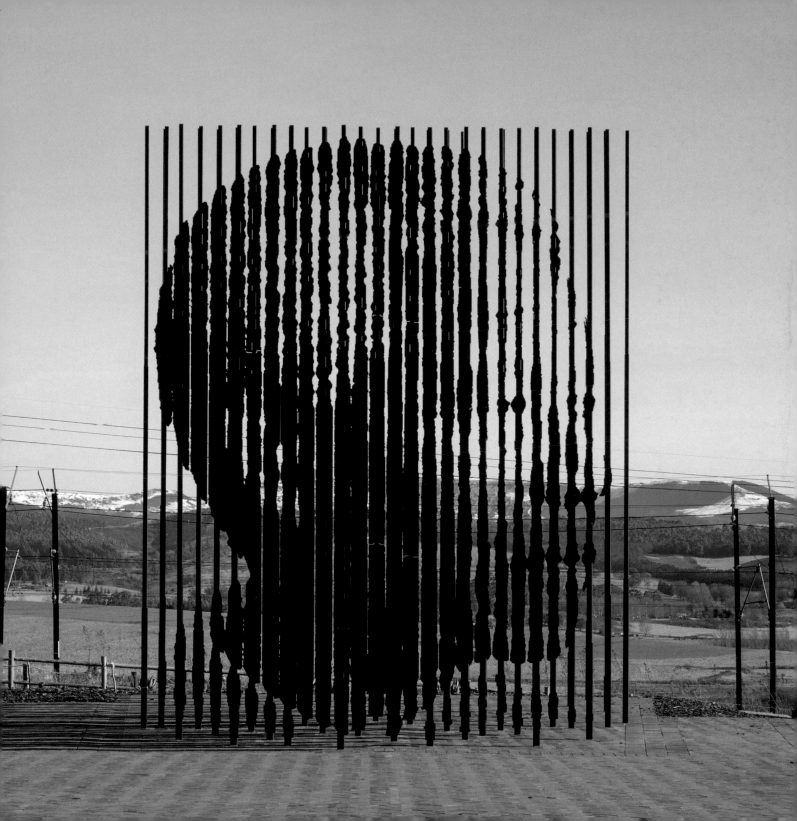

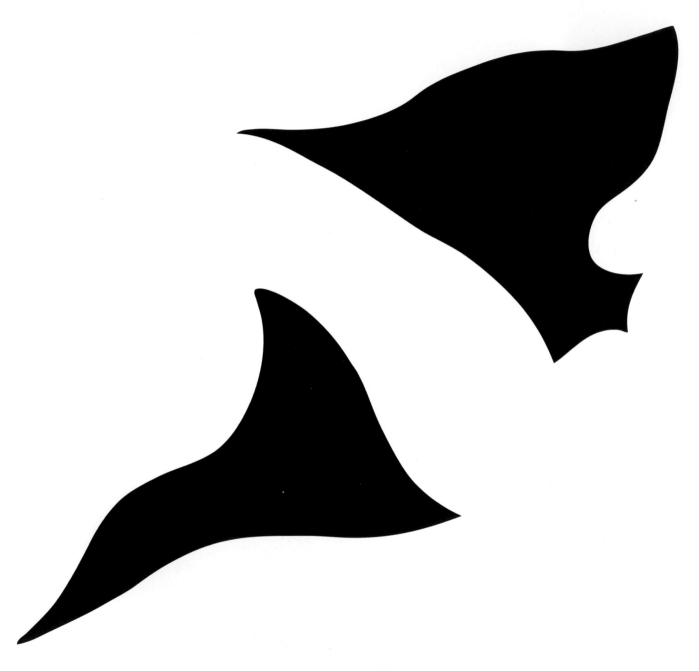

Dick Termes (born 1941). *Negative Lady*. 1993.

Birds. Undated.
• *In which direction are the birds flying? Are they geese or hawks?*

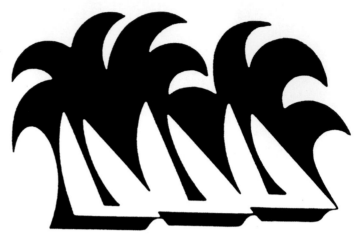

Palm trees and sail boats. Undated.

Roger N. Shepard (born 1929). *Sara Nader*. c. 1990.
A saxophonist plays an aubade, a love song,
for Sara Nader.

Don't miss the boat! Undated.

Peter Brookes (born 1943). *Cat or Mouse?* 1979. ▶

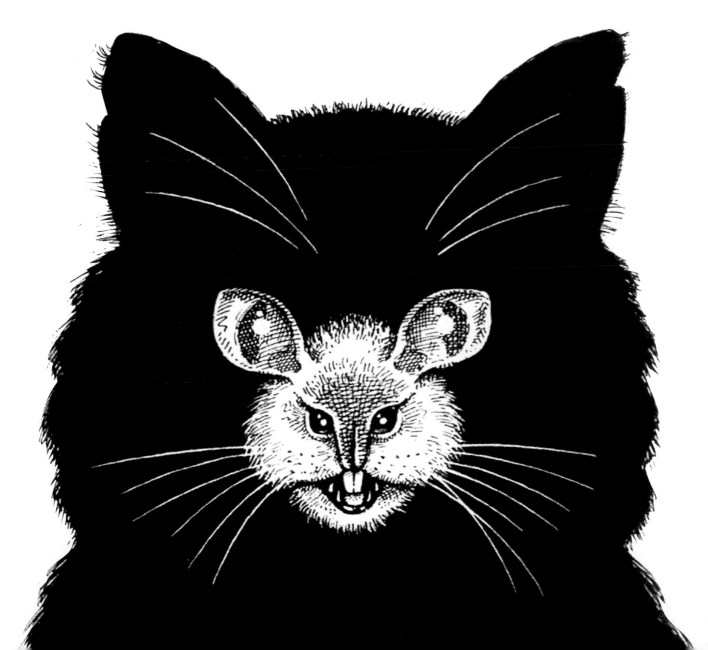

189

Island of Sleeping Dogs. Undated.

Townscape with Head. Undated.

István Orosz (born 1951). *Island-Watcher*. 1993. ▶

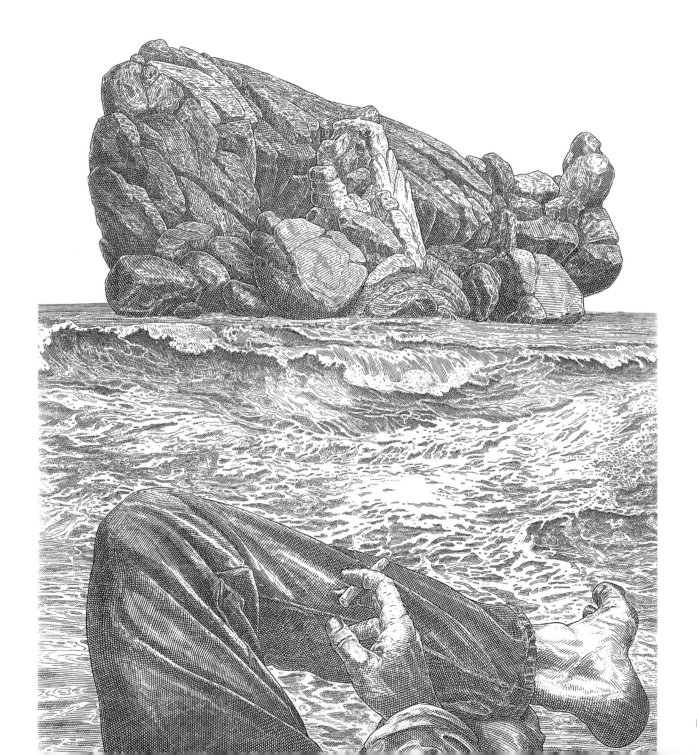

191

István Orosz, *Untitled*. 1999–2006.
A series of illusionistic skulls illustrating a modern edition of the
medieval satire *Das Narrenschiff*, or *Ship of Fools*.

István Orosz. *Columbus*. 1992. ▶

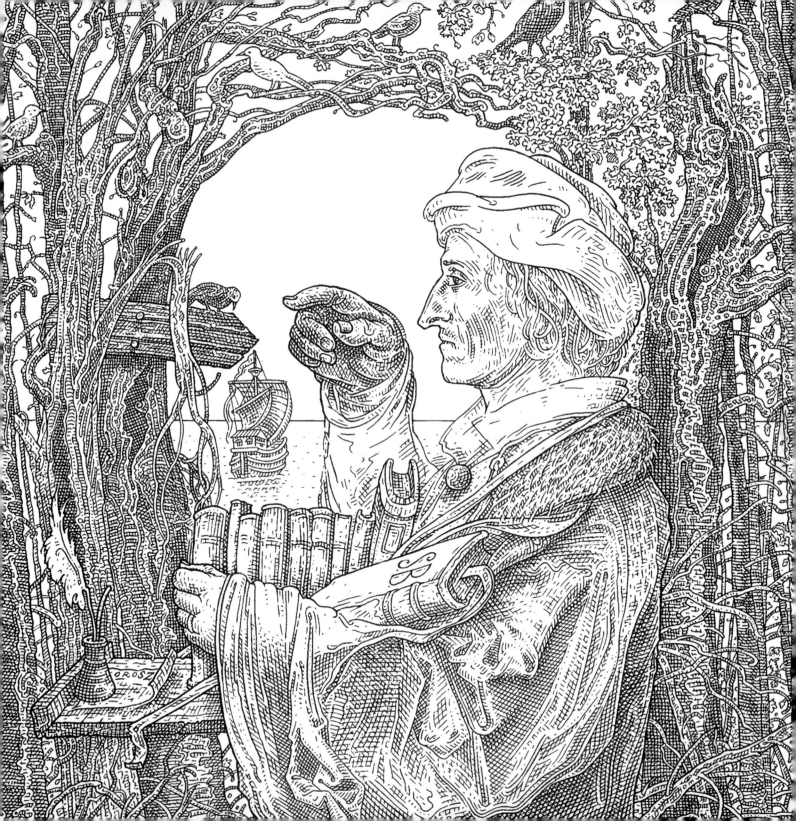

194

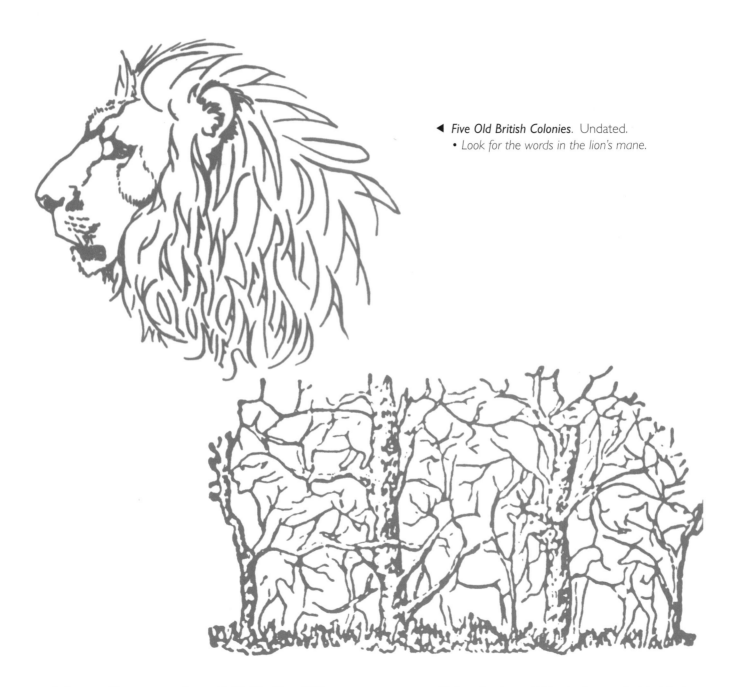

◀ *Five Old British Colonies*. Undated.
• *Look for the words in the lion's mane.*

◀ **Jeroen Henneman** (born 1942). *The Kiss*. 1992.
Husband and wife.

Eight animals are hidden in the woods. Undated.

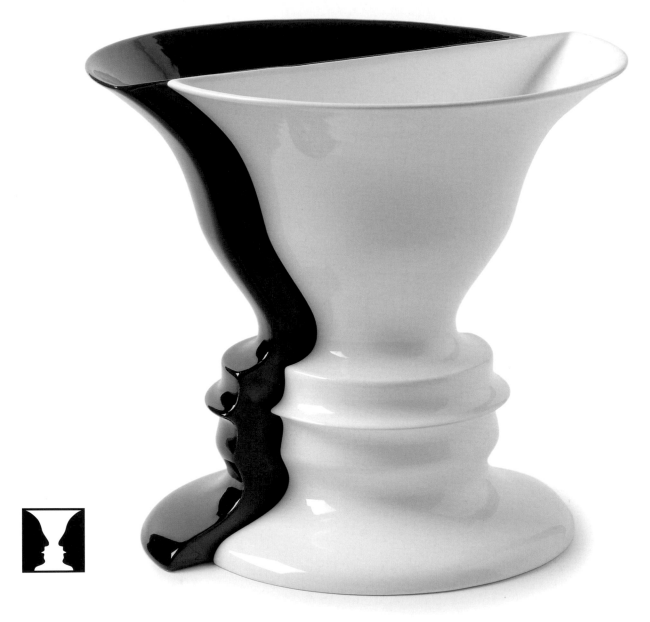

Paul M. Baars (born 1949).
Tête à Fleur. 2005.
Ambiguous face vase, based on
the optical illusion *Two Faces, One Vase* (1915)
by Danish psychologist *Edgar J. Rubin*.

Coen Holten. *Tête à Fleur (Paul M. Baars)*. 2012. ▶
This *single image random dot stereogram (SIRDS)*
conceals a 3-D image of a vase. • *One way to see it is to stare
at an object behind the page and then gradually move your
attention to the page itself without refocusing your eyes.
Some people find it easier than others.*

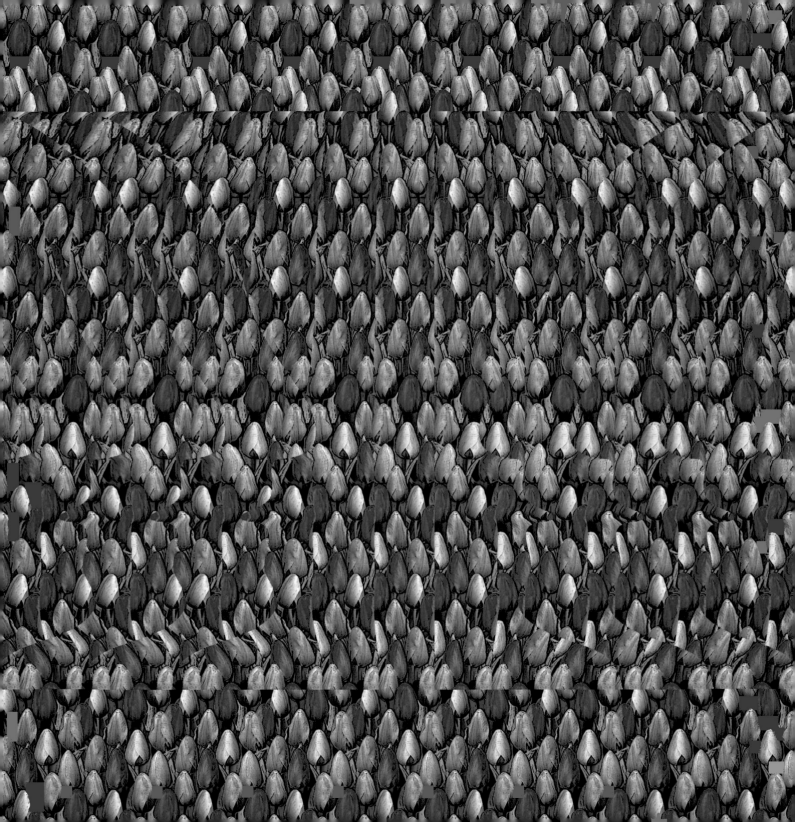

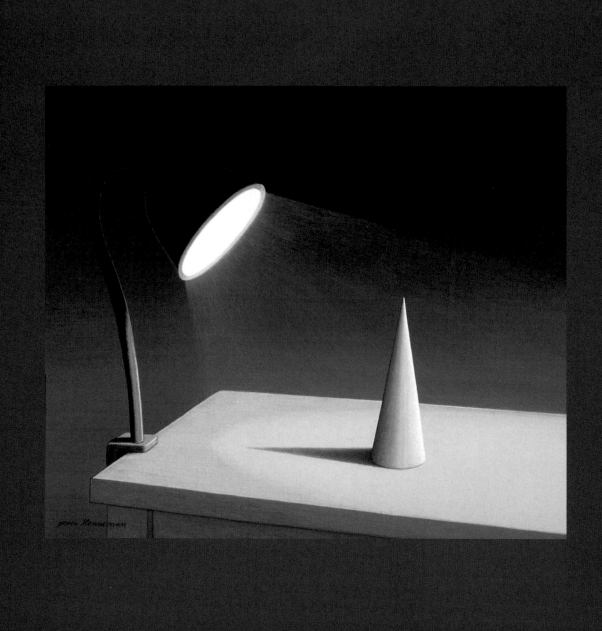

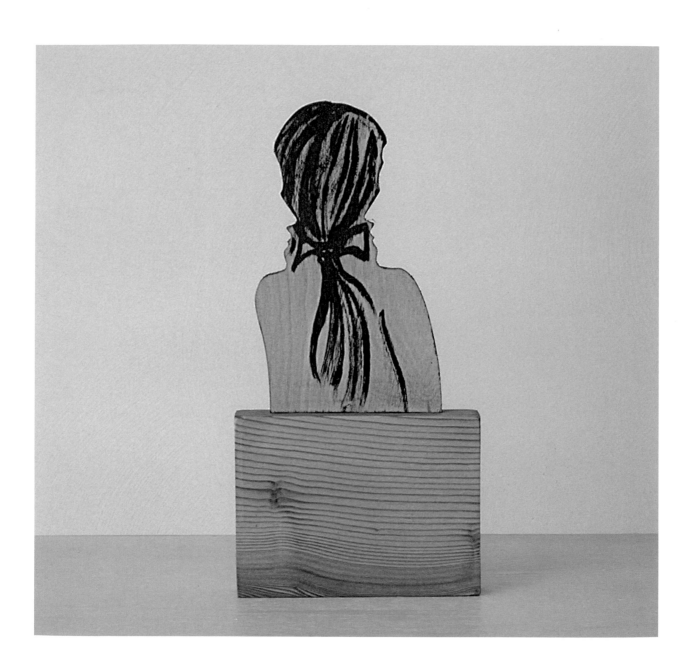

◄ **Jeroen Henneman**. *As Always*. 1979.　　　　　　　　　**Jeroen Henneman**. *Parents*. 1998.

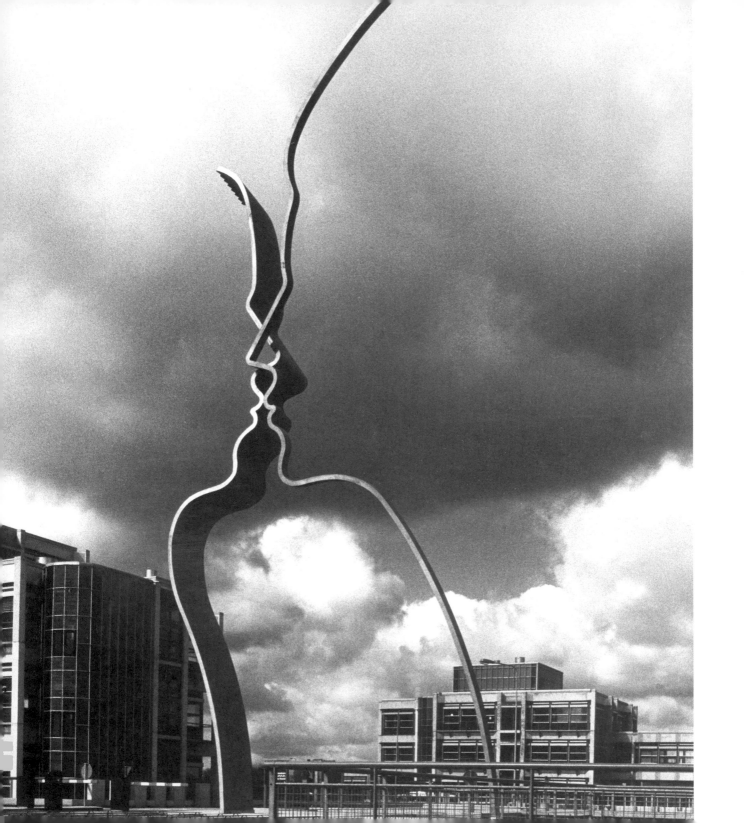

Alexander Khokhlov (born 1982). *Silhouette*, from the "Weird Beauty" series. 2012.

◄ **Jeroen Henneman**. *The Kiss*. Bijlmerdreef, Amsterdam, 1982.

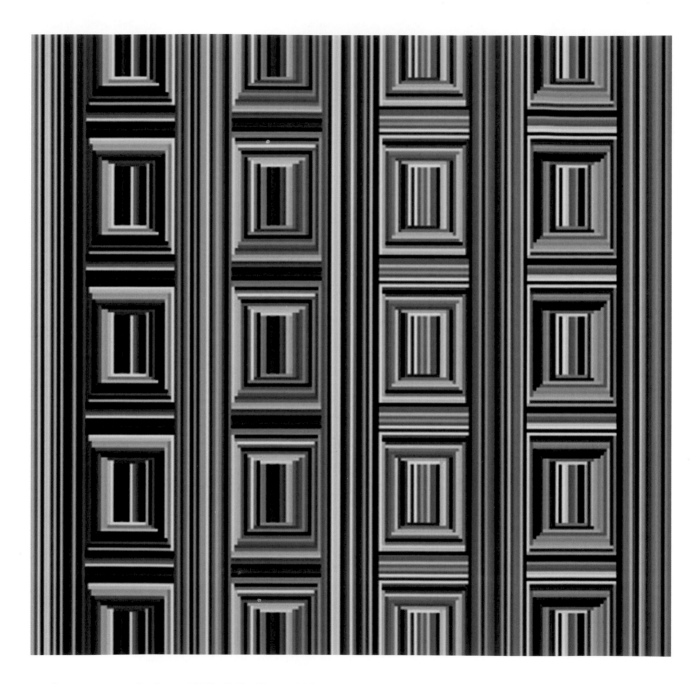

Anthony M. Norcia (born 1953). *Coffer Illusion*. 2006.
• *Can you find the circles hidden in the "door panels"? (Solution on page 319.)*

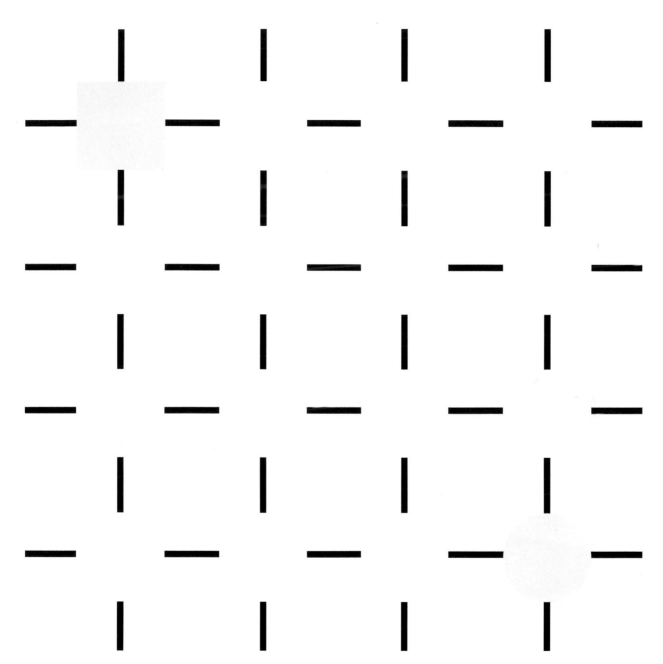

Ambiguous shapes. Undated.
Depending on which gray shape you look at last, white squares or
circles may appear at the intersections of the black lines.

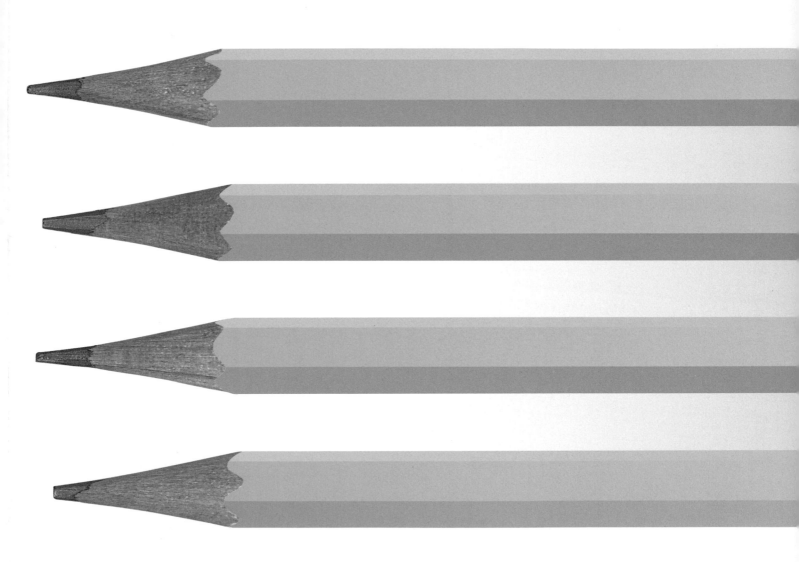

Studio PBD. *Pencils 4 Three*. 2010.
• *Four pencils or …*

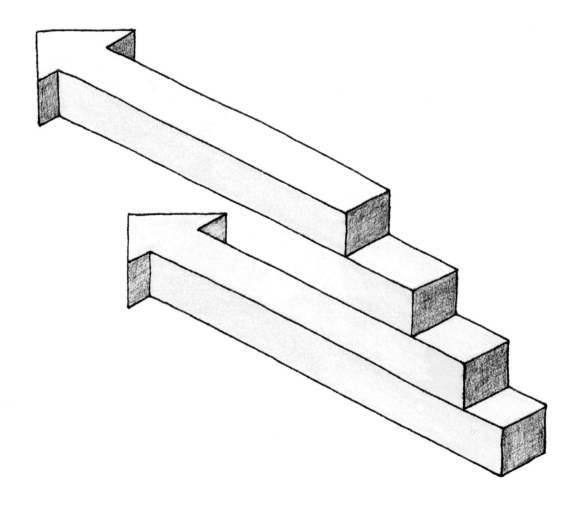

Oscar Reutersvärd (1915–2002). *Two Arrows*. Undated.
This illusion and the preceding one by *Studio PBD* are related to the impossible fork. *(See page 68.)*

If there is anyone out there who still doubts that America is a place where all things are possible, who still wonders if the dream of our founders is alive in our time, who still questions the power of democracy, tonight is your answer. It's the answer spoken by young and old, rich and poor, Democrat and Republican, black, white, Latino, Asian, Native American, gay, straight, disabled and not disabled, Americans who sent a message to the world that we have never been a collection of Red States and Blue States. We are and always will be the United States of America. It's been a long time coming but tonight, because of what we did on this day, in this election at this defining moment, change has come to America. The road ahead will be long. Our climb will be steep. We may not get there in one year or even in one term, but America, I have never been more hopeful than I am tonight that we will get there. I promise you we as a people will get there. I will always be honest with you about the challenges we face. I will listen to you, especially when we disagree. And above all, I will ask you join in the work of remaking this nation the only way it's been done in America for two hundred years, block by block, brick by brick, calloused hand by calloused hand. Let us summon a new spirit of patriotism, where each of us resolves to look after not only ourselves but each other. Let us remember that in this country we rise or fall as one nation, as one people. Let us resist the temptation to fall back on the same partisanship and pettiness and immaturity that has poisoned our politics for so long. Let us remember that it was a man from this state who first carried the banner of the Republican Party to the White House, a party founded on the values of self-reliance, individual liberty, and national unity. Those are the values we all share, and while the Democratic Party has won a great victory tonight, we do so with a measure of humility and determination to heal the divides that have held back our progress. As Lincoln said to a nation far more divided than ours, "We are not enemies, but friends. Though passion may have strained it must not break the bonds of affection." And to those Americans whose support I have yet to earn - I may not have won your vote, but I hear your voices, I need your help, and I will be your President too. And to all those who have wondered if America's beacon still burns as bright, tonight we proved once more that the true strength of our nation comes not from the might of our arms or the scale of our wealth, but from the enduring power of our ideals: democracy, liberty, opportunity, and unyielding hope. This is our moment. This is our time, to put our people back to work and open doors of opportunity for our kids, to restore prosperity and promote the cause of peace, to reclaim the American Dream and reaffirm that fundamental truth that out of many, we are one, that while we breathe, we hope, and where we are met with cynicism, and doubt, and those who tell us that we can't we will respond with that timeless creed that sums up the spirit of a people: "Yes we can." Thank you, God bless you, and may God Bless the United States of America.

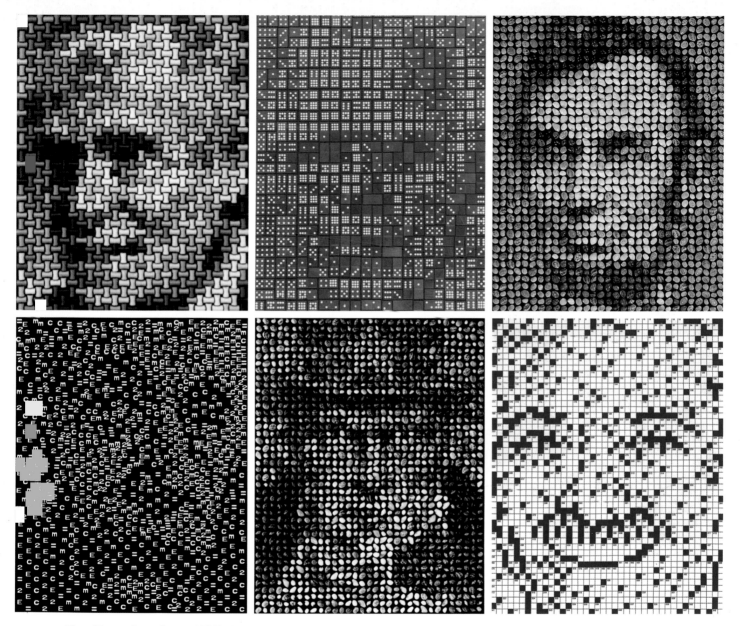

Ken Knowlton (born 1931). Above, from left to right: *Aaron Feuerstein* (Director, Bobbin Yarn Factory). 2001. Spools of thread; *Martin Gardner*. 1993. Six sets of 9-9 dominoes; *Abraham Lincoln*. 1992. Seashells; *Albert Einstein*. 2001. Symbols from the equation E=mc2. Computer graphics print; *Uncle Sam*. 1991. Seashells; *Will Shortz* (*New York Times* crossword puzzle editor). 2003. Computer-assisted crossword-format drawing.

◄ **Ken Knowlton**. *Barack Obama*. 2009. Image and text from Obama's 2008 presidential acceptance speech. Computer graphics mosaic portrait with special computer-set font.

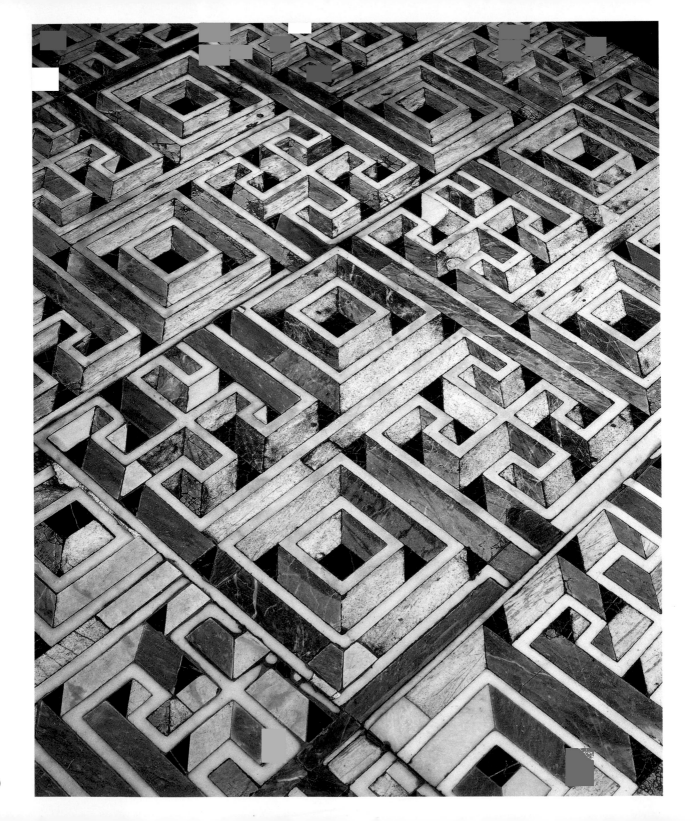

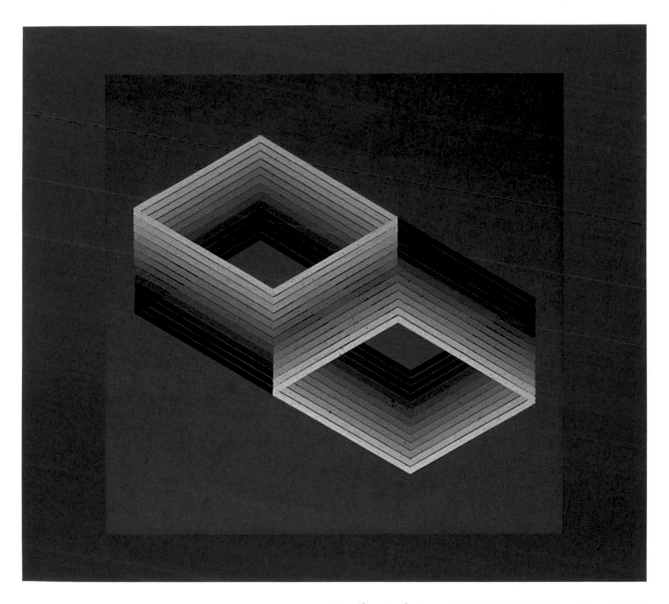

Monika Buch (born 1936). *Untitled* (Thiéry's Figure). 1958.
In 1895, psychologist *Armand Thiéry* published an illustration that appeared to be constantly fluctuating
between different perspectives. It has been adapted by many artists. *(See also page 302.)*

◀ *Marble floor with illusionistic maze design*. Capella Sansevero, Naples. c. 1600.

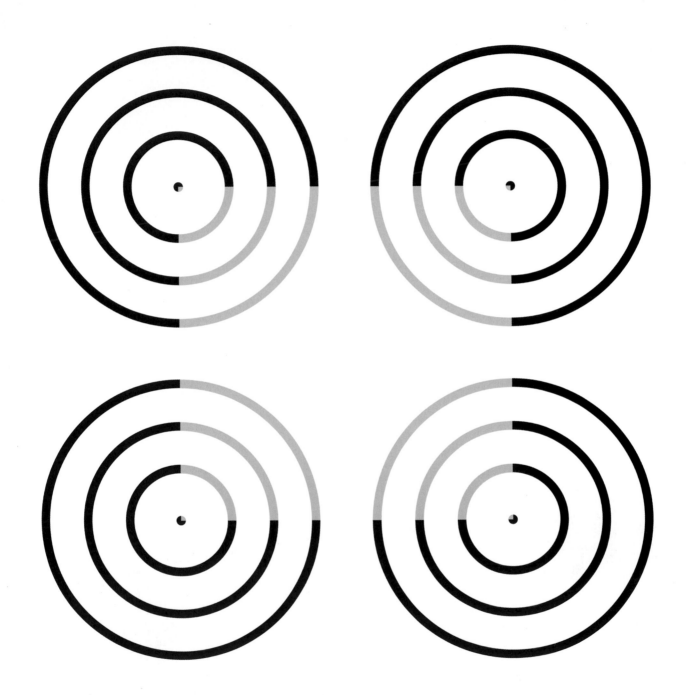

Studio PBD. *Illusory Pink Square*. 2007.

Neon- and After-Effects, Color Brightness, Static Movements, and Vibrations

Studio PBD. *Wine Bottle for Friedrich Schumann*. 2011.
Psychologist *Friedrich Schumann* explored the perception of illusory contours in a paper written in 1900. Cheers!

Studio PBD. *Figment Figures*. 2010.
Incomplete shapes are completed (and created) by the brain.
These illusory contour illustrations were inspired by psychologist *Gaetano Kanizsa*'s triangle, 1976.
For obvious reasons, Kanizsa figures are also called "Pacman configurations."

Watercolor Spreading Illusion. Undated.
This example of a neon effect is based on an illustration by *G. J. Brelstaff*, *B. Pinna*, and *L. Spillmann*, 2001.
Low luminance contrast colors appear to spread beyond their boundaries until constrained by a border—hence the illusion that the area within the orange line is tinted orange.

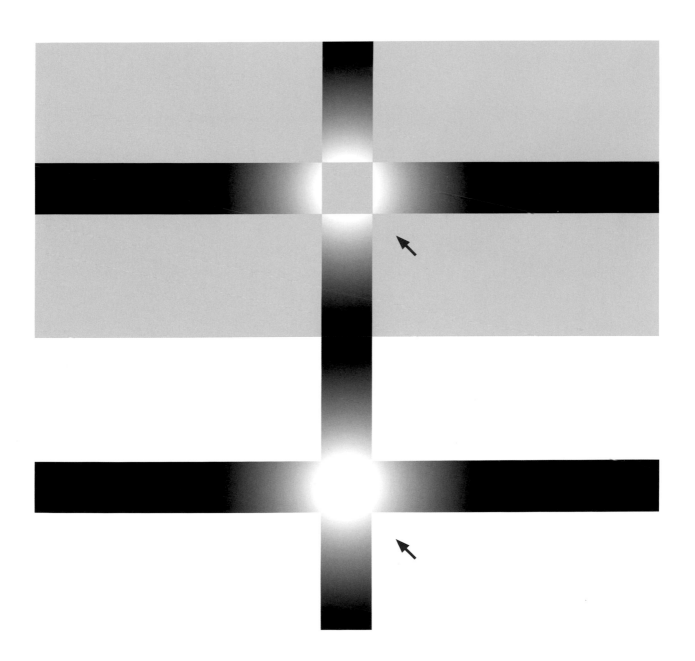

Studio PBD. *Illusory Shades of Gray?* 2009.
The gray shadows (see arrows) are an illusion.

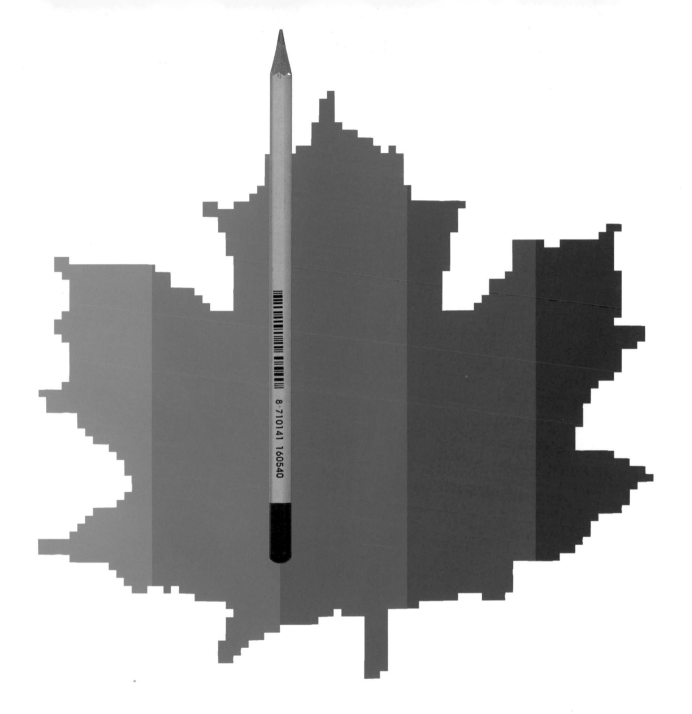

◄ **Studio PBD**. *The Glowing Lamp*. 2011.
• *Move the image forward and backward.
Do you notice the light glow brighter?*

Studio PBD. *Leaf of Shades*. 2008.
• *Cover the vertical borders between the different shades of green
and see what happens to the contrast between them.*

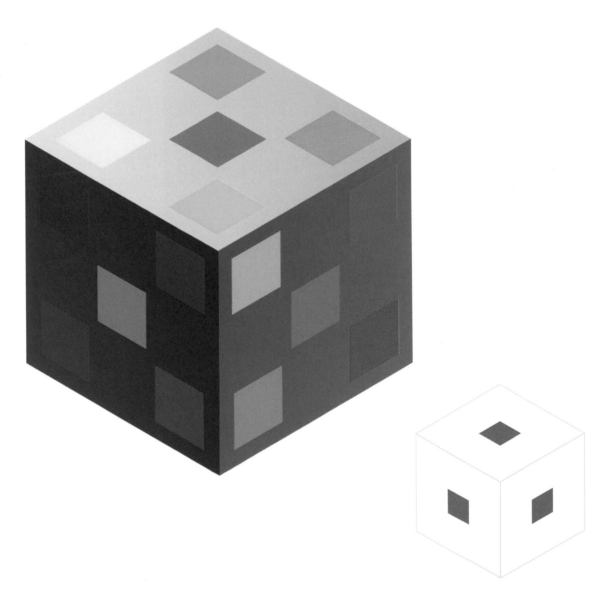

Shadow Color Illusion. Undated.

The gray squares at the center of each side of the cube appear to have different levels of luminosity, but are actually the same. The trick is that the other colors on the cube have been made progressively darker on each side. Our eyes perceive the luminosity of a color in relationship to its immediate surroundings.

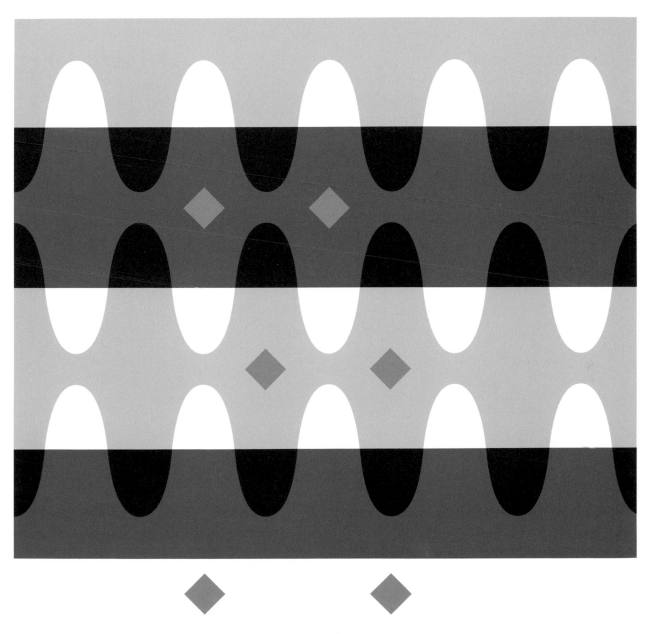

Edward H. Adelson (born 1952). *Snake Illusion*. Undated.
The diamonds in the top row appear to be lighter than the ones in the bottom row,
but they are actually the same shade of gray.

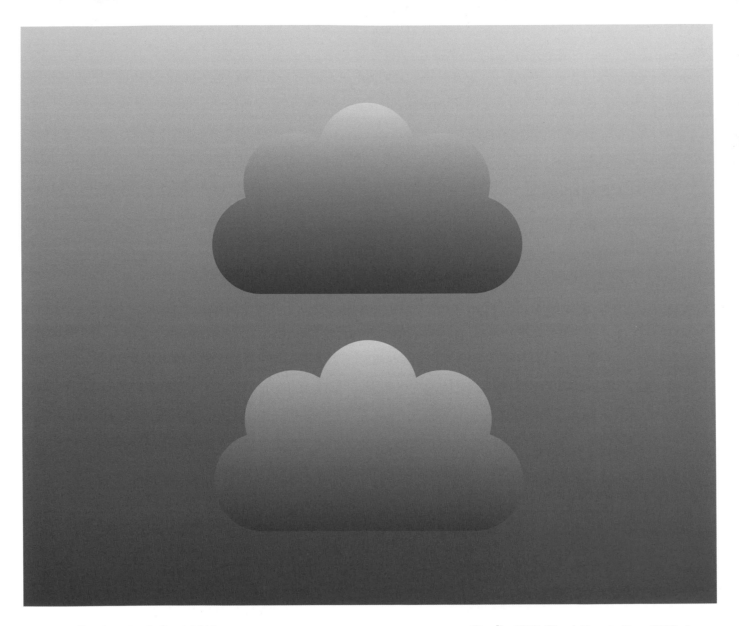

Studio PBD. *Dark Cloud*. 2012.
The upper cloud appears to be darker than the
lower one because of the shifting luminosity of
the background. In fact, both clouds are the same.

Studio PBD. *Tête à Fleur in Lines*. 2012. ▶
These two profiles have the same "skin" tone.
The apparent difference is due to the same color
being viewed in contrast to black or white.
You can verify this by looking at the continuous
tan strips at the top and bottom of the page.

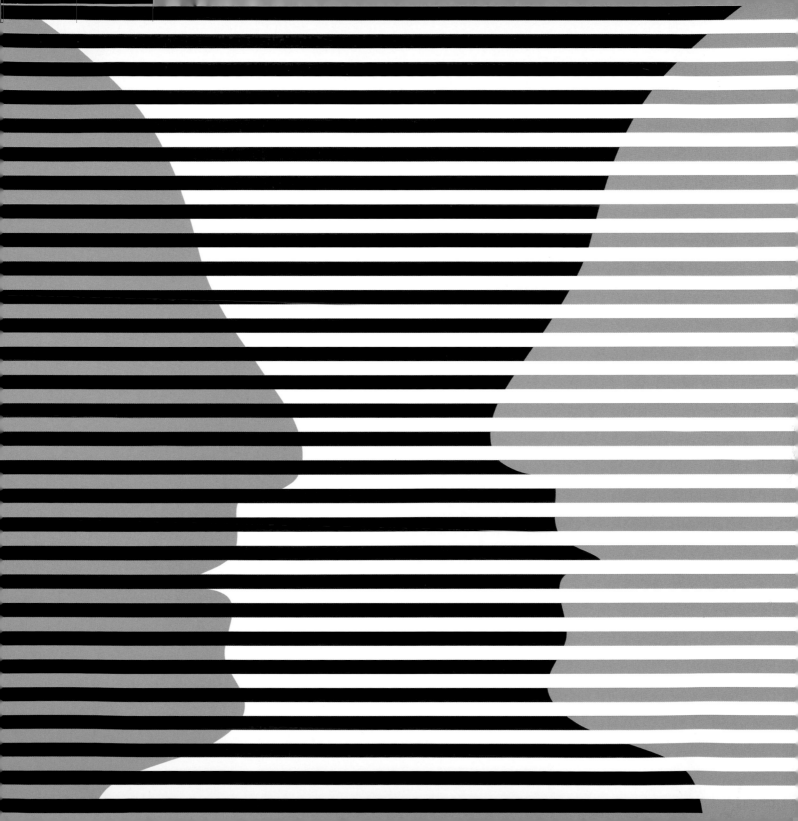

Studio PBD. *Color Blindness Test* (variation). 2011.

• *Can you read the numbers in these four circles? If you are color blind, you may not be able to see all of them.*

Studio PBD. *Anderson and Winawer Lightness Illusion*. 2012.
The same disc appears to be lighter or darker, depending on the luminosity of the area that surrounds it.
This image is based on an illusion devised by the psychologists *Barton L. Anderson* and *Jonathan Winawer*, 2005.

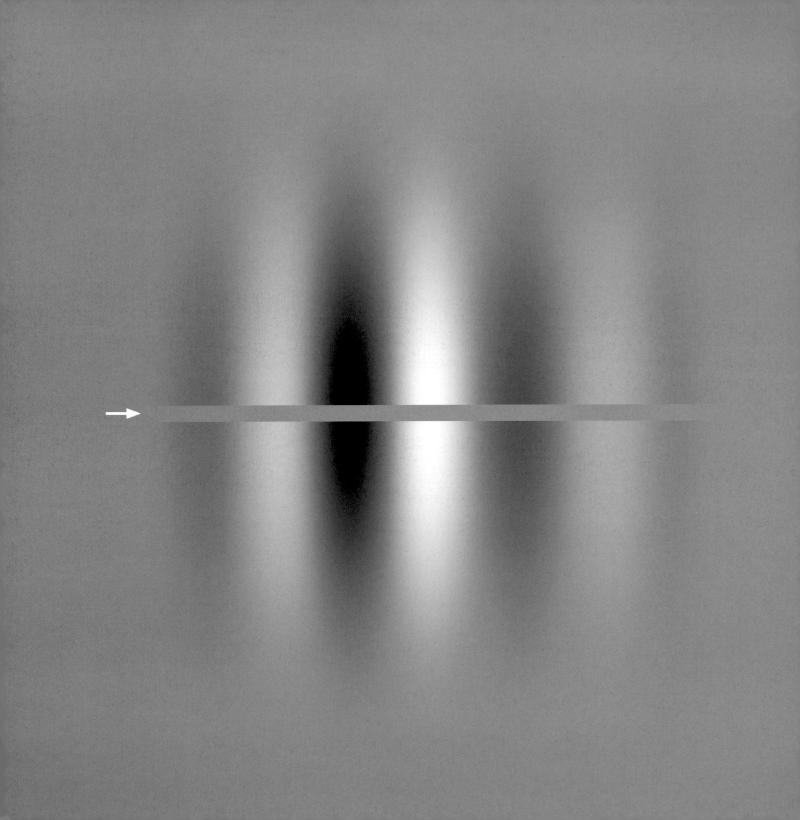

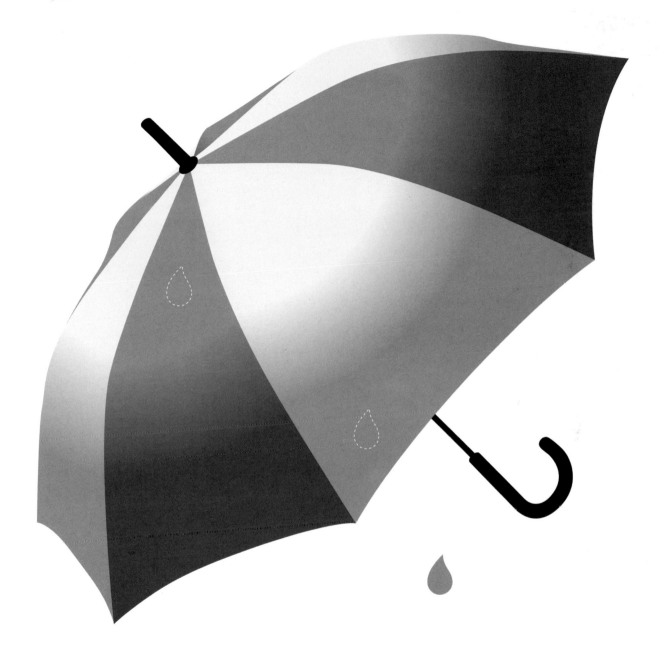

◄ *Gray bar*. Undated.

• *Stare at the light gradients in the background,*
then focus on the gray bar. Do you see gradient shades in the gray bar?
Don't trust your eyes! The bar is a solid gray.

Studio PBD. *Umbrella Shade*. 2012.
The raindrops on the umbrella are the same
grey tint even though the one on the white
panel appears to be lighter.

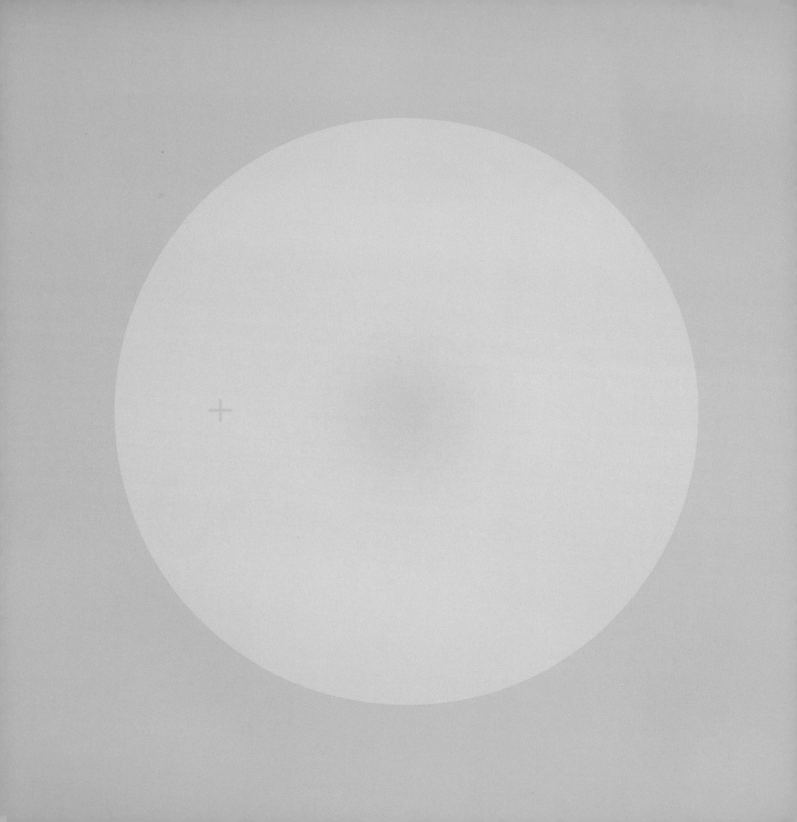

◀ *Troxler's Fading*. Undated.
• *Stare at the cross for about ten seconds and the green-blue haze in the center begins to disappear. If you stare even longer, only a light field of green will remain.*
The physician *I. P. V. Troxler*, a friend of Beethoven, observed this phenomenon, also called Troxler's Effect, in 1804.

Troxler's Effect. Undated.
• *Stare at the small dot. The gray haze will get smaller and smaller, and eventually disappear.*
Troxler's Effect is related to our general tendency to lose awareness of stimuli that impinge on our sensory systems and then don't change.

Hermann's Grid. Undated.
• *If you stare at this grid of dark squares, gray spots appear
at the intersections of the white (or light) lines. However, if you
focus directly on one intersection, no spot appears there.*
This phenomenon was observed by the psychologist
Ludimar Hermann in 1870.

Bergen's Grid variation. Undated. ▶
In this grid, black spots appear to flash in the
white circles. This illusion was first observed
by *J. R. Bergen in 1985.*

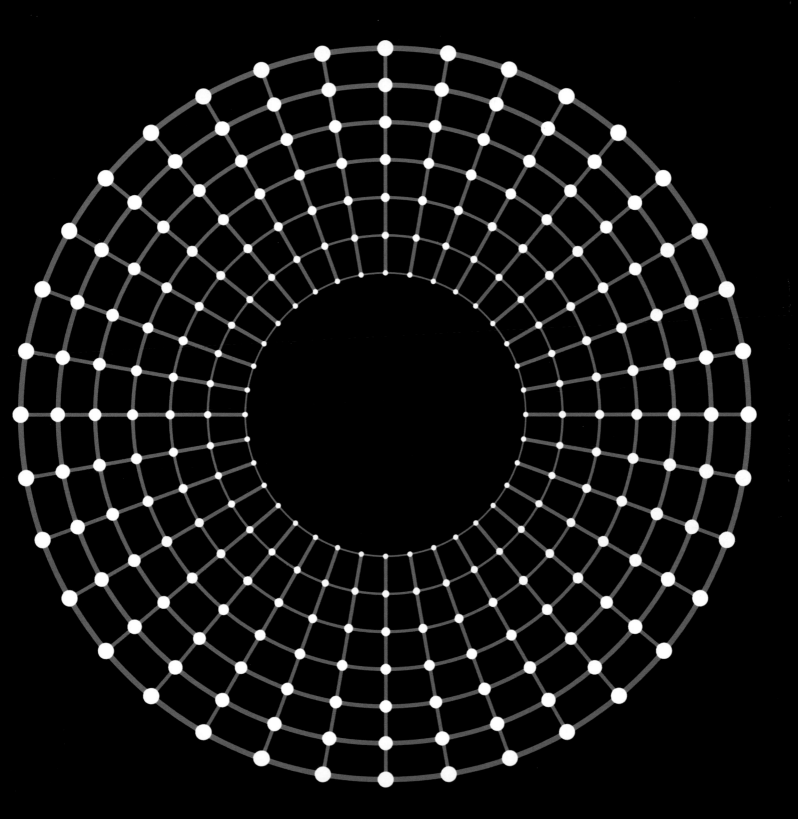

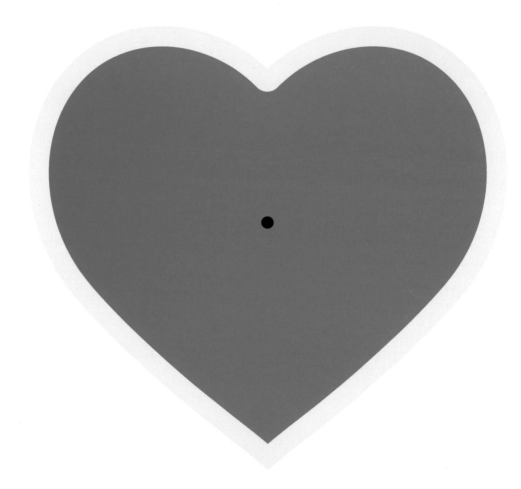

Negative Heart. Undated.
• *Stare at the black dot in the middle of the heart for thirty seconds.*
Then look at a white surface. What colors do you see?
This is called a negative afterimage.

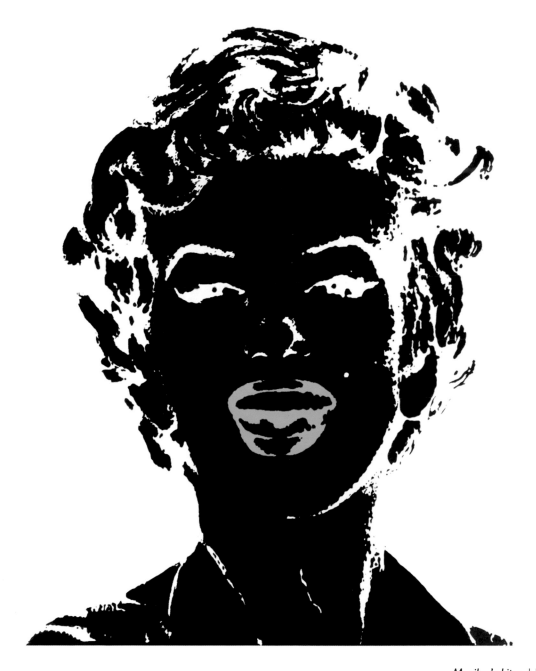

Marilyn's Lips. Undated.
• *Stare at the middle (the lips) of this image for thirty seconds. Then look at a white surface. What do you see?*

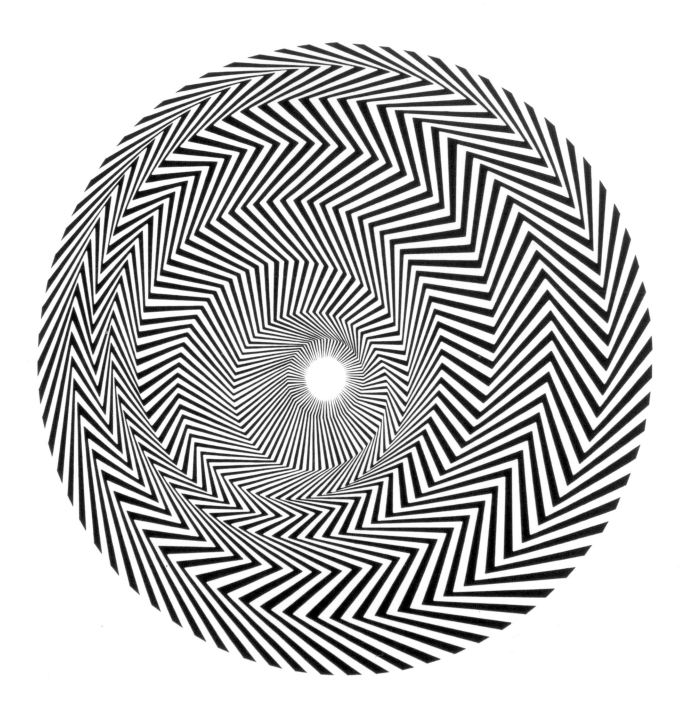

Bridget Riley (born 1931). *Blaze.* 1964.

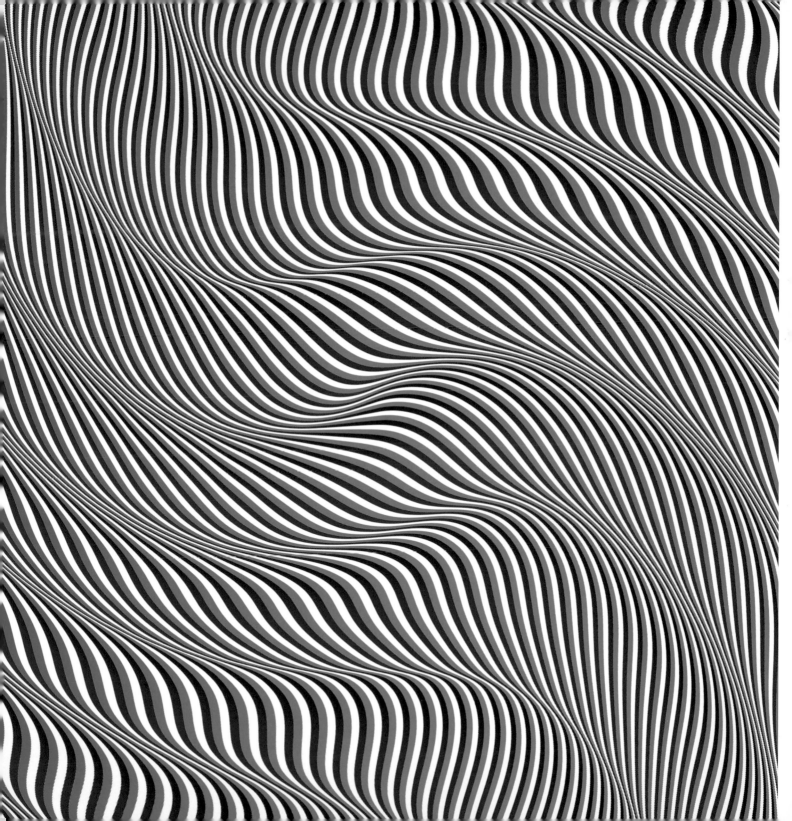

◄ **Studio PBD**. *Riley's Waves*. 2011.
(Tribute to Bridget Riley, *Cataract 3*, 1967.)

Akiyoshi Kitaoka. *Warp 4*. 2003.
The dark bands appear to pulsate.

Leviant's Enigma. Undated.
In this illustration based on a well-known painting by *Isia Leviant* called **Enigma** (1981), most viewers perceive a rapid flowing movement in the concentric colored circles. Researchers believe they have traced the illusion to tiny involuntary eye movements called microsaccades.

Floating square. Undated. ▶
The box of squares appears to be on a plane in front
of the spots and can be made to "slide" against the
background when you move your head.
The sliding motion illusion was discovered
by *Baingio Pinna* and *Lothar Spillman* in 2002.

MacKay Rays variations. Undated.
The radial lines in MacKay Rays appear to shimmer,
a phenomenon first observed by neuroscientist
Donald M. MacKay in 1957.

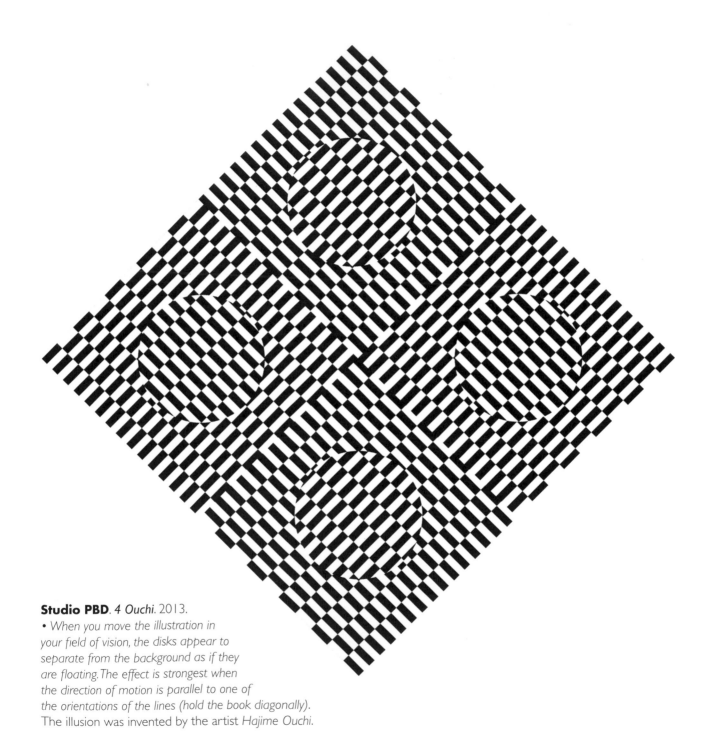

Studio PBD. *4 Ouchi*. 2013.

• *When you move the illustration in your field of vision, the disks appear to separate from the background as if they are floating. The effect is strongest when the direction of motion is parallel to one of the orientations of the lines (hold the book diagonally). The illusion was invented by the artist Hajime Ouchi.*

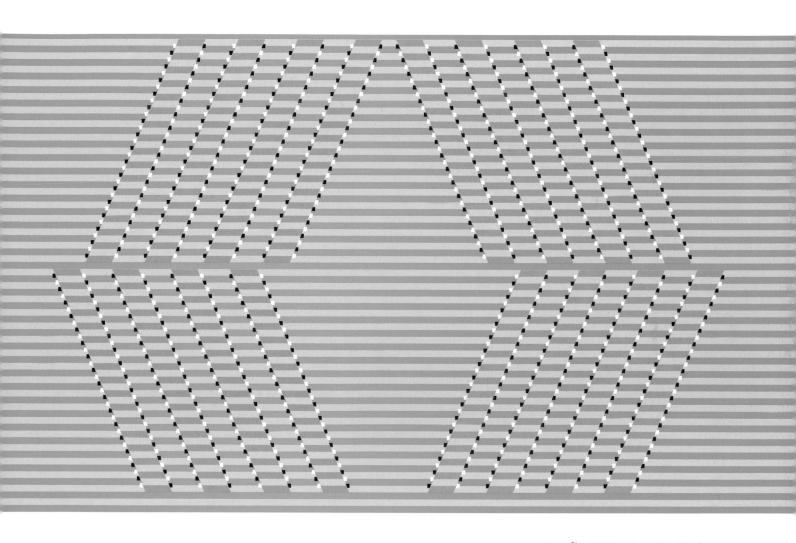

Studio PBD. *Waterside*. 2013.

Akiyoshi Kitaoka. *Naruto Spirals*. 2009. ▶
The apparent spirals are actually concentric circles.
• *Experiment with making them rotate by moving the image. (See also page 266.)*

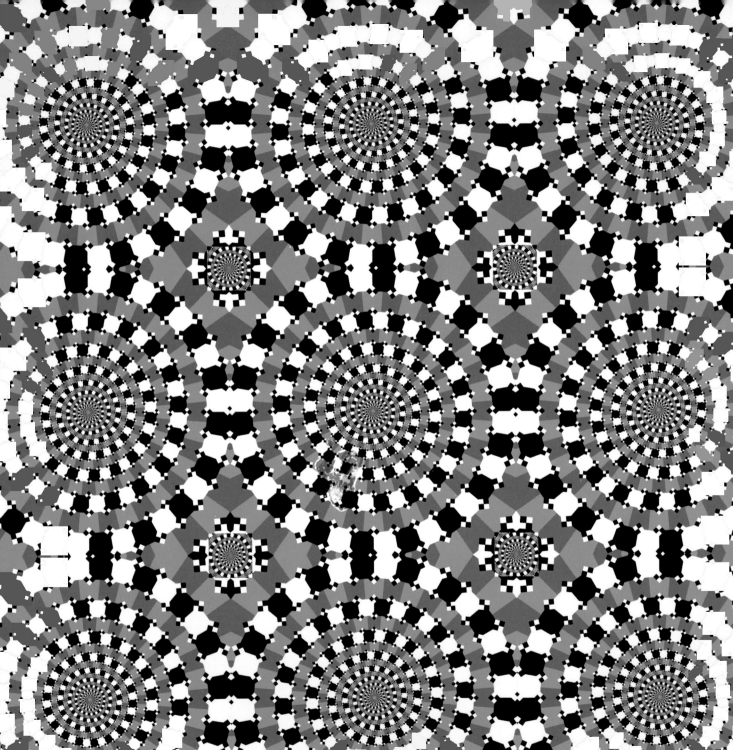

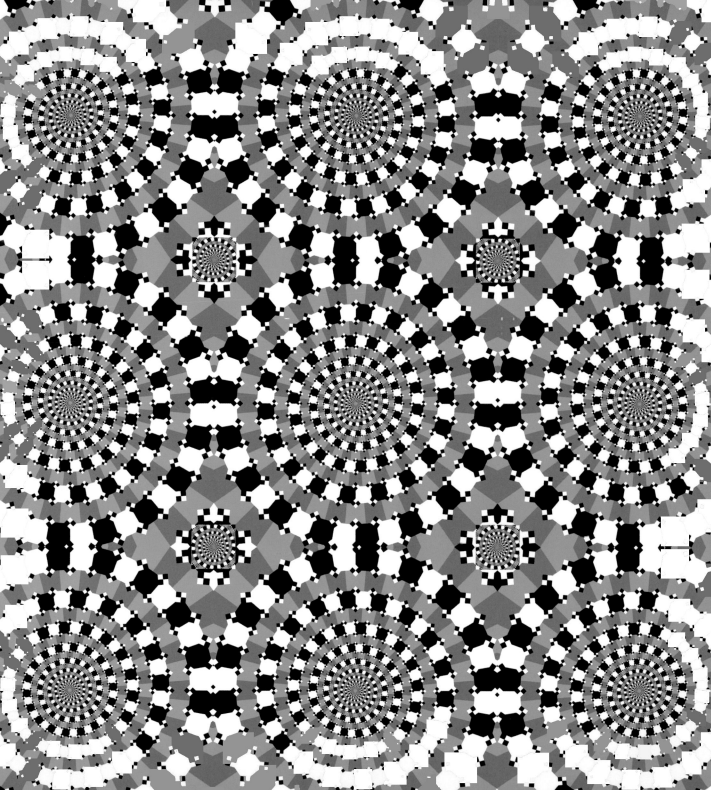

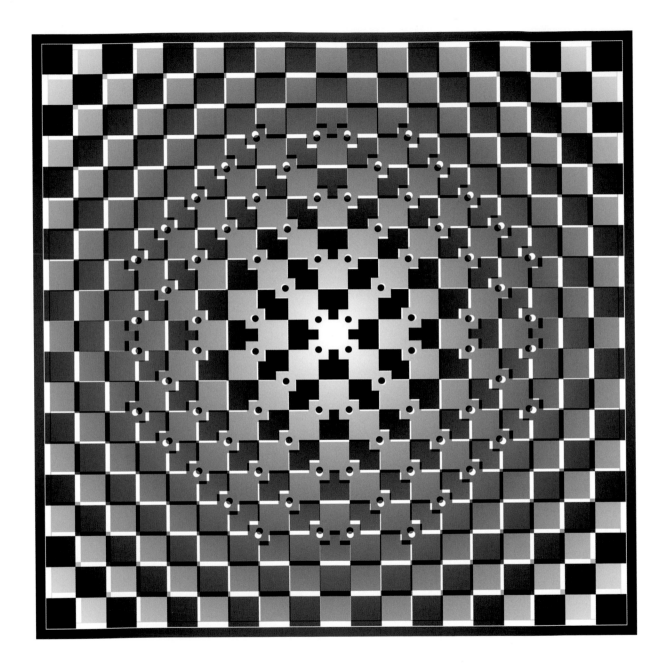

Akiyoshi Kitaoka. *Metallaunch*. 2008.
The primary illusion is a geometrical transformation: the center appears to swell to a dome even though the grid is precisely orthagonal. For some viewers, the dome even appears to expand and contract.

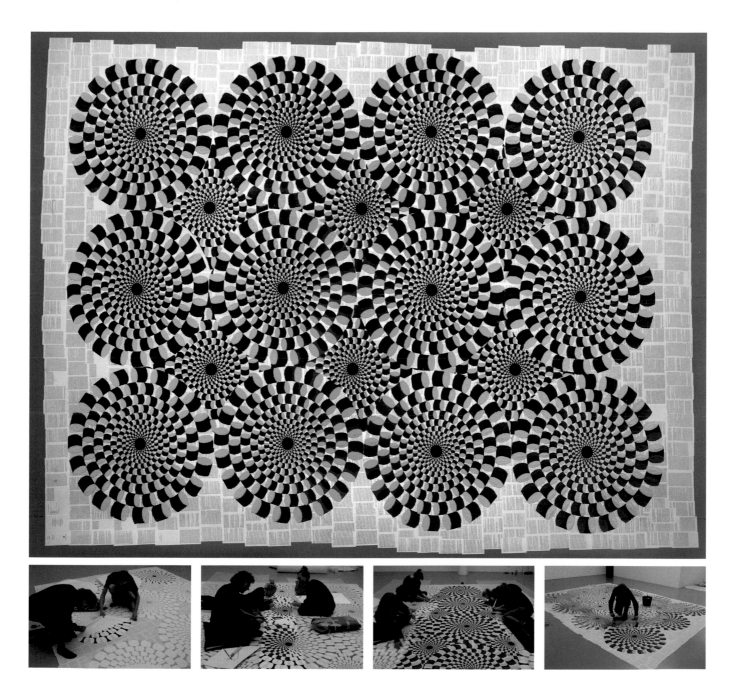

Job Koelewijn (born 1962). *The Nursery Piece*. 2009.
This installation incorporating sand, pigment, eucalyptus, and texts by Spinoza was inspired
by Akiyoshi Kitaoka's *Rotating Snakes*, 2003.

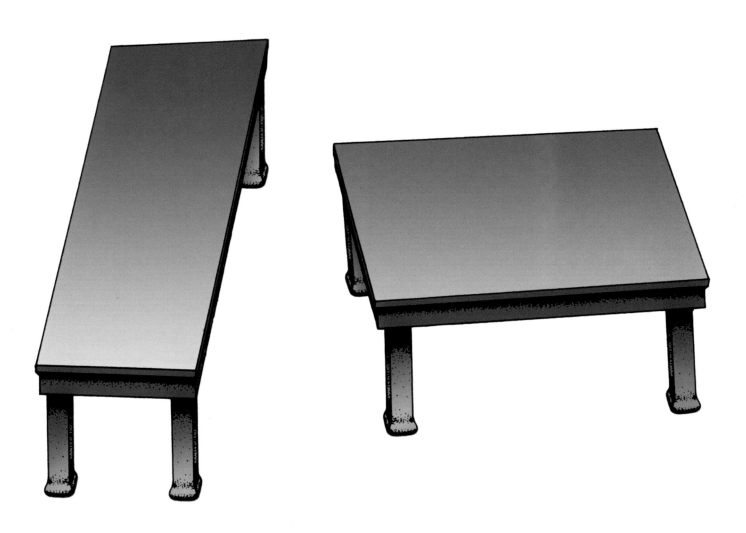

Shepard's Tabletops. Undated.
According to the carpenter, these two tabletops in an illusion invented by *Roger N. Shepard* (**Turning the Tables**, c. 1990) are exactly the same size and shape. Our depth perception tricks us into seeing them as extremely different.

Estimated Sizes, Image Distortions, and Geometric Illusions

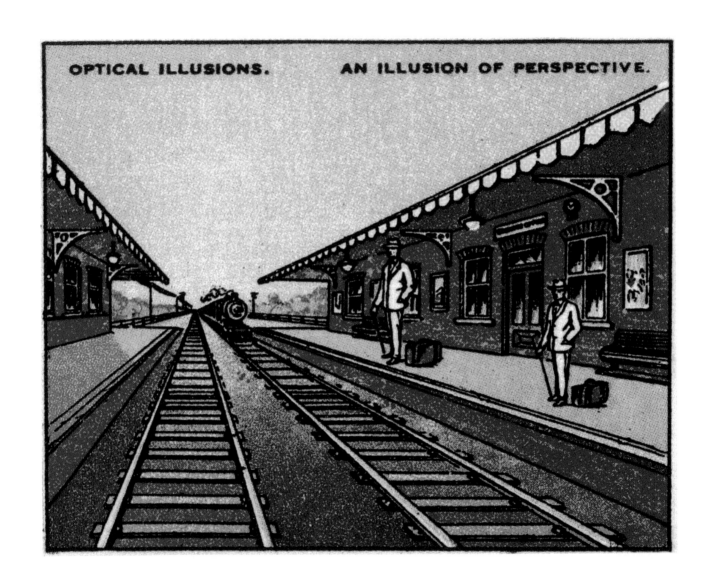

Optical Illusions: An Illusion of Perspective. From a cigarette-card series, 1926.

• *Which man is taller? (You'd better measure to be sure.)*

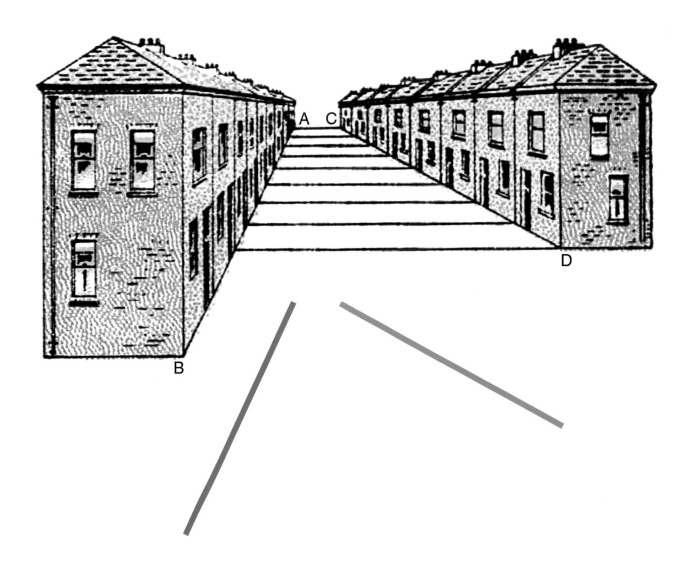

Deceptive by Perspective. From Ogden's Optical Illusions cigarette-card series, 1923.
• *Which is longer: A to B or C to D? (Measure to be sure.)*

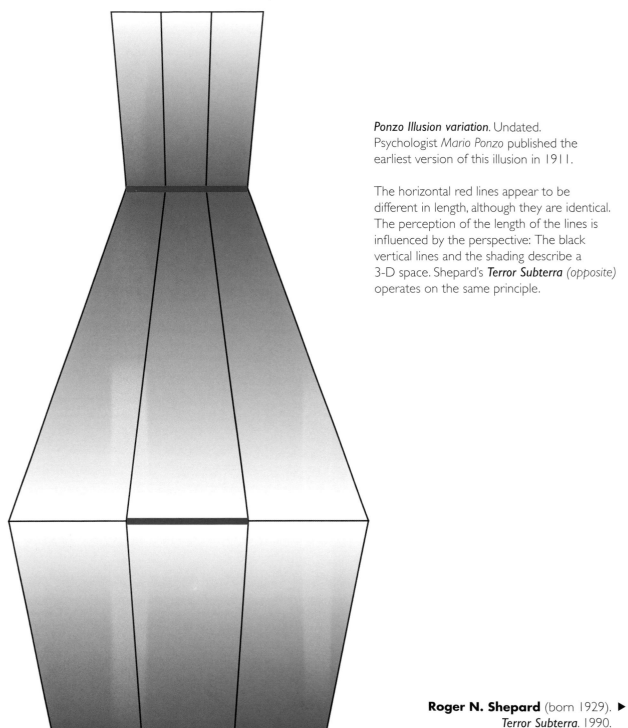

Ponzo Illusion variation. Undated. Psychologist *Mario Ponzo* published the earliest version of this illusion in 1911.

The horizontal red lines appear to be different in length, although they are identical. The perception of the length of the lines is influenced by the perspective: The black vertical lines and the shading describe a 3-D space. Shepard's **Terror Subterra** *(opposite)* operates on the same principle.

Roger N. Shepard (born 1929). ▶
Terror Subterra. 1990.

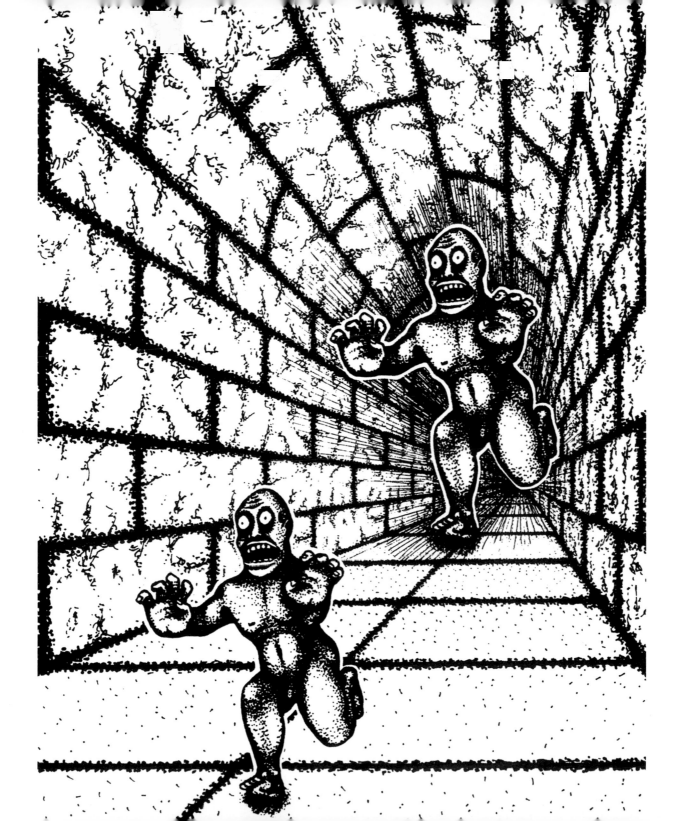

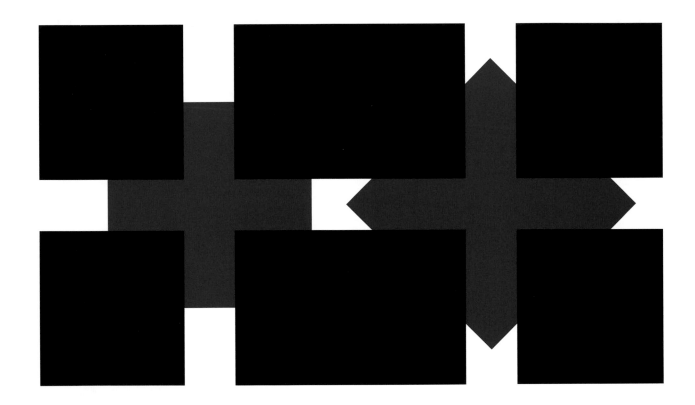

Square illusion. Undated.
The red squares appear to be different sizes.

• *But are they?*

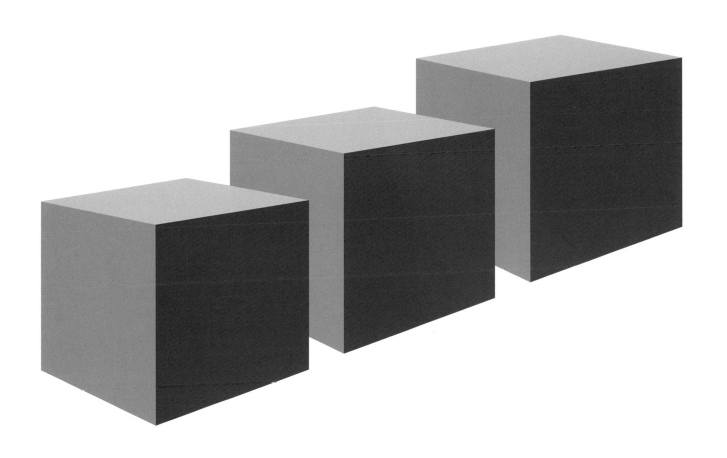

Deceptive Blocks. Undated.
• *Which box is the largest? (Measure to be sure.)*

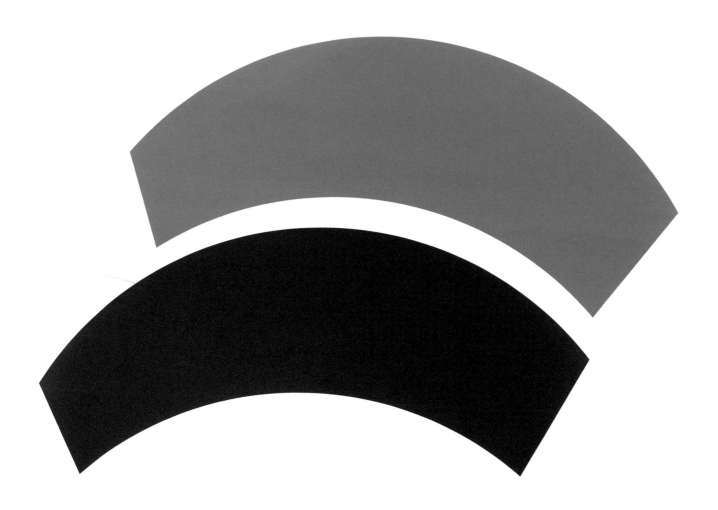

Jastrow Illusion. Undated.
Psychologist *Joseph Jastrow* discovered this illusion in 1889.
The upper shape appears to be smaller than the lower shape, because we compare the shorter side of the former with the longer side of the latter. The illusion persists even when the shapes are centered over one another.
It immediately disappears when one of the shapes is rotated 180 degrees.

Stretching the line. Undated.
• *Make a quick guess: Are all the horizontal lines the same length?*
(Measure to find out.)

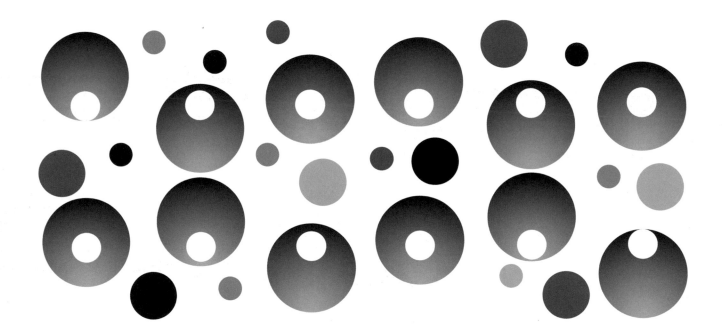

Image distortion illusion. Undated.
• *Are the white circles perfectly aligned in two rows?*
Our perception is influenced by their positions in the larger dark circles.

Poggendorf Illusion variations. Undated. ▶
In 1860, Physicist *Johann Christian Poggendorff* discovered that we misperceive the position of lines in certain circumstances.

Figures at top:
• *Are the colored lines aligned or not?*
Figures at bottom:
• *Can you make a perfect blue square and a yellow circle by completing the missing blue and yellow lines?*

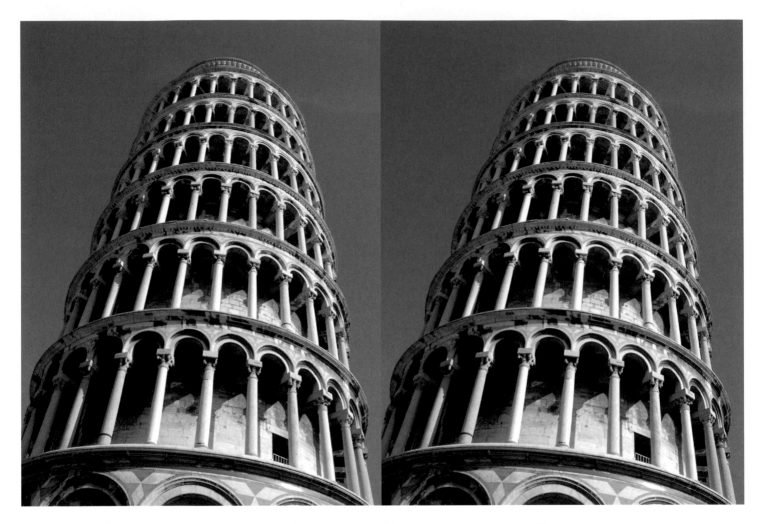

F. Kingdom (born 1953), with **A. Yoonesi** and **E. Gheorghiu**. *Leaning Tower Illusion*. 2007.
• *Is one version of the Leaning Tower of Pisa leaning more to the right than the other?*
Actually, the two images of the Leaning Tower of Pisa are identical, yet the tower on the right appears to lean more. This is because our visual system treats the two images as if part of a single scene. When confronted with two towers whose corresponding outlines are parallel, the visual system assumes they must be diverging as they rise.

Hidden pentagram picture puzzle. Undated. ▶
• *Search for a five-pointed star.*
(Solution on page 319.)

Studio PBD. *LottoLab Object Angles*. 2013.

Neuroscientist *R. Beau Lotto* discovered this illusion. • *Are the angles formed by these objects different?* Actually they're all 90 degrees. You can check with the corner of a piece of paper. Again, we are fooled by our depth perception into seeing these angles as being extremely different.

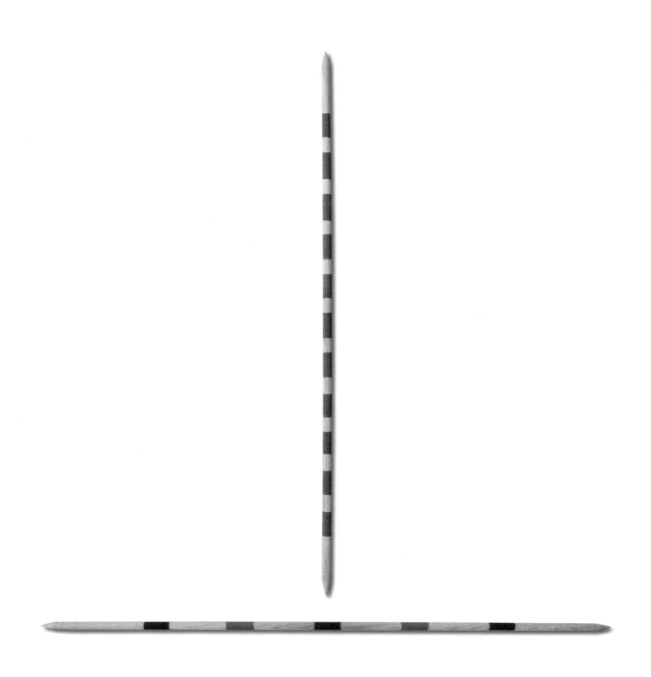

Studio PBD. *Longest Mikado Stick*. 2009.
• *Is one of the sticks longer? Guess which one it is, and then measure to check. Surprised?*
The T-illusion says that for two identical lines in this configuration, we will overestimate the length of the vertical one.

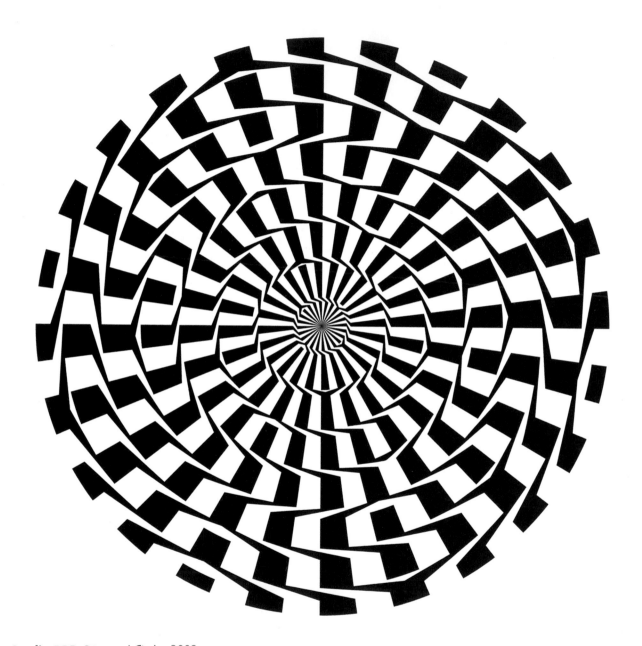

Studio PBD. *Distorted Circles*. 2009.

• *Are these concentric circles or spirals?*

Psychologist *Sir James Fraser* discovered this illusion in 1908, when he filled the circular paths in his design with line fragments that were out of alignment with the circles. A similar principle underlies the café-wall illusion. *(See page 272.)*

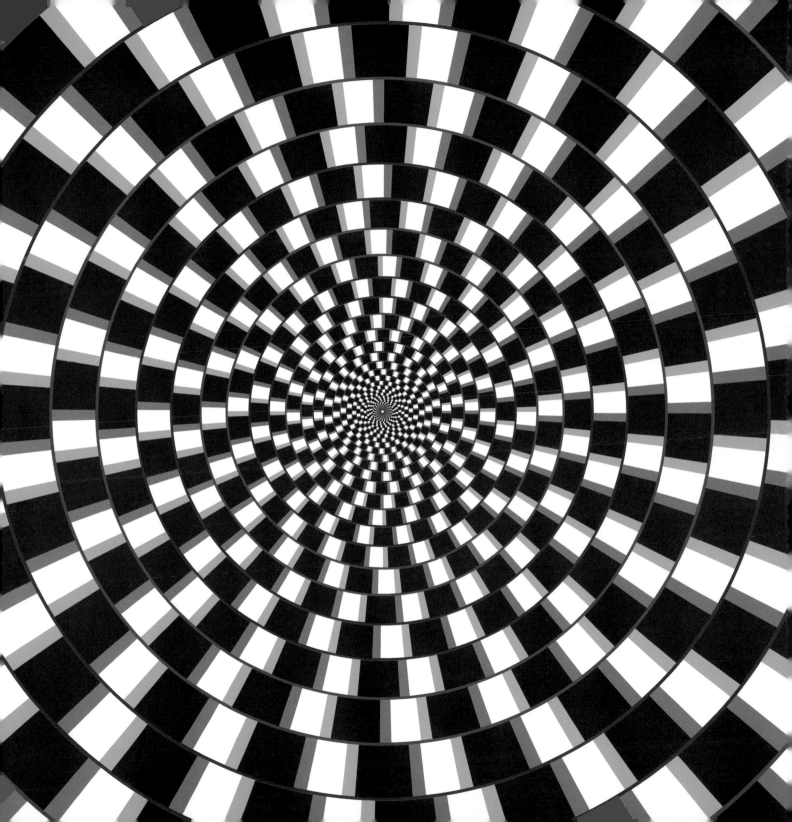

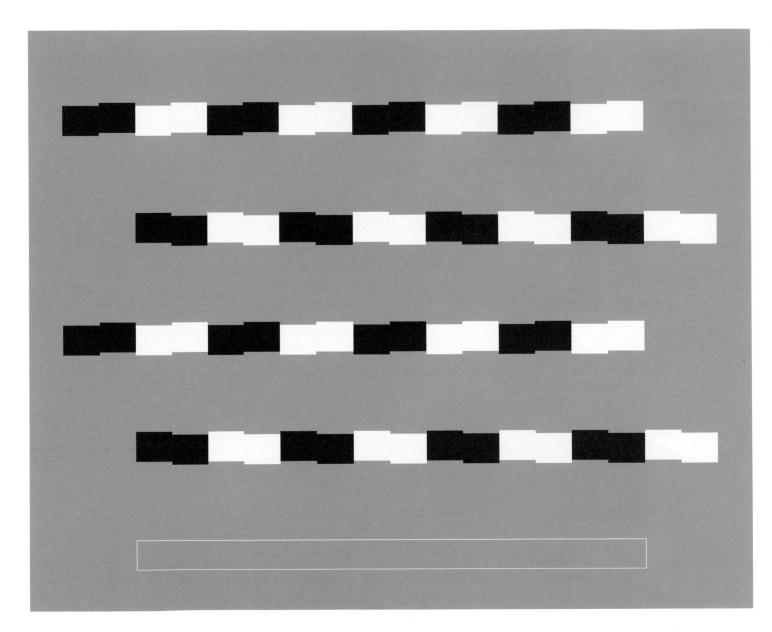

◄ **Studio PBD**. *Twisted Circles*. 2013.
A phantasmagoria of concentric circles inspired by the work of *Akiyoshi Kitaoka*, *Baingio Pinna*, and *Gavin Brelstaff*, 2001, this illustration combines the Fraser and café wall illusions.

Studio PBD. *Tilting the Beams*. 2011.
After *Kitaoka*, *Brelstaff* and *Pinna*:
Illusion of shifted edges. 2001, 2004.
• *Are these rows parallel?*

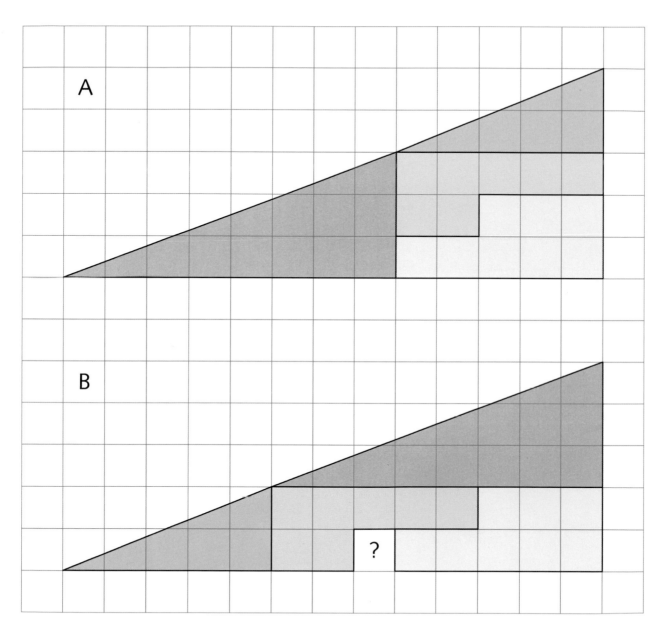

A

B

?

Missing square puzzle. Undated.
Shapes A and B appear to be the same size and have identical parts.
• *So how do we explain the missing square in B?*
Hint: *Place a straight edge against the long side of each one . . . and think hard.*
Are A and B the triangles that they appear to be?

271

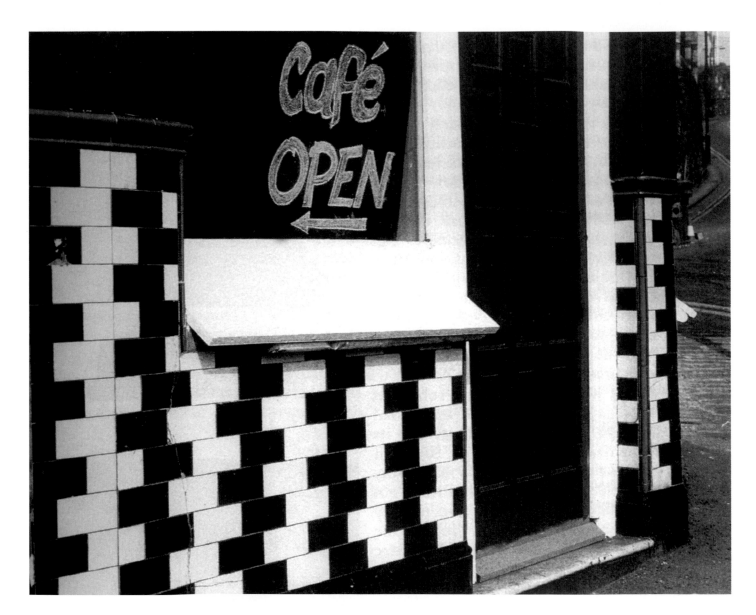

Café wall, Bristol, England.
The mortar lines between the tile courses are parallel in spite of appearances. The famous café-wall illusion is a variation of the shifted-chessboard or Münsterberg illusion, 1897, in which the lines between the rectangles are black instead of gray. *(See page 16.)*

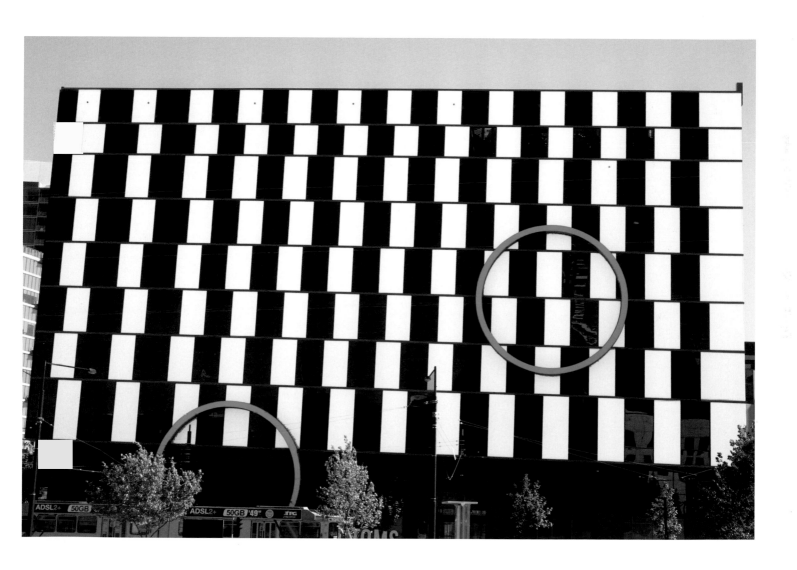

Ashton Raggatt McDougall (ARM Architects). *Customs House*, Melbourne, Australia. 2007.

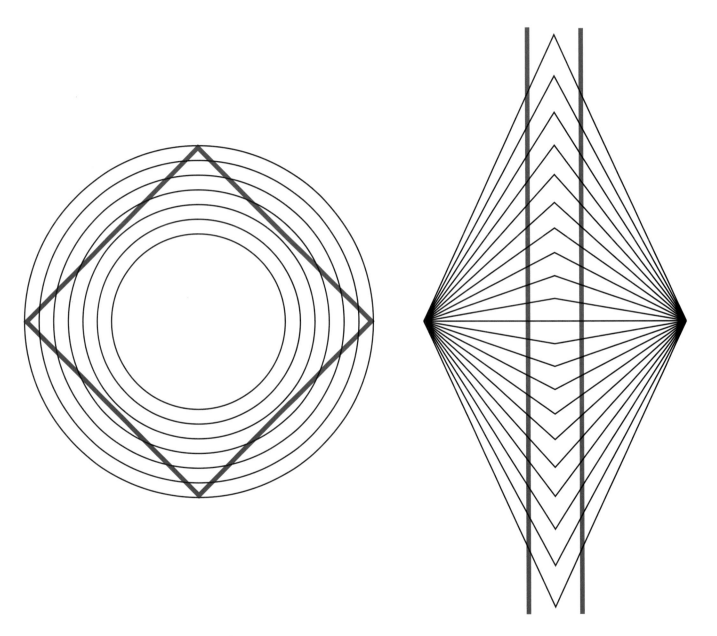

Studio PBD. *Bent Lines Illusion*. 2013.
In the Wundt Illusion, discovered by psychologist *Wilhelm Wundt* in the nineteenth century,
the straight lavender lines appear to be curved inward, an illusion created by the pattern of lines behind them.

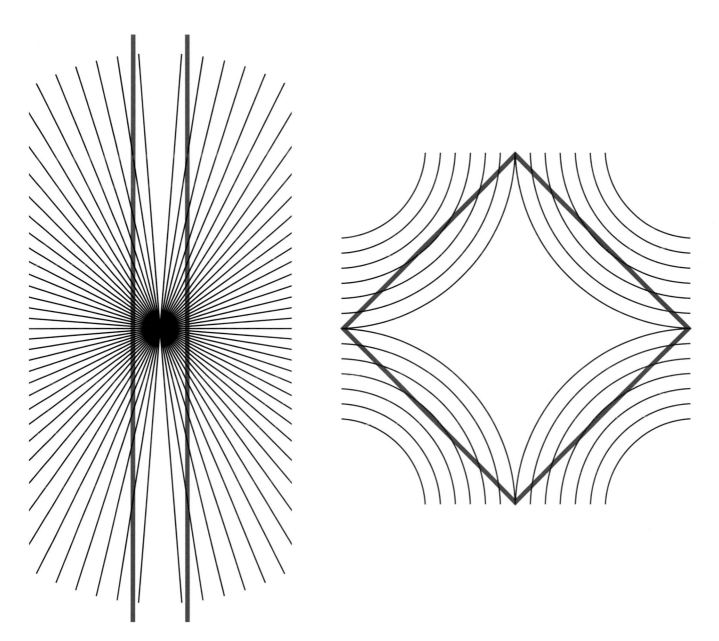

Studio PBD. *Bent Lines Illusion*. 2013.
Physiologist *Ewald Hering* discovered the Hering Illusion in 1861:
The pattern of black lines has the reverse effect on the straight lavender lines to the Wundt Illusion.

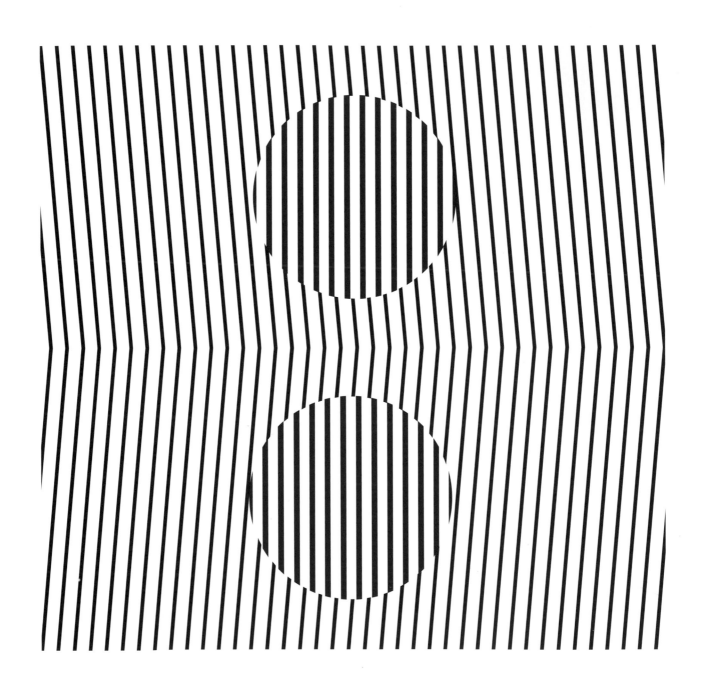

Tilt variation. Undated.
The red lines are parallel from one circle to the other.

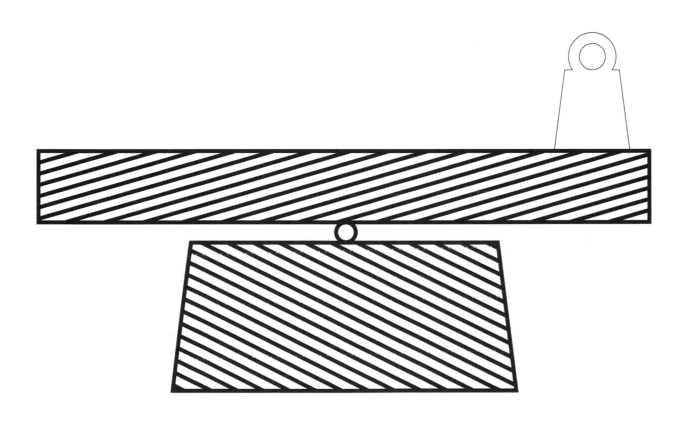

Studio PBD. *Variation of the Zöllner Illusion*. 2013.
The beam appears to be tilted downward on the right side.

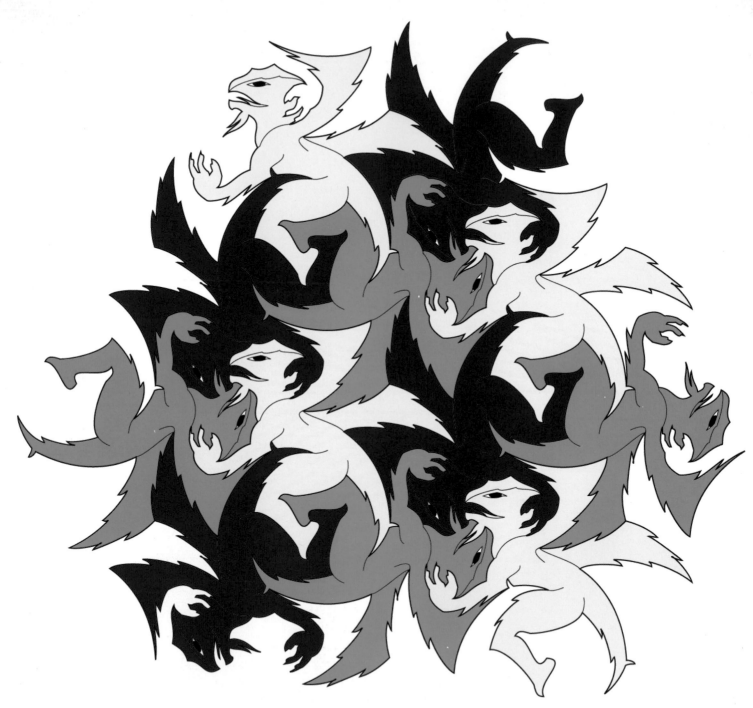

Hollister "Hop" David (born 1955). *Dragons*. 2002.
Tessellation inspired by M. C. Escher.

Tessellations
and Illusions of Depth
and Distance

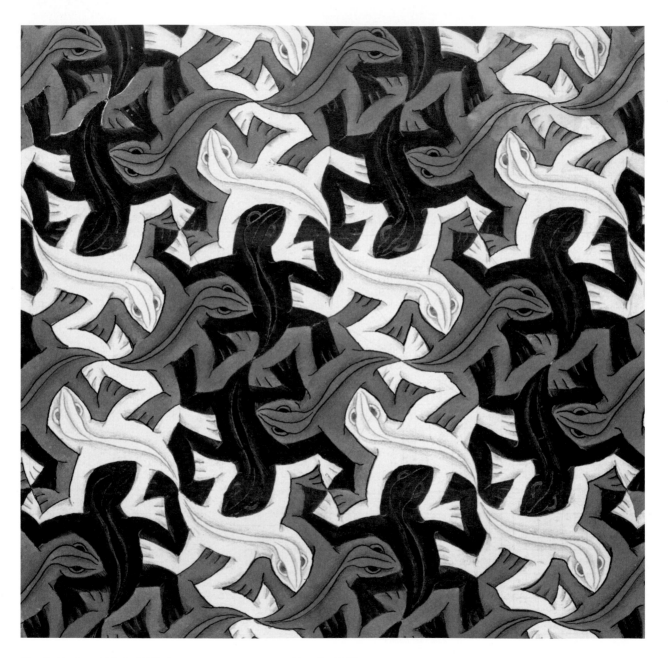

M. C. Escher (1898–972). *Symmetry Drawing E56* (detail). 1942.

M. C. Escher. *Smaller and Smaller*. 1956. ▶

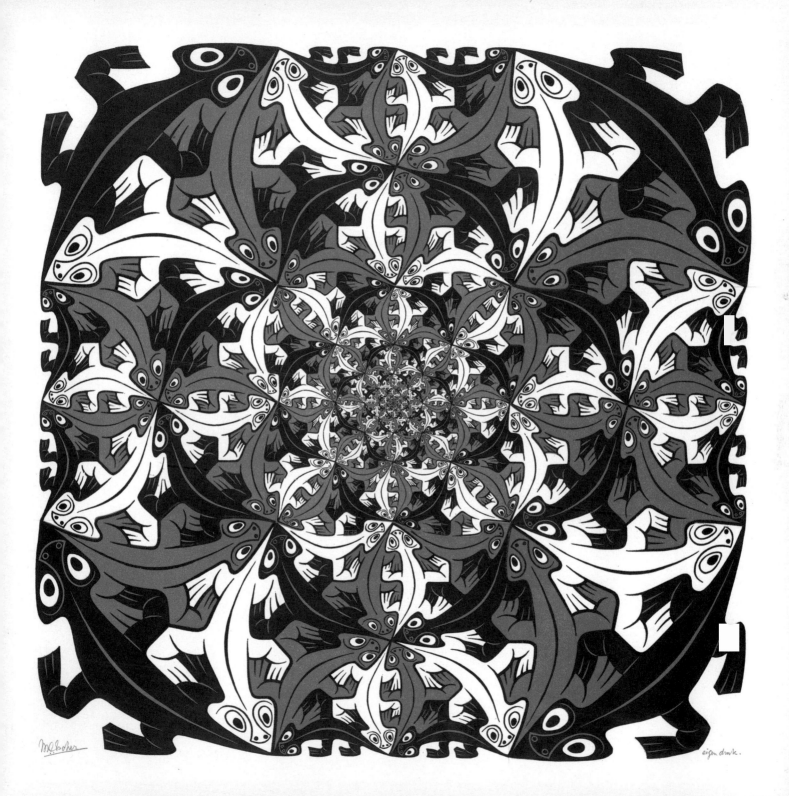

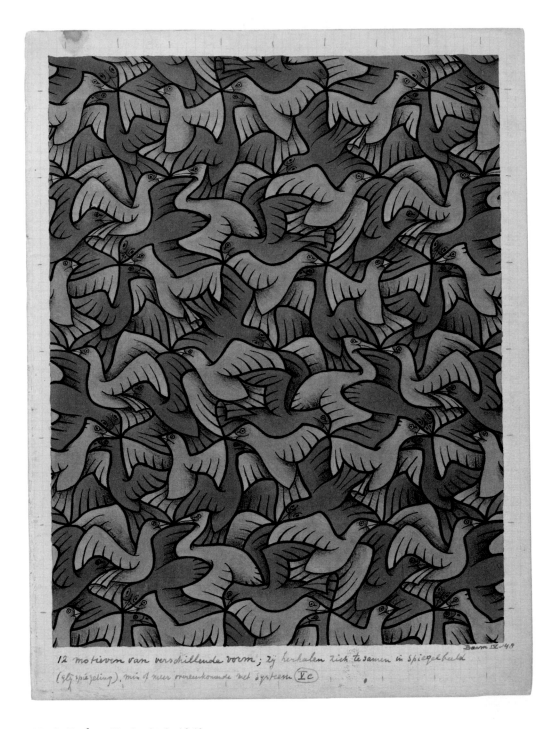

M. C. Escher. *Twelve Birds*. 1948.

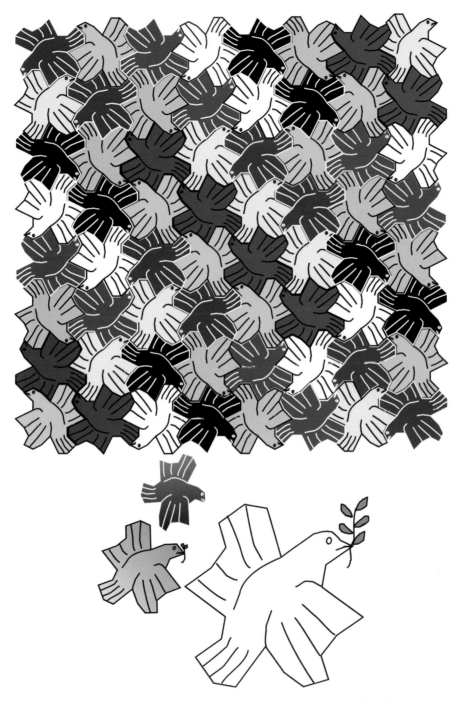

Peter Raedschelders (born 1957). *Peace*. 2009.
Tessellation inspired by M. C. Escher.

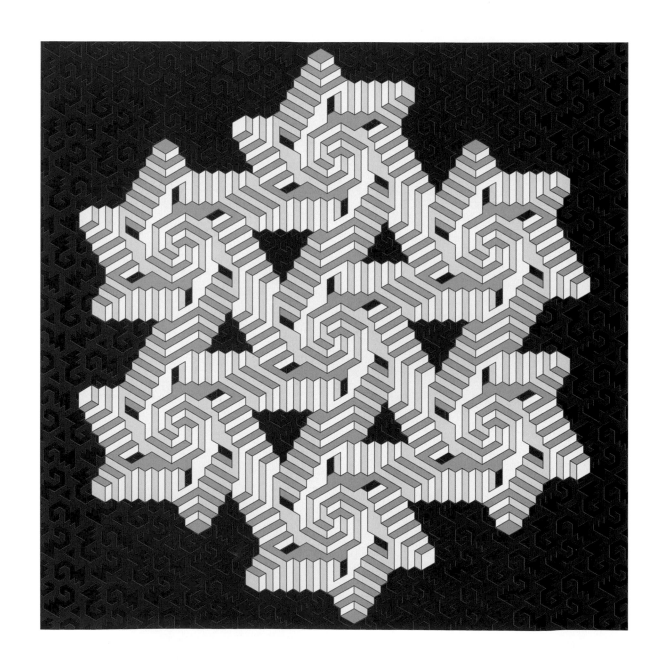

Tamás F. Farkas (born 1951). *Turning the Stairs*. Undated.

Jos de Mey (1928–2007). *Pergola With Pythagoras Trees and Greek Sculpture.* 1985.

Hans Kuiper (born 1946). *Kiss.* 1989.

Peter Raedschelders. *Circle Limit*. 2007.

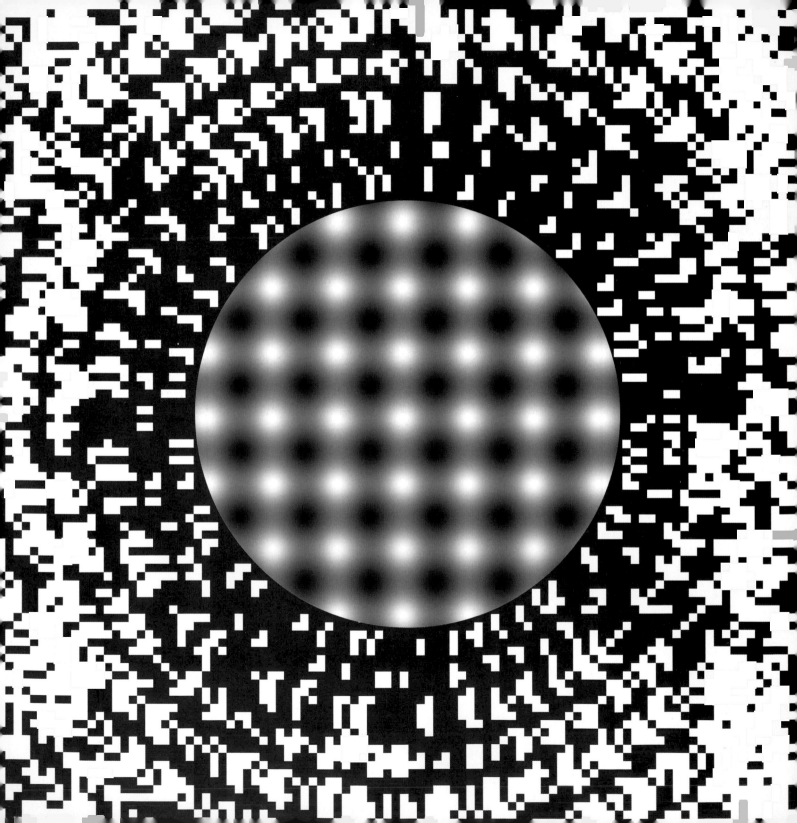

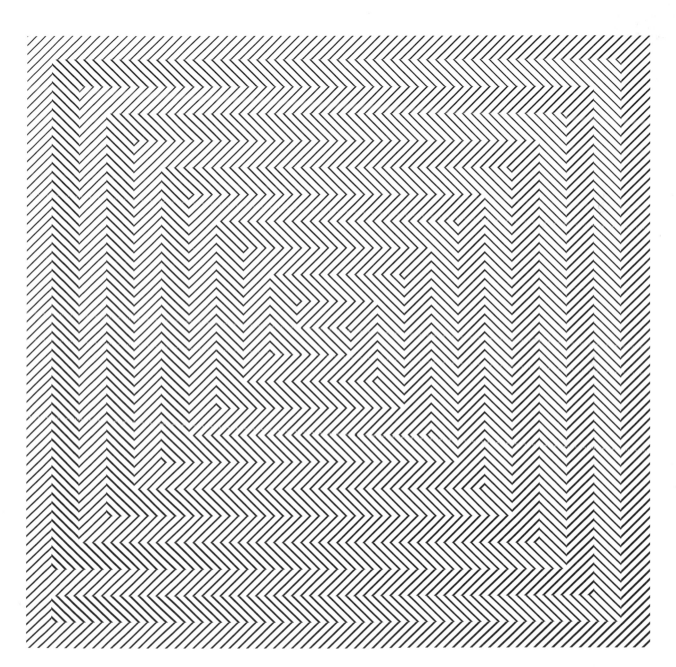

◄ **Studio PBD**. *Kitaoka's Out of Focus*. 2013.
Inspired by Akiyoshi Kitaoka's *Out of Focus*, 2001, this illusion is
similar to the floating square illusion *(page 243)*, but here we
appear to look through a hole into a deeper space.

Studio PBD. *Shaded Relief*. 2013.
3-D effect with illusory dark and light shading.

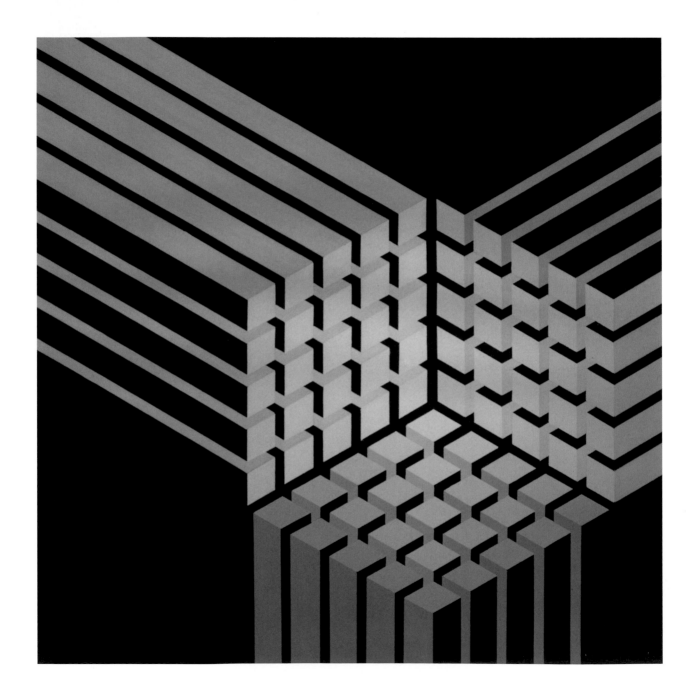

Monika Buch (born 1936). *Untitled*. 1982.

• *Cube or corner?*

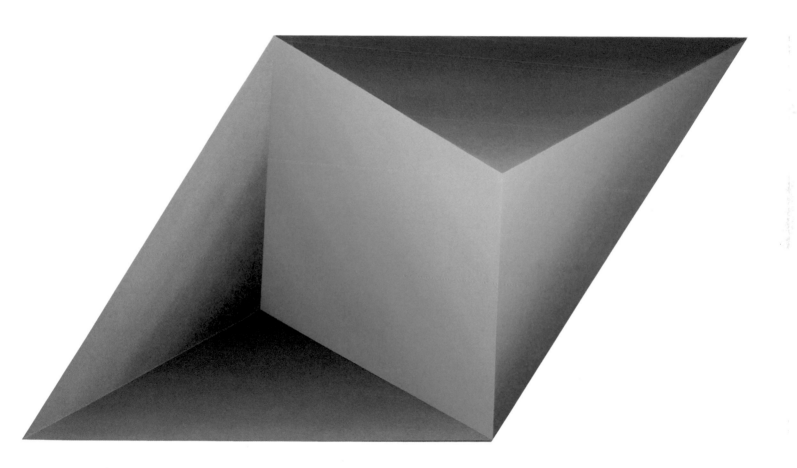

Freek van Ginkel (born 1947). *Inside or Outside of the Cone.* 2002.
• *Are you inside or outside?*

Dejan Todorović (born 1950). *Elusive Arch*. 2005.
• *Two ribs ... or three?*
Todorović's arch is related to the impossible fork. *(See page 68.)*

Freek van Ginkel (born 1947). *Twist*. 2000.

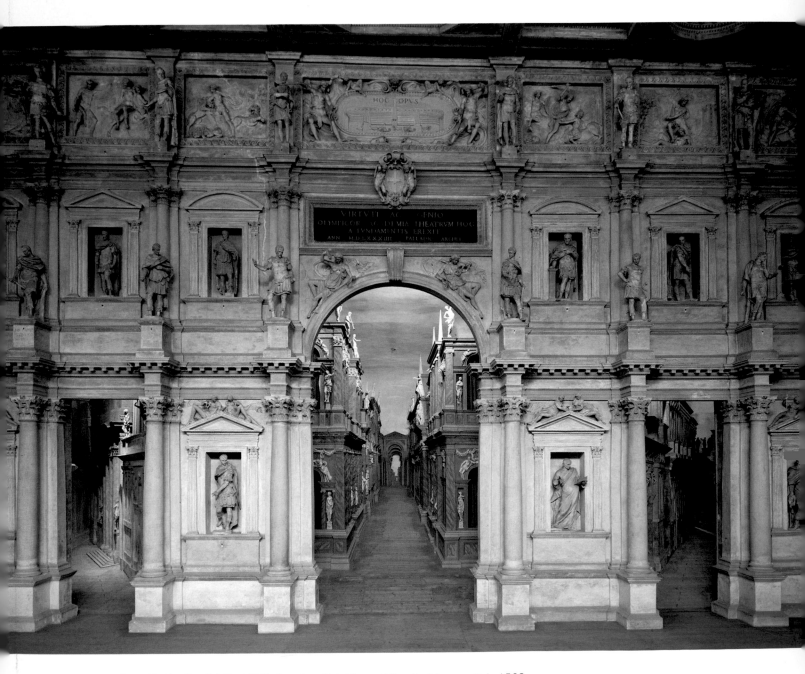

Andrea Palladio (1508–1580). *Interior of the Teatro Olimpico,* Vicenza, Italy, 1589.
The perspective views through the openings are intended to give people in the audience the illusion of long streets disappearing into the distance.

Wrought-iron perspective gate. 1725. ▶

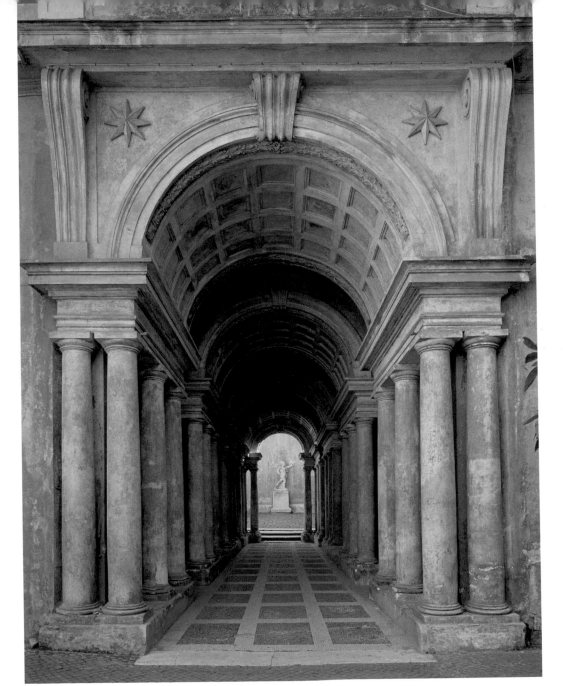

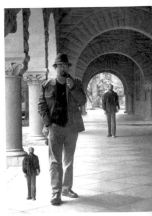

Ponzo Illusion effect.
(See also page 254.)

Francesco Borromini (1559–1667). *Perspective gallery*, Palazzo Spada, Rome.
The arched passageway diminishes in size as it recedes. This construction makes the passageway appear deeper than it is when viewed from the front, and also makes a person standing at the end seem taller than he is.

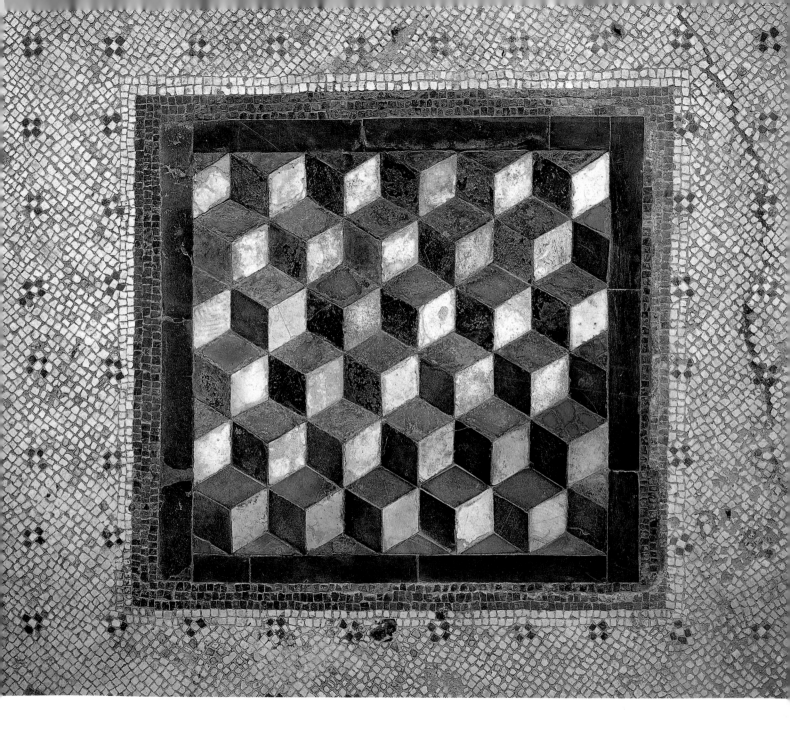

Illusionistic marble floor-mosaic from a room in a Roman villa.

Rotating cubes: concave and convex. Undated.

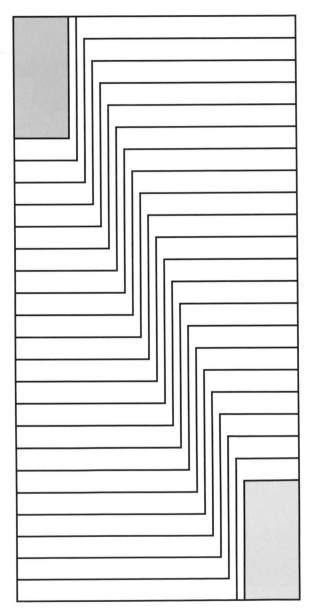

Thiéry's Figure variation. Undated.
• *Where in space is the pink square in relation to the blue square?*
(See also page 211.)

Tessellation: turning cubes inside out. Undated. ▶

302

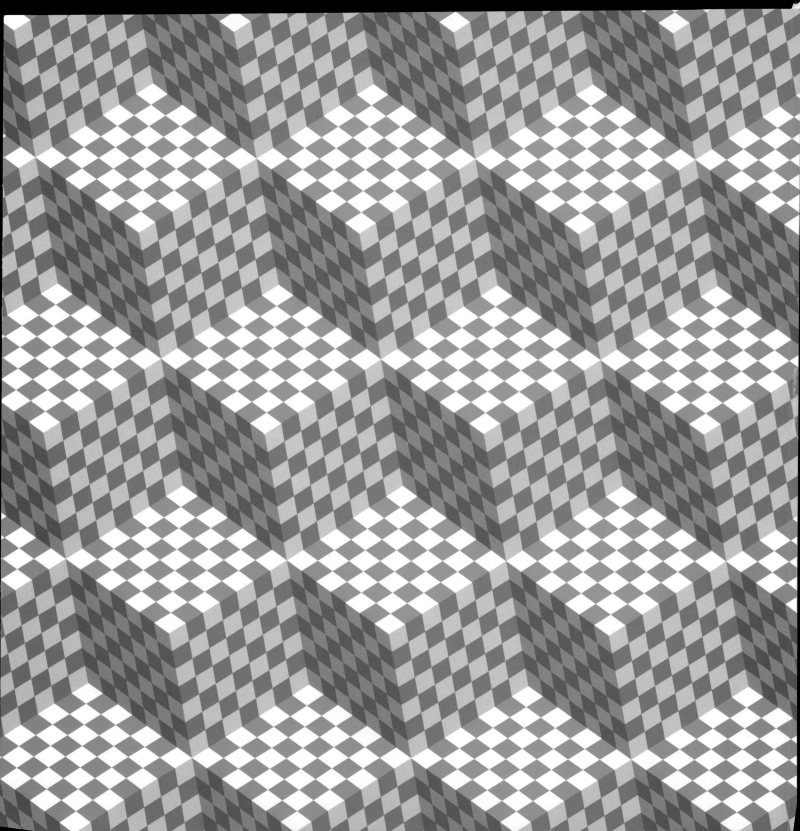

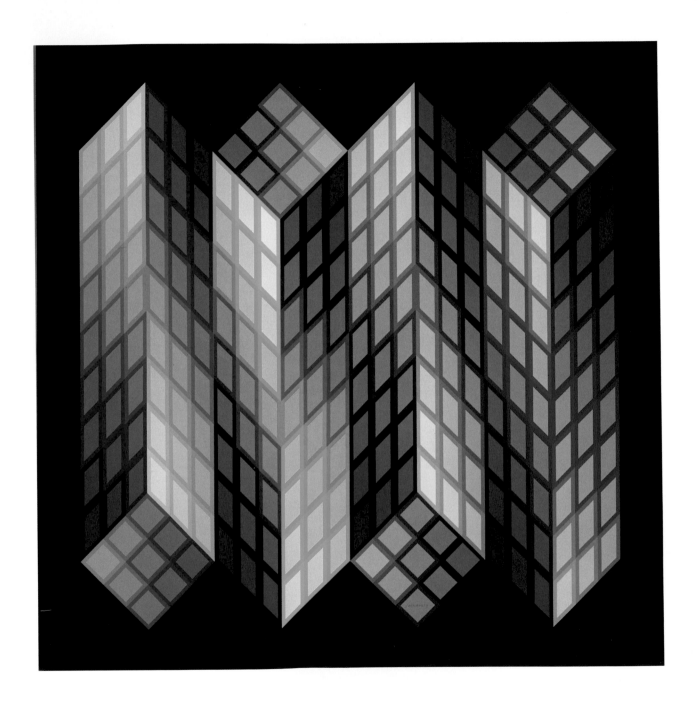

Victor Vasarely (1908–1997). *Toroni-Nagy*. 1969.

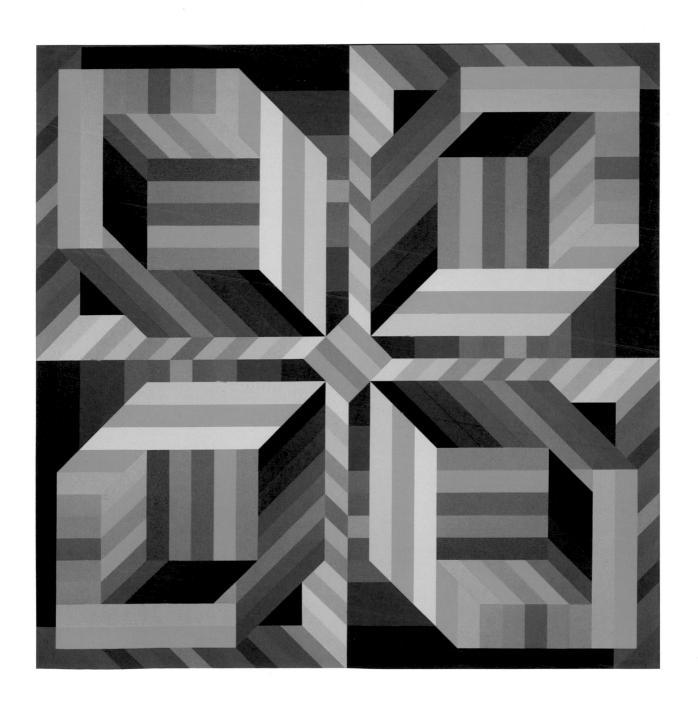

Victor Vasarely. *Kocka Urvar*. 1983.

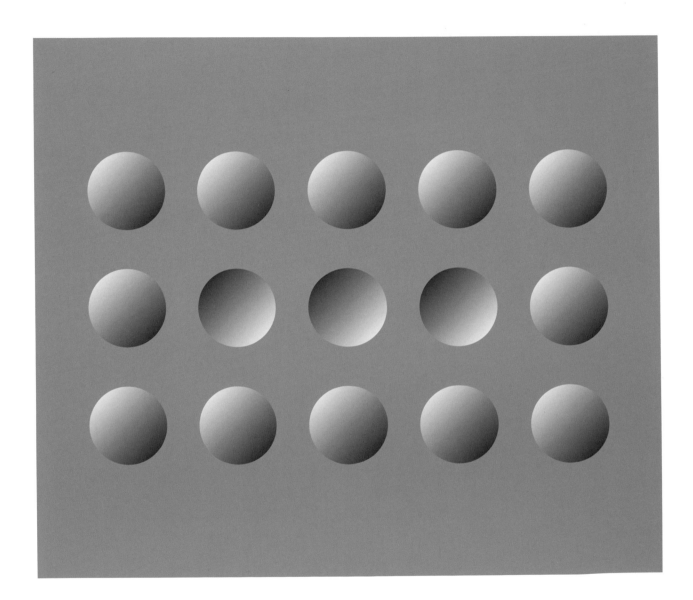

Spheres and bowls. Undated.

• *Count the spheres and the bowls in this image. Turn the book upside down and count again.*

Our perception of forms is influenced by the assumption (reasonable for Earthlings) that light comes from above.

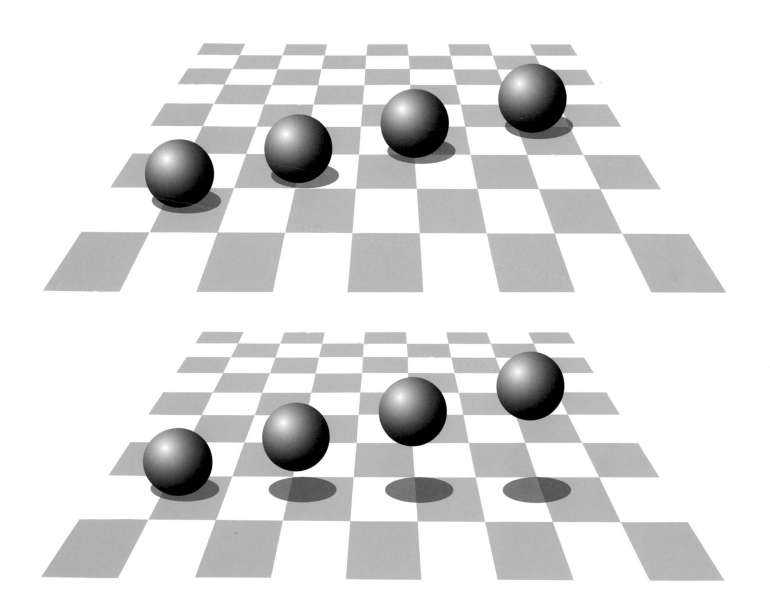

Daniel Kersten. *Perception of Relative Depth*. 1996.
The balls on the top appear to rest on the checkerboard, while those on the bottom seem to float in the air. Both sets of balls are in exactly the same position in relation to the board. The illusion is caused by the location of the shadows.

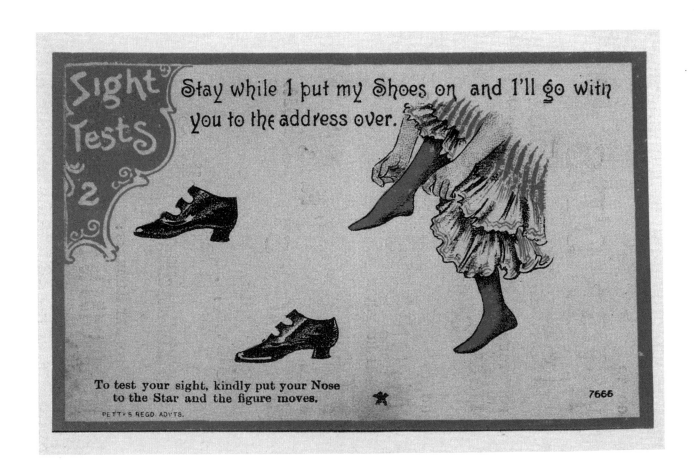

Stay while I put my Shoes on … Nineteenth-century advertising card.
• *Follow the directions and see what happens!*

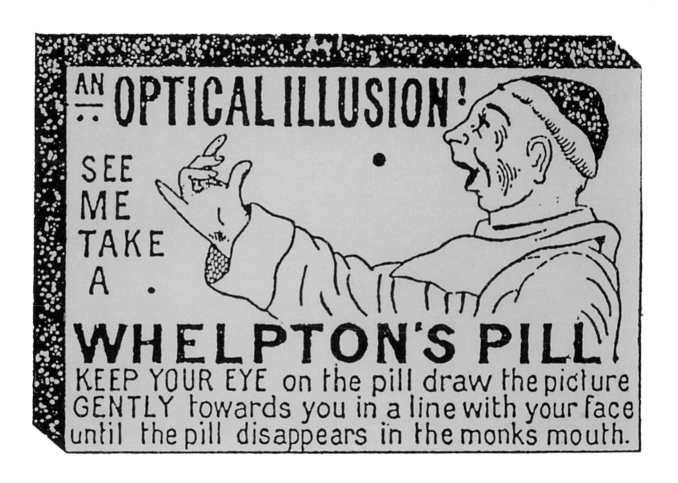

"Whelpton's Pill" advertisement. Late nineteenth century.
• *Follow the directions and watch the monk take his medicine.*

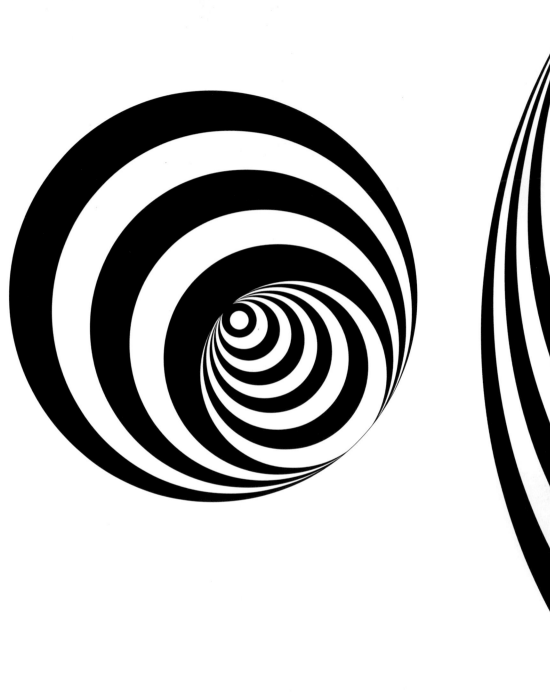

Concave/convex. Undated.

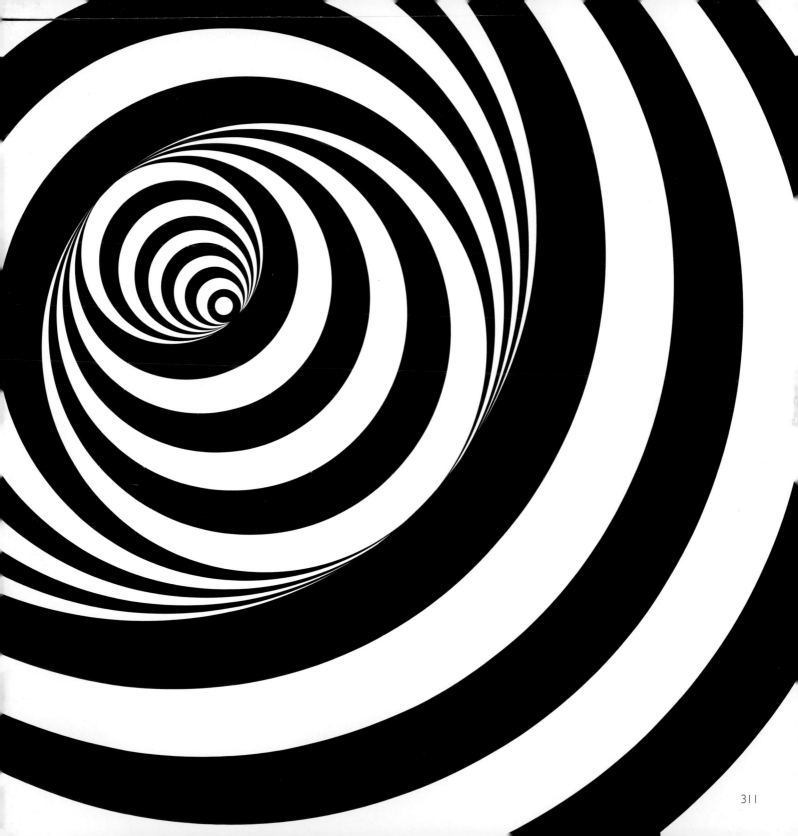

List of Illustrations and Credits

List of Illustrations and Credits

Knowlton, Ken (born 1931). All images © Ken Knowlton. All rights reserved. www.knowltonmosaics.com.
Barack Obama. 2009. (From 2008 presidential acceptance speech.) Computer graphics mosaic portrait with special computer-set font. Page 208.
Aaron Feuerstein (Director, Bobbin Yarn Factory), 2001. Spools of thread. Collection Aaron Feuerstein;
Martin Gardner. 1993. Six sets of 9-9 dominoes. Collection Martin Gardner;
Abraham Lincoln. 1992. Seashells;
Albert Einstein. 2001. Symbols from equation F=mc2. Computer graphics;
Uncle Sam. 1991. Seashells;
Will Shortz (NY Times crossword puzzle editor), 2003. Computer-assisted crossword-format drawing. Page 209.

Koelewijn, Job (born 1962).
The Nursery Piece. 2009. Page 249.

Krasnoukhov, Vladimir (born 1944).
From Possible to Impossible? 2008. © Vladimir Krasnoukhov. www.planetagolovolomok.ru/. Page 64.

Kuiper, Hans (born 1957).
Kus (Kiss). 1989. Computer graphic tessellation. © Hans Kuiper. http://web.inter.nl.net/hcc/Hans. Kuiper/. Page 286.

Kuniyoshi, Utagawa (1798–1861).
At first glance he looks fierce, but he is really a nice person. 1847–1848. Page 169.

Laan, Nico (born 1956). All images from the Anamorphoses Series, Meijendel beach, The Netherlands. © Nico Laan. http://nicolaan.info.
Tower at the Sea. 2009. Sand drawing. Pages 31, 34
Illustration and design plans for *Gateway to the Sea*. 2008. Page 32
Below Sea Level. 2009. Sand drawing. Page 33.
Gateway to the Sea. 2008. Sand drawing. Page 35.

Loyd, Sam (1844–1911).
Trick Donkeys. 1871. Page 182.
(Solution on page 319.)

Macdonald, David (born 1943). All images © David Macdonald. www.cambiguities.com.
Pool. Undated. Photograph. Page 79.
Peregrination. Undated. Photograph. Page 79.
The Terrace. 1998. Photograph. Page 81.
The Engineer, Nursery School. 2007. Photomontage. Page 87.
The Engineer, Primary School. 2007. Photomontage. Page 88.
The Engineer, High School. 2007. Photomontage. Page 89.
The Engineer, University. 2007. Photomontage. Page 90.

Magritte, René (1898–1967).
Le Blanc-Seing (Free Hand). 1965. Oil on canvas, 81.3 × 65.1 cm. © 2013 C. Herscovici, London/ ARS, NY. Photo Credit: Banque d'Images, ADAGP / Art Resource, NY. National Gallery of Art, Washington, DC. Page 73.
Le Viol (The Rape). 1934. Oil on canvas, 73 × 54 cm. © 2013 C. Herscovici, London/ ARS, NY. Photo Credit: Visual Arts Library/Art Resource, NY. Courtesy of the Menil Collection. Page 156.

Mantegna, Andrea (1431–1506).
Ceiling oculus. Fresco, 1465–1474. Photo Credit: Scala/Art Resource, NY. Camera degli Sposi, Palazzo Ducale, Mantua, Italy. Pages 9, 20.

Marcus, Jan W. (born 1941). Images © Jan Marcus. All rights reserved. http://janmarcus.nl.
Impossible Arch. 2010. Page 37.
Devil's Fork. Undated. Page 69.

Mey, Jos de (1928–2007). Images © Estate of Jos de Mey.
Escher's Thinker Observed by Magritte's Therapist. 1997. Acrylic on canvas, 60 × 50 cm. Courtesy of the Veldhuysen Collection. Page 67.
Confusing Triangulated Idol. 1990. Page 70.
An Afternoon Serenade in the Country Under an Escher-like Arch. 1990. Page 103.
Escher-Sphere and Knot With Magritte Man in a Constructed Landscape in Dali Colors. 1996. Acrylic on canvas, 50 × 40 cm. Courtesy of the Horst Holstein Collection. Page 104.
UFO Above the Flemish Landscape. 2005. Acrylic on canvas, 50 × 40 cm. Courtesy of Jan Broeders Collection. Page 113.
Pergola With Pythagoras Trees and Greek Sculpture. 1985. 80 × 100 cm. Acrylic on canvas, Courtesy of the Holstein Collection. Page 285.

Moss, Olly (born 1987).
The Great Dictator—Movie Poster Re-imagined (detail). 2010. © Olly Moss. All rights reserved. http://ollymoss.com. Page 139.

Müller, Edgar (born 1969). Images © Edgar Müller www.metanamorph.com.
The Crevasse. 2009. Acrylic paint on pavement, approx. 250 sq. meters. Pages 47–48.
The Waterfall (Turning River Street Into a River). 2007. Acrylic paint on pavement, approx. 280 sq. meters. Pages 48–49.
Lava Stream. 2008. Acrylic paint on pavement. Page 50.

Newell, Peter (1862–1924).
Cartoon. c. 1900. *Two men meet on the avenue...* Topsy-turvy drawing. Page 125.
Cartoon. c. 1900. From the *Naps of Polly Sleepyhead* series. Topsy-turvy drawing. Page 125.

Norcia, Anthony M. (born 1953).
Coffer Illusion. 2006. © Anthony Norcia. Page 202.
(Solution on page 319.)

Ocampo, Octavio (born 1943).
Hollywood Lights. 1982. Oil on canvas. © Octavio Ocampo. Used with permission of Visions Fine Art International, Sedona, AZ. Pages 150, 151.

315

List of Illustrations and Credits

Orosz, István (born 1951). All images © István Orosz. *http://utisz.blogspot.com*. *www.gallerydiabolus.com/gallery*.
> *Greek Column*. 1994. Page 39.
> *Stairs*. 1992. Page 55.
> *Horse*. 1996. Page 72.
> *The Wall* (Fal 1). 2005. Page 75.
> *Chateau, Chateau*. 2005. Page 78.
> *Round Tower*. 1997. Detail from *I Space Gallery* exhibition poster. Page 97.
> *Library 1*. 2005. Page 100.
> *Window*. 1993. Page 101.
> *Arc de Triomphe*. 1996. Page 102.
> *Crossroads*. 1998. Page 136.
> *Hidden Face*. 1979. Page 141.
> *Island-Watcher*. 1993. Etching. Page 191.
> *Untitled*. 1999–2006. Series of skulls in honor of the *Das Narrenschiff* (Ship of Fools) by Sebastian Brant, 1494. Page 192.
> *Columbus*. 1992. Page 193.

Palladio, Andrea (1508–1580).
> *Interior of the Teatro Olimpico*. 1589. Vicenza, Italy. Photo Credit: Erich Lessing / Art Resource, NY. Page 294.

Palmer, Catherine (1957).
> *Aqueduct, No. 4*. 2004. © Catherine Leah Palmer. Page 106.
> *Aqueduct, No. 2*. 2004. © Catherine Leah Palmer. Page 107.

Picasso, Pablo (1881–1973).
> *The Acrobat*. 1930. Oil painting on canvas. Musée National Picasso, Paris. Digital Image © RMN-Grand Palais / Art Resource, NY. Page 152.
> *Baboon and Young*. Vallauris, October, 1951 (cast in 1955). Bronze (53.3 × 33.3 × 52.7 cm). © 2013 Estate of Pablo Picasso/ARS, NY/ADAGP, Paris. Courtesy of the Simon Guggenheim Fund. Digital Image © The Museum of Modern Art/Licensed by SALA/Art Resource, NY. The Museum of Modern Art, New York, NY. Pages 170–171.

Poyet, Louis (1846–1913).
> *The Head of the Inventor*. 1890. Woodcut originally published in La Nature, Paris, 1890. Institut Catholique, Paris. Page 148.

Pozzo, Andrea (1642–1709).
> *The Glorification of St Ignatius*, ceiling fresco. 1691–1699. Photo Credit: Scala/ArtResource, NY. S. Ignazio, Rome, Italy. Page 27.

Pugh, John (born 1957). Images © John Pugh. *www.artofjohnpugh.com*.
> *Siete Punto Uno (7.1)*. 1990. Acrylic on MDO board (plywood board), 16 × 24 ft. (4.88 × 7.32 m). Page 24.
> *Mana Nalu* (Spirit of the Wave). 2008. A photorealistic trompe-l'oeil mural in Honolulu, Hawaii. Page 25.

Pugh, John & Marc **Spijkerbosch** (born 1967).
> *Reverse, Lateral and Loop*. 2002. Page 26.

Raedschelders, Peter (born 1957). © Peter Raedschelders. *http://home.scarlet.be/~praedsch/*.
> *Peace*. 2009. Computer graphic. Page 283.
> *Circle Limit*. 2007. Computer graphic. Page 287.

Reutersvärd, Oscar (1915–2002). Undated drawings © Estate of Oscar Reutersvärd.
> *Perspective Japonaise*, No. 350. Pages 9, 76.
> *Untitled*. Pen drawing of endless stairs. Page 11.
> Untitled drawing from *Perspective Japonaise*. Page 74.
> Untitled drawings from *Perspective Japonaise*. Page 84.
> Series of 3 postage stamps (from 1982). Page 85.
> *Perspective Japonaise*, Nos. 466, 360, 274. Page 85.
> *Perspective Japonaise*, No. 262. Page 91.
> Untitled drawing from *Perspective Japonaise*. Page 94.
> *Perspective Japonaise*, No. 315. Page 108.
> *Concave Stairs, Convex Stairs*. Page 142.
> *Two Arrows*. Page 207.

Reutersvärd, Oscar (1915–2002) and Bruno **Ernst** (born 1926).
> *Kariatiden (Caryatids)*. Undated. Page 108.

Riley, Bridget (born 1931).
> *Blaze*. 1964. © Bridget Riley 2013. All rights reserved, courtesy Karsten Schubert, London. Photo Credit: Tate, London / Art Resource, NY. Pages 14, 234.

Rust, Rusty (born 1932).
> *Hidden Lion*. Undated. *www.rustyart.net/*. Reprinted with permission of the artist. Page 57.

Schoen, Erhard (c.1491–1542).
> *Vexierbild*. Anamorphic portraits of Charles V, Ferdinand I, Pope Paul II, and Francis I. Woodcut, circa 1530. Photo Credit: bpk, Berlin/ Art Resource, NY. Kupferstichkabinett, Staatliche Museen. Berlin, Germany. Page 30.

Shepard, Roger N. (born 1929). Images © R. N. Shepard. Published in Shepard, R.N. *Mind Sights: Original Visual Illusions, Ambiguities, and Other Anomalies*. (1990). New York: WH Freeman and Company.
> *Sara Nader*. Pages 12, 188.
> *Terror Subterra*. Pages 15, 255.
> *Wrought Up*. 1984. Page 97.
> *Glee Turns Glum*. Page 129.

Studio PBD. All images © Studio PBD.
Tête à Fleur in Lines. 2012. Pages 13, 223.
Illusory Pink Square. 2007. Pages 13, 212.
4 Ouchi, 2013. Pages 14, 244.
Bent Lines Illusion. 2013. Pages 15, 274–275.
Impossible Fork. 2012. Page 68.
Impossible Four Bar. Page 82.
Two drawings after Josef Albers's *White Embossings on Gray* series, 1971. Page 112.
Variation on Schröder stairs. 2012. Page 143.
Variation: *Male and Female Legs*. After the original poster by Shigeo Fukuda (1932–2009): *Female and Male Legs*. 1975. Page 160.
Pencils 4 Three. 2010. Pages 204–206.
Wine bottle for Friedrich Schumann. 2011. Page 214.
Figment Figures. 2010. Page 215.
Illusory Shades of Gray? 2009. Page 217.
The Glowing Lamp. 2011. Page 218.
Leaf of Shades. 2008. Page 219.
Dark Cloud. 2012. Page 222.
Color Blindness Test (variation). 2011. Page 224.
Anderson & Winawer Lightness Illusion. 2012. Page 225.
Umbrella Shade. 2012. Page 227.
Rotating Blocks. 2011. Page 235.
Riley's Waves. 2011. Page 239.
Waterside. 2013. Page 245.
LottoLab Object Angles. 2013. Page 264.
Longest Mikado Stick. 2009. Page 265.
Distorted Circles. 2009. Page 266.
Zöllner's Horizontal Alignment. 2012. Page 267.
Twisted Circles. 2013. Page 269.
Tilting the Beams. 2011. After Kitaoka, Brelstaff and Pinna: *Illusion of shifted edges*. 2001, 2004. Page 270.
Bent Lines Illusion. 2013. Pages 274–275.
Variation of the Zöllner Illusion. 2013. Page 277.
Kitaoka's Out of Focus. 2013. Page 288.
Shaded Relief. 2013. Page 289.

Sullivan, Luke (1705–1771).
Satire on False Perspective. 1754. Etching and engraving, after William Hogarth (1697–1764). Original engraving designed by Hogarth, engraved by Sullivan, and published in 1822 by William Heath. Page 18.

Termes, Dick (born 1941).
Escher to the Third Power. 1983. Termesphere. 16 in. (40.64 cm) diameter. © Termespheres. All rights reserved. *http://termespheres.com/*. Page 41.
Brain Strain. 2004. Termespheres, 24 in. (60.96 cm) diameter. Page 42.
Negative Lady. 1993. © Dick Termes. All rights reserved. Page 186.

Todorović, Dejan (born 1950).
Elusive Arch. 2005. © Dejan Todorović. Page 292.

Utagawa, Kuniyoshi (1798–1861).
At first glance he looks fierce, but he is really a nice person. 1847–1848. Page 169.

Varini, Felice (born 1952).
Five Concentric Black Circles (Cinq cercles concentriques noir). 1997. Acrylic painting. © 2013 ARS, NY/ADAGP, Paris. Photo: André Morin. Photo Credit: Banque d'Images, ADAGP / Art Resource, NY. Private Collection. Page 21.
Five Concentric Black Circles, Outside Perspective (Cinq cercles concentriques noir, Hors pointe de vue). 1997. Acrylic painting. © 2013 ARS, NY/ADAGP, Paris. Photo: André Morin. Photo Credit: Banque d'Images, ADAGP / Art Resource, NY. Private Collection. Page 22.

Vasarely, Victor (1908–1997).
Toroni-Nagy. 1969. Acrylic on canvas. © 2013 ARS, NY/ADAGP, Paris. Photo Credit: Erich Lessing/ ArtResource, NY. Private Collection, USA. Pages 17, 304.
Kocka Urvar. 1983. Acrylic on canvas. © 2013 ARS, NY/ADAGP, Paris. Photo Credit: Erich Lessing/ ArtResource, NY. Private Collection, Monaco. Page 305.

Verbeek, Gustave (1867–1937).
From: *The Upside-Downs of Little Lady Lovekins and Old Man Muffaroo—A Fish Story*. 1904. In *The New York Herald*. Pages 130–132.

da Verona, Giovanni, Fra (1457–1525/6). Intarsia with geometric instruments, from choir stalls. Trompe-l'oeil. 1502. Photo credit: Scala/ArtResource, NY. Abbey, Monte Oliveto Maggiore, Italy. Page 23.

Whistler, Rex (1905–1944). Images published posthumously in *¡OHO! Certain Two-Faced Individuals*. London: The Bodley Head, 1946.
Thinker/Housewife. Pen and ink topsy-turvy drawing. Page 118.
Policeman/Sailor. Pen and ink topsy-turvy drawing. Page 119.
Old Man/Young Man. Pen and ink topsy-turvy drawing. Page 120.
King/Queen. Pen and ink topsy-turvy drawing. Page 121.

Yoshifuji, Utagawa (1828–1887).
Kittens Gather Together to Become a Mother Cat. c. 1850. Page 169.

Yoshitora Utagawa (c. 1840–1880). Japanese *joge-e* (two-way) drawings. 1861. Woodblock print. Source: *http://pinktentacle. com/2008/04/joge-e-two-way-pictures/*. Page 140.

Yossi, Lemel (born 1957).
Israel Red Hands. 1995. Detail of poster for Amnesty International. *http://www.lemel.co.il/ mainframe.html*. Page 161.

List of Illustrations and Credits

Anonymous / Unknown Artists

Painting of a human figure surrounded by bison in the Grotte des Trois Frères, Montesquieu-Avantès, France, c. 13,000 BC. Page 8.

MALI CORVI MALVM OVVM ("A bad crow from a bad egg"). Pope/Devil image, c. 1543. Silver cast medal. Page 8.

Anamorphic painting of a ship, c 1744–1774. This example was originally attributed to Van de Velde, a Dutch artist, but its origins are now uncertain. Photo Credit: SSPL/Science Museum / Art Resource, NY. Science Museum, London, Great Britain. Pages 10, 38.

Dodecahedron, c. 1600. On the twelve faces are heads that can be read upside down as well as straight. German or Dutch. 3rd quarter of the 16th century. Watercolor on parchment. Photo Credit: Erich Lessing/ Art Resource, NY. Schloss Ambras, Innsbruck, Austria. Pages 11, 128.

The Old Man of the Mountain. Cannon Mountain, New Hampshire. Photographer unknown. Pages 12, 149.

Shepard's Tabletops. After Roger N. Shepard's *Turning the Tables.* c. 1990. Pages 16, 250.

Double-Head of Pope and Devil. Oil on canvas, c. 1600. Courtesy of Werner Nekes Collection. Page 116.

Courtship and Matrimony. Lithograph, c. 1884. Courtesy of the Werner Nekes Collection. Page 124.

Napoleon and Donkey. Upside-down cartoon. c. 1800. Page 126.

Turn it round… Finito Mussolini. Upside-down poster. c. 1945. Page 127.

Topsy-turvy/ambiguous figure: *Pointed finger/Cat.* Undated. Page 138.

Sigmund Freud: What's on a Man's Mind. Undated. Page 157.

Island of Sleeping Dogs. Undated. Page 190

Townscape with Head. Undated. Page 190.

Detail of floor with illusionistic design. Marble inlay. Capella Sansevero, Naples, Italy. Photo: Luciano Romano. Photo credit: Scala / Art Resource, NY. Page 210.

Troxler's Effect. Undated. Pages 14, 228, 229.

Hermann's Grid. Undated. Page 230.

Bergen's Grid (variation). Undated. Page 231.

Negative Heart. Undated. Page 232.

Marilyn's Lips. Undated. Page 233.

Leviant's Enigma. Undated. Page 241.

Floating Square Illusion. Undated. Page 243.

Optical Illusions: An Illusion of Perspective. From a cigarette cards series. 1926. Page 252.

Deceptive Perspective. From Ogden's Optical Illusions Cigarette Cards series. 1923. Page 253.

Deceptive Blocks. Undated. Page 257.

Jawstrow Illusion. Undated. Based on Jastrow Objects. 1889. Page 258.

Wrought-iron perspective gate. 1725. Parish Church, Ingolstadt, Germany. Photo Credit: Erich Lessing / Art Resource, NY. Page 295.

Detail of floor of the cubiculum with three-dimensional design. Marble inlay, Roman. Location: House of the Griffins, Palatine Hill, Rome, Italy. Photo by Luciano Romano. Photo Credit: Scala/Art Resource, NY. Page 301.

Spheres and bowls. Undated. Source: *http://rationalwiki.org/wiki/Bayesian.* Page 306.

On the back cover:

Anonymous. *Bergen's Grid (variation).* Undated.

Studio PBD. *Impossible Fork.* 2012. © Studio PBD.

Abélanet, François. *Who to Believe?* 3D Anamorphosis. 2011. © François Abélanet.

Müller, Edgar. *Lava Stream.* 2008. © Edgar Müller.

Studio PBD. *Tête à Fleur in Lines.* 2012. © Studio PBD.

Anonymous. *Tesselation.* Undated.

Cianfanelli, Marco. *National Monument–Nelson Mandela.* 2012.

Reutersvärd, Oscar. Untitled drawing, from *Perspective Japonaise.* Undated. © Estate of Oscar Reutersvärd.

Studio PBD. *The Glowing Lamp.* 2011. © Studio PBD.

Note: Every effort has been made to establish and properly credit all rights and copyright information for images used. Any omission is unintentional.

Solution to puzzle page 182.

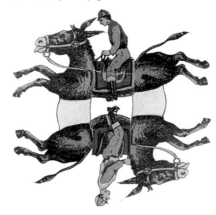

Sam Loyd (1844–1911). *Trick Donkeys*. 1871.

Solution to puzzle page 263.

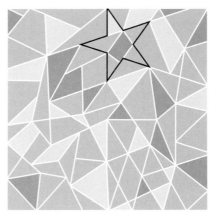

Hidden pentagram. Undated.

Solution to puzzle page 202.

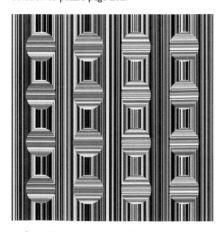

Anthony M. Norcia (born 1953).
Coffer Illusion. 2006.

Art Editor and Designer:	Paul M. Baars
Project Directors:	Joost Elffers and Andreas Landshoff
Project Coordinator:	Lindy Judge
Art Coordinator and Design:	Robert J. J. Stevens
Introduction:	Dick Verroen
Translations from the Dutch:	Marjolijn de Jager

An Andreas Landshoff Production
For Joost Elffers Books